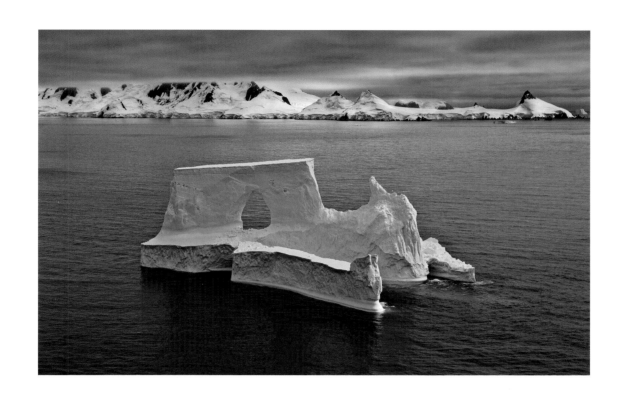

CONCEPTS OF NATURE

First published 2008 by Argentum an imprint of Aurum Press Ltd,
7 Greenland Street, London NW1 0ND.

A catalogue record for this book is available from the British Library.

ISBN 978 1 902538 52 5

Designed by Eddie Ephraums.

Printed in Singapore by CS Graphics.

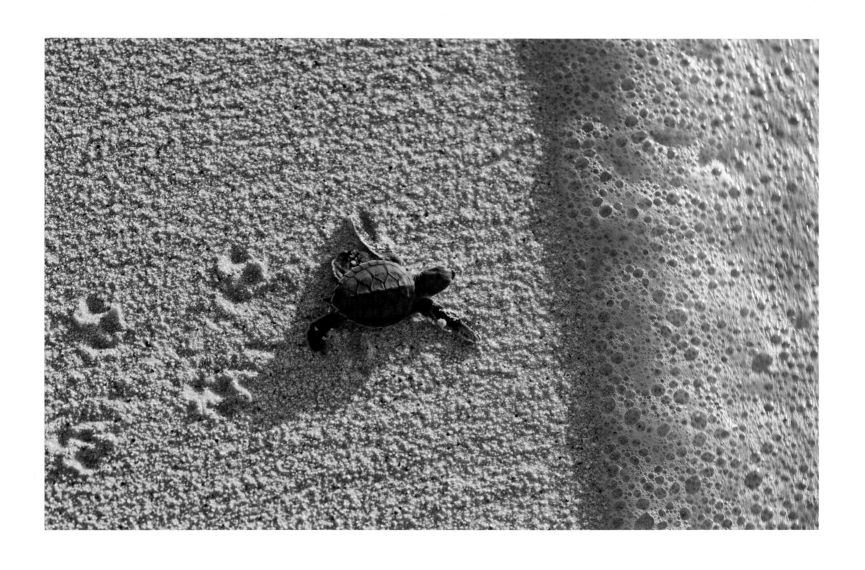

CONCEPTS OF NATURE

A Wildlife Photographer's Art

ANDY ROUSE

Argentum

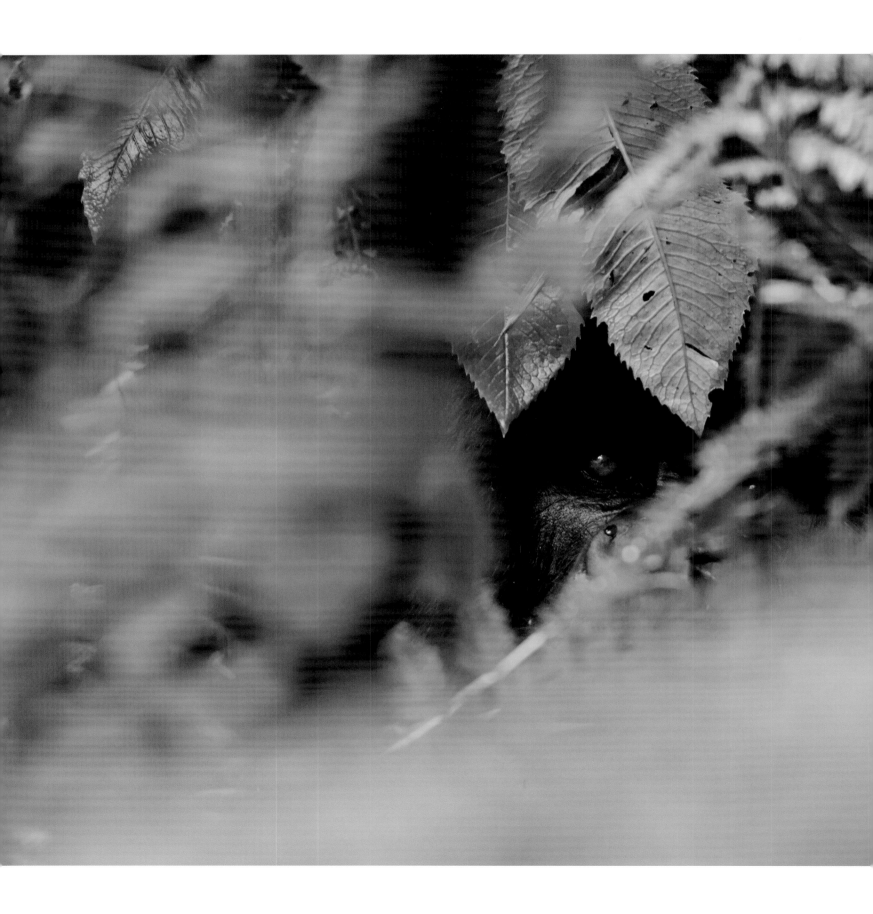

CONTENTS

VISION – EXPRESSION – INSPIRATION

Concepts of Nature is not just a book about wildlife photography; it is also a book about the everyday challenges that we face as we seek to express ourselves through the medium of photography. I believe that by constantly challenging ourselves as photographers we can move our work to a higher level and that the best photographers are those who admit that they learn something new every day. Certainly, my own career has been one challenge after another. As an unknown photographer, with no silver spoon and no big money corporate career behind me, I had to really fight to get a foothold in a tough commercial world and turn my passion for animals into the lifestyle that I have today. After some false starts and some equally false expectations of my own ability, my photography has steadily improved over the past ten years but it is only quite recently that I feel that I have become the type of photographer that I really want to be.

One of my great skills, I believe, is that I have the ability to learn from the work of other photographers who specialise in genres of photography outside wildlife. I have taken inspiration from the great portrait, sports, landscape and reportage photographers of our time, by analysing what their images have to say and applying the lessons to my own work. We can all learn from each other and it is my hope that *Concepts of Nature* will cut across the traditional boundaries in photography and be inspirational to all.

Photographers the world over share the same passion for light. Portrait photographers use light to create images that portray their clients in a way that is appealing for them. Wedding photographers use light to ensure that the images from the big day are timeless and evoke wonderful memories for years to come. Landscape photographers are dependent on light to bring their subjects to life and create a sense of wonder or awe, while in complete contrast news photographers frequently use light to tell a story of suffering and hardship. All of us, no matter what our chosen genre of photography, warp and bend light to express ourselves and tell a story of what we see. As photographers, we are storytellers, with the power to influence or corrupt, to excite and inspire; it is my sincere hope that *Concepts of Nature* will inspire you, irrespective of your favoured field of photography.

This is really three books in one – Vision, Expression and Inspiration. Vision explores the development of my professional life, from my first potentially suicidal ventures into Africa to my most recent story-led environmental portfolios of South Georgia and Antarctica. It reveals how I have developed from a one 'big shot' merchant to a photographer who has learned to see and use the light to tell a story and depict a scene. Expression looks at some common techniques that I use via a series of themed portfolios – 'Red5', 'Just Plain Beautiful', 'AtmosFear', 'Predator & Prey' and 'Going Places'. Finally, Inspiration briefly looks at photographers whose work has inspired me, both from within my own genre of wildlife photography and beyond. Above all, it is my sincere wish that *Concepts of Nature* should inspire photographers to make innovative and inventive use of light rather than allowing light to use them and dictate the work they produce.

Meet Amber, *granddaughter of the famous Queen, who has become a real favourite of mine after the many weeks I have spent following her every move. I was present when she introduced her cubs to the world for the first time and watched as they matured and set out to discover life on their own. Of all the thousands of pictures I have taken of her over the years this is one of my favourites, solely because of its simplicity. To borrow the style of the celebrity chef Gordon Ramsay I would summarise my feeling about this picture as: 'Beautiful animal, beautiful light. Done'*

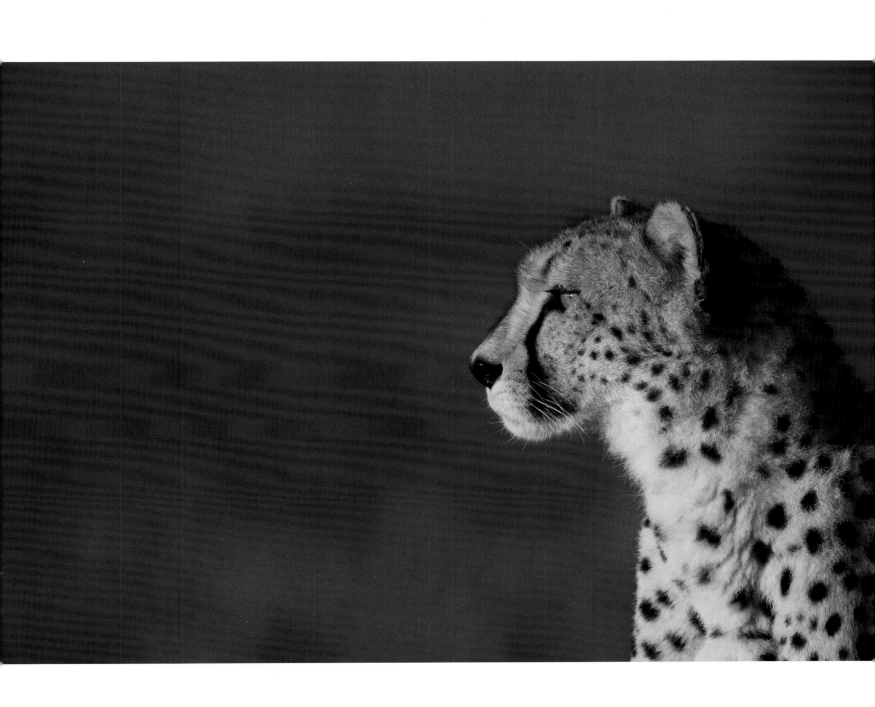

A risky business

My first foreign trip as a professional photographer was a month-long African safari. In truth it almost bankrupted me. The trip was a huge financial risk. I had no safety net in the shape of another career. However, I had tremendous self-belief, bordering on arrogance, and probably incredible ignorance, too. I believed that I could come back with something different from the usual safari shots that I had seen around. As soon as I stepped on African soil for the first time I knew that Africa was in my heart and from that day I haven't looked back.

As pretty much everything in Africa had been photographed well already, I knew that to get new and novel images I really had to think outside of the box. The opportunity to express myself presented itself sooner than I imagined, in fact on my second day on the African continent. A group of elephants were using a mud wallow, and it was while lying flat on the ground watching them that I had an interesting idea for a shot. A few minutes later, when the wallow was empty, I crept over to its edge and embedded my tripod deep in the mud; I attached a camera, a wide-angle lens and a remote control then crept back to the vehicle to wait. Eventually, a bull elephant appeared, walked straight into the wallow and began his free spa treatments. As he chucked mud all over himself I merrily clicked away for a few minutes, smiling since all seemed to be going rather well. I should have known better. The elephant must have heard the camera's shutter. He suddenly reached out his trunk, scooped up some mud and prepared to hurl it at the source of the disturbance. Instinct told me to start shooting; I pressed the remote control just as a 'trunkful' of mud hit the camera! This is the resulting image; a really novel shot of everyday elephant behaviour.

The success of this picture in many ways kick-started my career, as it won the Animal Behaviour section in the annual BBC Wildlife Photographer of the Year competition. It put my name on the map as a photographer and taught me some vital lessons in the process. Seeing an opportunity for an image is the real skill of any photographer and I firmly believe that this is something that cannot be taught; you either have it or you don't.

Visualising a shot, and turning an opportunity into reality, is surely the essence of all photography and is an expression of our individual creativity. This image is living proof that a little lateral thinking can reap rewards…even if I did sacrifice a camera in the process.

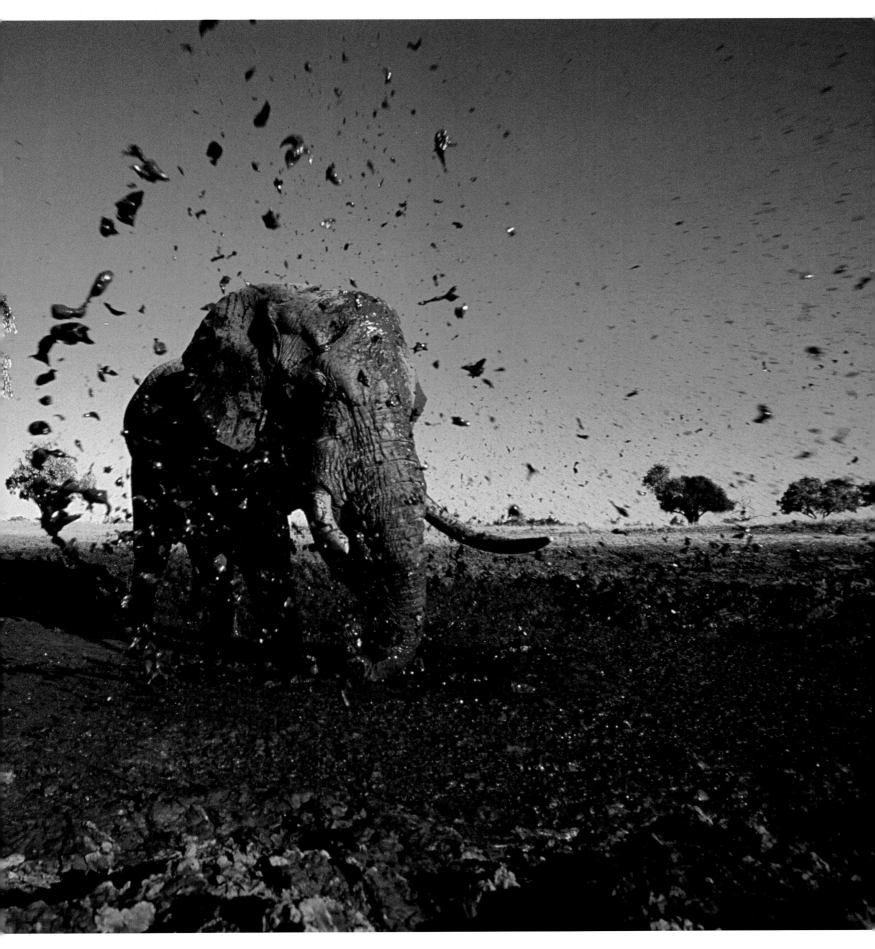

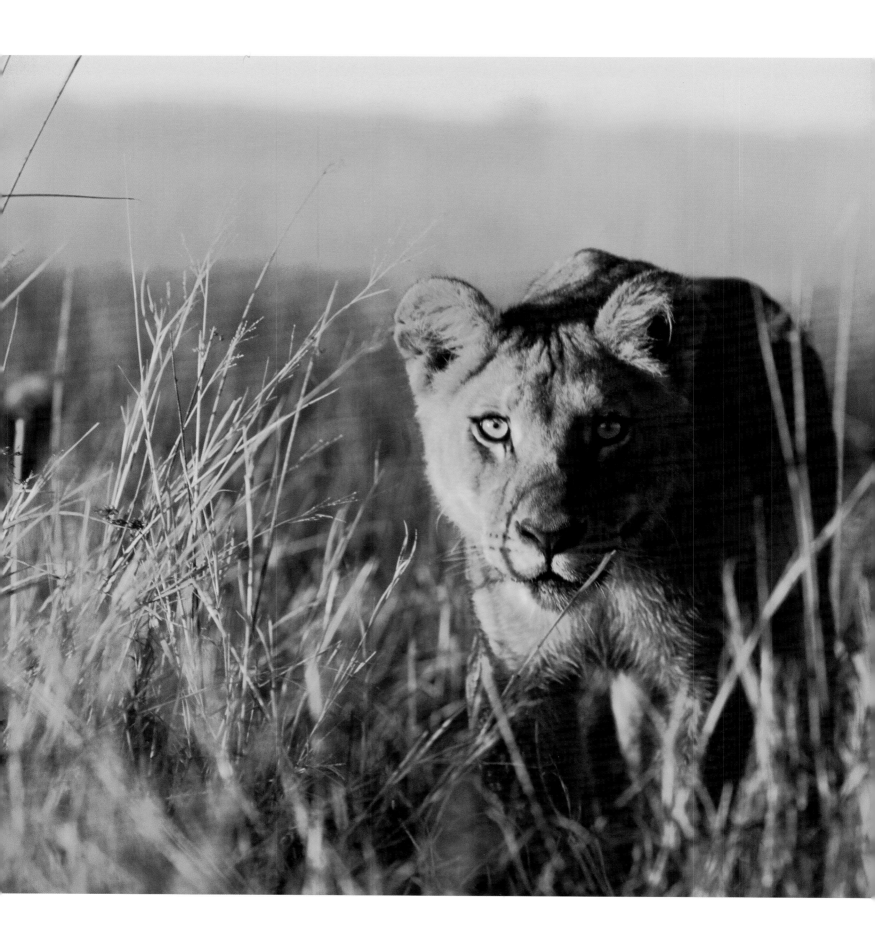

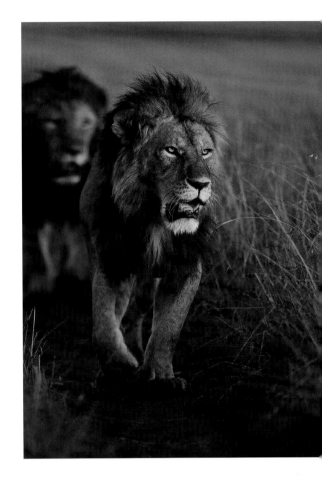

Left: **The light was intensely red** *and, little did I know it at the time, red light would become an obsession for me. It was made even redder because I used an 81A warm-up filter on all my lenses then and shot with Fuji Velvia 50 film, a variety of film not known for subtle tones. Although I love the intensity of this image I hate the light angle that I chose at the time; back then I always let the light govern what I did rather than using it to create my own image.*

Right: **A more up-to-date image** *showing a much better use of red light and with an interesting story to tell. It's a bit subtler, too, than the stalking lion and perhaps lacks the intensity that came with the imminent threat to my life.*

An extreme low-angle shot, but this time *not* taken with a remotely control, I was actually behind the camera. I didn't get in the grass with lions because it was a macho thing to do; I did it so that I could feel a direct connection with them. Being in a vehicle you simply can't feel the same connection and I believe that whatever you choose to photograph you have to connect somehow with the subject. I wanted to know what it felt like from the prey's-eye-view to be stalked by a wild lion. It was a weird sensation, my adrenaline was flowing like an open tap and I felt a strange sense of fear and excitement, but my brain was screaming at me to abandon ship and get the hell out of there. To run would have invited a chase that I could not win so I had no choice but to concentrate my mind on getting the picture. But during those brief moments I felt utterly powerless and totally vulnerable; I freely admit that I was terrified.

To this day, I have no idea what possessed me to walk up to three fully-grown lions (with a blanket on my head to stop *them* being scared of *me*). It is a weird state of affairs to take your posthumous exhibition photo whilst you are still alive! What my crazy behaviour did achieve was to allow me to capture a very intense look, perhaps similar to that the lion's prey would see during its final moments: a very compelling yet chilling experience. Would I repeat it again? Certainly not, and I now think that there are easier ways to get the same intensity in your shots. Still, I do feel passionately that being in the same landscape as your subject gives your pictures a certain distinction. The eye contact is something that I loved then and which I love now as it makes the image a little bit more edgy, this one doesn't really tell a story but at that time I was just looking for 'the big shot'. How times change.

Finding a direction

It is important for all photographers to develop their own style and not to copy others. A photograph conveys your feelings, your emotions or mood at the time and this in turn affects your interpretation of what you see. Therefore to copy someone else's shot is to try and copy their feelings, which is impossible and also means that the photograph can never be your own. My style of photography, as you will see, has changed and evolved over the years. As I have said before, I always take inspiration from other photographers work, but I don't copy it. Rather, I work out what the picture is trying to say and what technique is being used, I can then apply it to my own photography. It can be difficult to generate your own style and in the early days of my photography I did struggle to find an identity and a 'look' for my images. My first African trip, the results of which you have seen, saw me shoot in a variety of styles but it took my first trip to the Arctic to determine which of these styles suited me the best and to start to find myself.

Luckily, I had made enough money from the African trip to eat more than beans on toast and so decided to invest the lot on a trip to Svalbard. Looking back, I can see that I was playing a kind of Russian roulette at that stage of my career, as I was constantly gambling with what little money I had. Fortunately I never looked at it from the money side of things. If I had the money then I would spend it travelling to see animals rather than giving it to the taxman and that remains my simple philosophy to this day.

I had always dreamed of photographing polar bears and wanted to take something different from the work I had seen, which, although beautiful, was usually shot on tundra and always from a high angle. I already knew enough about my style to recognise that I wanted to shoot the bears on sea ice and to be in the environment with them, not removed from it; the lessons from the African trip had bored deep into my soul. To cut a long story short, some time later I found myself snowmobiling across the sea ice to the east of Svalbard in search of polar bears in the company of wilderness guide Arne Kristoffersen. It was to be an amazing trip, being out on the sea ice gives you an incredible feeling of freedom and after a few days I had no idea what day it was…and frankly nor did I care as the rest of the world seemed a lifetime away.

The first bear we found was a huge male, walking slowly across the ice. We drove the snowmobiles ahead of him, about a mile in fact, switched off and waited. I lay down on the ice and made an improvised beanbag from a lump of ice with my knife, the tripod having been shaken apart by the journey. After a while the bear appeared and I muttered to Arne that he appeared to be heading towards us 'Of course,' he said with an unnerving smile, 'you look like a seal lying on the ice.' Great, I had unintentionally been using the old 'Rouse as prey' trick again. Slowly the polar bear advanced; the noise of his paws scrunching the fresh ice getting louder and louder. He was just magnificent and I have never seen such a huge male since. Before I knew it, he had reached his 'circle of safety' – the limit of his comfort zone if you like. All animals have this circle of safety within which they feel comfortable because they still have the option to take flight. As a wildlife photographer it is my responsibility to know exactly how far this extends as it differs from species to species. Breaching this circle can induce enormous stress and cause the animal to become scared and, in extreme cases, provoke an attack. If in doubt it is best to sit well away and let the animal come to you, and this was our plan, as it put the bear in control. Actually, he had no interest in us as potential prey; fortunately bears of all

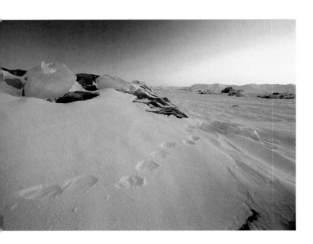

Taking pictures of footprints *is a great technique in photography as they always raise questions like 'what made them?' or 'where are they going?' Our only question here was 'where is the bear now?' and after spending a few minutes searching, whilst being careful not to spoil my potential shot with skidoo tracks, we were satisfied that the bear was gone. The shot works on several levels; the stunning Arctic environment and twilight combine with the visual perspective of the polar bear tracks leading away from the foreground. Compositionally I could not do a lot else; my hands were frozen solid after being out of the gloves for a minute in -40 degrees and I couldn't move the zoom dial after that!*

Opposite: **The depth of field** *in situations like this is all-important. I wanted the polar bear to be sharp from head to tail but I only wanted an impression of the mountains behind. Any more than an impression and the emphasis of the story would be changed; I wanted the viewer's attention squarely focused on the bear, as he was magnificent. I used the depth of field preview button to check out all combinations and finally arrived at f8 as the best compromise; these days I would have shot it much wider but I was a different photographer then.*

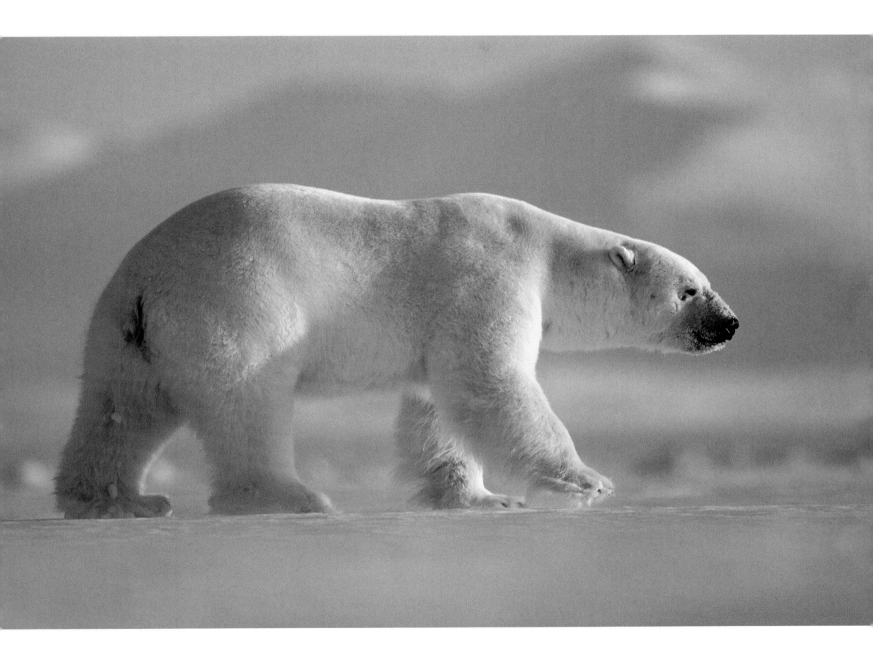

kinds don't consider us as food. Our bear was clearly on a mission and wasn't going to stop for us. Inexperience meant that I wasted the photographic opportunities presented to me as I could only afford one camera at that time and it had frozen solid to a 600mm lens. These days I would have given myself a wide-angle option too. I really love this shot as the light is soft and there is just a hint of Arctic mountains behind. Here, as with the early African images, it is the low angle that really makes the image stand out. This was clearly forming the basis of my developing style.

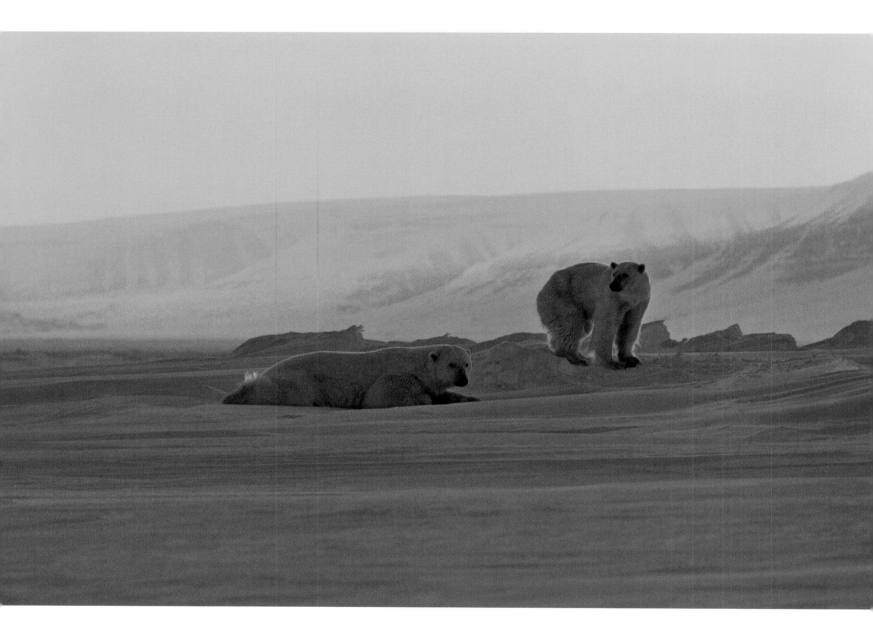

I had limited composition options here and at times like this I just let the animals and the light do the talking. Sometimes we get too obsessed with composition and forget the basics. In this low light my main concern was shutter speed and not composition, as I would rather have a sharp image that I can crop later than a beautifully composed image that is soft.

We met the male again several days later. The quest he was on was revealed, as he wasn't alone. He had hooked up with a female and they were in the midst of the courtship ritual. For several days we followed them, always at a discrete distance as we didn't want to disturb the spectacle unfolding in front of us. Polar bears are unpredictable and can never be trusted; we were alone on the ice miles from anywhere and without any safety net. However, these thoughts were far from my mind at the time; the courtship was so beautiful to watch. The male padded softly behind the female, tenderly calling to her all the time, I had to pinch myself to be sure that I wasn't dreaming. We stayed on the ice with them for three days, sleeping when they slept and taking it in turns to stay on guard whilst the other grabbed some rest on the snowmobile seat. When you have something incredible in front of you in the world of wildlife photography you stay with it. These polar bears were sharing their world with us and I wasn't going to miss it for anything.

With all reference to day or time (other than it was nearing sunset) far from my thoughts, I watched the bears busily hunting seals. I had taken my fill of full-frame shots for the day. I felt really unhappy, though, about the images that I had taken, they may have been beautiful (or so I hoped as these were the days of film) but they would not do any justice to the location or the bears in their environment. Something was missing, and it wasn't just the light, the sun had been shining all day. As the evening wore on the midnight sun dipped lower on the horizon until finally a golden glow started to light up the bears and the mountains behind. This golden light came and went and then the light turned red as the sun reached its lowest point; the ice mountains behind the bears caught fire and I knew that my moment had arrived. I made a momentous decision – to take off the big lens (now fully defrosted) in favour of a wider angle. The fanfares of trumpets were almost audible. The light was only there for a few seconds but that was all I needed. I saw, perhaps for the first time, the combination of an animal and its habitat, linked by great light. I suppose you could say that I saw the light, which is a horrible cliché but at this time probably most apt. The courtship carried on for a few more days but they gradually moved farther out onto the sea ice where it was too dangerous to follow, I wished them good luck and we started our long journey back to the hut we called 'home' for a little while at least.

On the way back I saw low cloud forming on the horizon, Arne stopped his snowmobile, looked though his binoculars and then told me to put my pedal to the metal and go full speed back to the hut; a storm was coming and we had to beat it. Thirty adrenaline-fuelled minutes later, most of which I seemed to spend in mid air, we screamed to a halt outside the hut and after refuelling the snowmobiles got inside just a few minutes before the storm struck. For three days it hit us hard and there was no chance of going out. When it finally passed we were desperate to see bears again – once we had dug our way out of the front door…

Ten years on, the combination of sea ice and polar bear is an emotive one especially as, with the increasing effects of climate change, neither might be there after a few more decades. A sobering thought.

Personal demons

I had always been scared of water and had never jumped into even a swimming pool. So when it came to slipping into a rough Pacific Ocean, 90 miles from shore, I naturally had second thoughts. However, the goal was worth it, just 30 feet from the boat was the fin of a humpback whale. So I took a deep breath, grabbed my Nikonos V underwater camera that little bit tighter, and slipped silently over the side. The sight that greeted me was something that I will never forget; if you think a whale is big on the surface, well, take a look at it underwater! It was huge and looked so beautiful just hanging there. It was calming too; I'm not sure why, but my fears just melted away and I had the confidence to kick away from the boat and follow the whale as it drifted by. It rolled its body sideways slightly and I am sure that it did so to look at me, I was so elated I forgot about the camera on my wrist and almost forgot about the snorkel too. They say that whales are spiritual; well, I have seen nothing to convince me otherwise and they certainly instil an amazing sense of calm when you spend some precious moments in their company. Why did I want to include this image? Well it shows how challenging yourself and pushing the boundaries of your photography, no matter how you do it, can only benefit what you create.

Since then I have conquered my fears of water and am now a qualified diver and relish the challenge of photographing underwater. I'll admit that I am not that good at it, but I do love it and that is all that counts. One day, I will return to swim with humpbacks again and perhaps by then I will do them a bit more justice photographically. Despite this, one thing is for sure; I still won't be jumping into any swimming pools!

I may be a terrible underwater specialist but I can certainly see light and it was the rays of light on the back of the whale that made me want to take this shot.

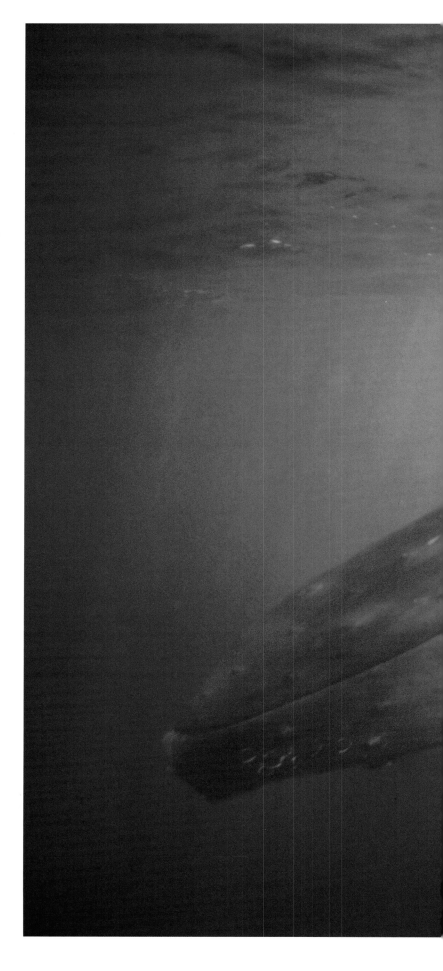

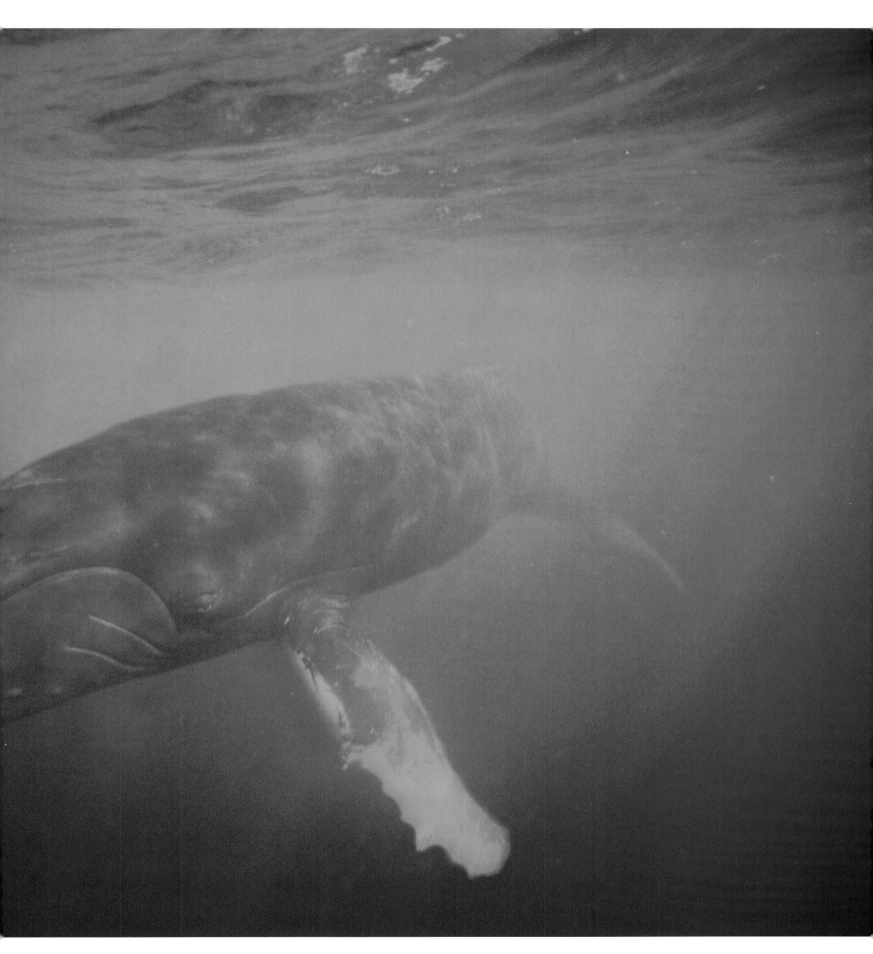

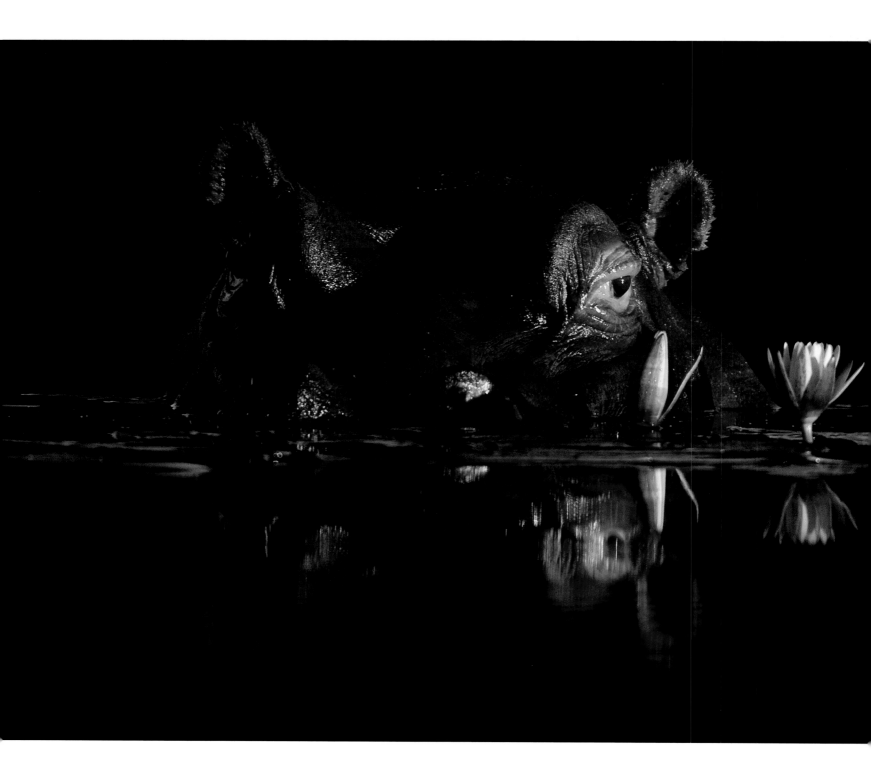

These days *I always make sure that during a shoot, no matter how intense it is, I take a few seconds to look away from the viewfinder to fully appreciate the subject for myself.*

The digital age

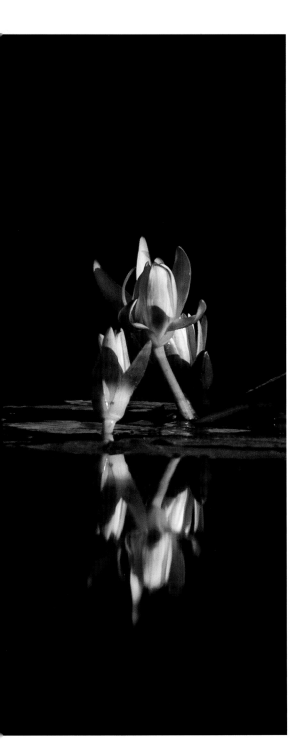

The arrival of the digital age presented me with some new trials, mainly because being an early convert was like being an explorer in virgin territory. My photography had been really improving at the time and, with a clutch of new awards and a steadily growing client and agent base, my pictures were much in demand; but I still was not happy with the kind of stuff that I was taking. Then I got my first digital camera and that was the spur I needed; from my point of view it allowed me to stretch my horizons and experiment with new styles and techniques, which has helped the continued development of my photography to this day.

My first real outing with a DSLR was a dream commission: to photograph the birth of a new national park in South Africa and the realisation of one man's dream. The only brief from him was to 'get great pictures' so I could really spend the time getting to know the wildlife and picking the best light to shoot in. After taking a week or so to get acclimatised to the pulse of the park I began to work with the newly arrived hippos, which were distributed in several different pods. Over the course of a few days I visited all of the pods in morning and evening light and figured out the best one to work with in terms of background, light, and safety. Safety is paramount when working with hippos as they are surprisingly fast despite their short stumpy legs and have breath that I never want to experience first-hand. The pod I chose had five individuals and I particularly liked the dominant female (naturally) who spent most of her time in a patch of water lilies and for that reason I named her 'Lily'. I had no idea at that time how important she would become to me and how one picture would shape how I look at light today.

The hippos gradually became used to my presence over the next week or so. It was time to see how much they would tolerate me, so I started to get out of the vehicle and sit near the edge of the pool whilst keeping a wary eye out for any adverse reaction. All animals tell you if they are alarmed or unhappy, you just have to learn to read the signs and back off when told to do so. Eventually, I could get to the water's edge without any reaction from the sleeping beauties in front of me; watching hippos sleeping is such a wonderfully peaceful and calming experience. The evening that I took this image was perfectly still; in fact, the silence was deafening, the only sounds being the occasional snort and my shutter as it clicked away. In the last seconds of light, the background was in deep shadow and against it the last rays of sun lit her face and the lilies with a magical light. The moment was something that I will never forget. I think that this is a real beauty-and-the-beast image; a beautiful picture of what can be one of the most aggressive of African mammals.

I will probably never take an image like this again in my life. If I were to pick the one seminal picture from my collection that has had the greatest influence on my photography, it would be this one. I remember looking it at thinking, 'Right, I am going to take whatever I want from now on and not what everyone expects from me.' This image, for me, combines many of the concepts of nature, which I explore later in this book. The image represents a defining moment in my career, as it showed that I could use the inspirations of great portrait photographers, combined with my visualisation of how best to use the available light and a well-honed set of techniques to ensure that I expressed the type of story that I experienced.

Thus, a new digital photographer was born…

Seeing the light

Writing this book has been a fascinating journey for me as I have been forced to analyse my work and to be honest about its strengths and weaknesses and the reasoning that underlies it. It has been really interesting to look at how my work has progressed as my career developed and I hope that by appraising by own images in this way I will encourage you to do the same with yours. The only way that you can ever improve your photography is by evaluating it as honestly and objectively as you are able – you must become your harshest critic as well as your number one fan.

There is no doubt that I see light much better these days and I have learned to mould and shape light to create the mood and atmosphere that I want. Being able (at last) to work with the light in this way has helped me achieve new and innovative shots of commonly photographed subjects. Animals such as lions, for example, have been photographed times beyond number and from every conceivable angle; the same is true of elephants and the early experience of the mud wallow taught me to always look for something a little different. Techniques used in classical portrait photography have provided some helpful ideas and I have learned

much, in particular, from the work of the late Patrick Lichfield. His photographs always had something extra, an edge that is difficult to put into words but which makes viewers look twice and feel like they are inside the picture with the subject. It is my great regret that I only met this truly great photographer once when we shared a stage and never really had the chance to tell him how much he had influenced my own work.

I took this lion image whilst jostling on safari with three other vehicles, all armed with big lenses that were trained on their target like the guns of battleships. It was early, literally in the first thirty seconds of light, and straight away I saw the potential for a great atmospheric portrait. Instead of shooting with the light, I positioned my vehicle to shoot into it at about 60 degrees; I knew that it would be enough to get the 'ring of fire' effect that you see here (and elsewhere in this book). By deliberately under-exposing I could retain the dark mood of the image. The lion's breath was a bonus, a typical Lichfield element and to be honest, a real stroke of luck; having luck is one thing but creating it is quite another.

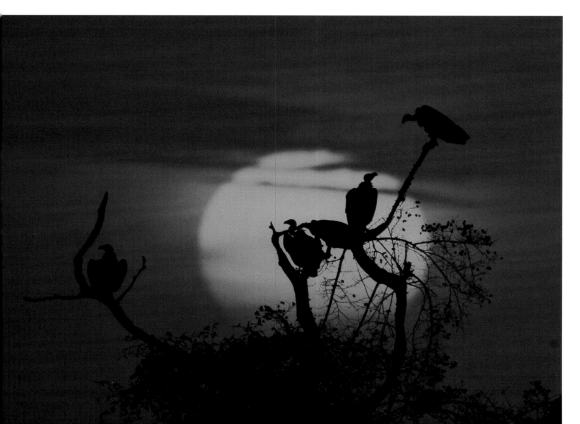

I love taking silhouettes as they can evoke feelings that would never be conveyed by an ordinary shot. In Zambia we came across these vultures roosting against the setting sun. Quite simply, I used a very bold composition to emphasise the shapes of the vultures, which were clean cut and distinctive. The problem with using the sun in this way is that the digital camera sensor burns out the bright areas and it looks awful; in this instance the setting sun was partially obscured by smoke from nearby illegal forest fires, which gave it a much softer appearance. As a keen conservationist, I would rather have had a burnt out sun but had to make use of the situation I was presented with.

Opposite: **On my tombstone** *will be the epitaph:: 'I wish I'd have shot it landscape.' One of the greatest problems for any photographer is choosing the correct orientation of the camera for the shot. On this occasion I had been taking a portrait of another lion and had the camera set to portrait format, I had no time to change so had to place the lion to the right of the frame; had I justified it in the centre then the breath would have been lost. That said, I still wish I had shot it as landscape!*

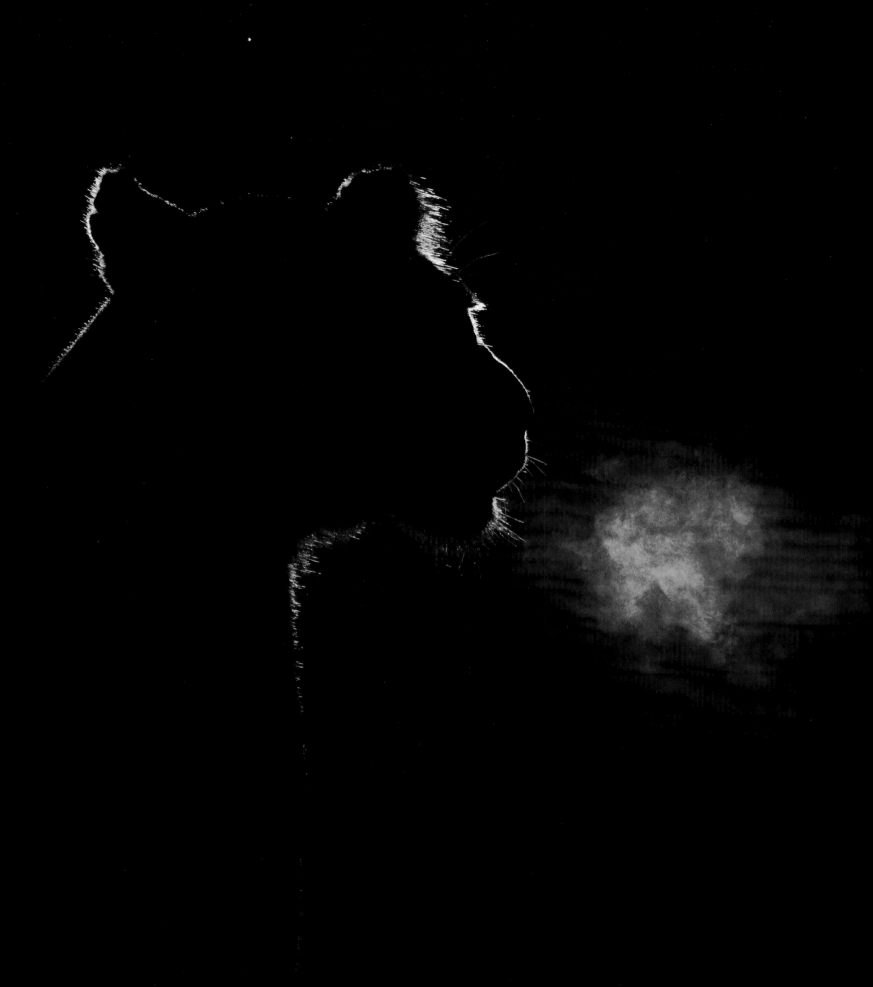

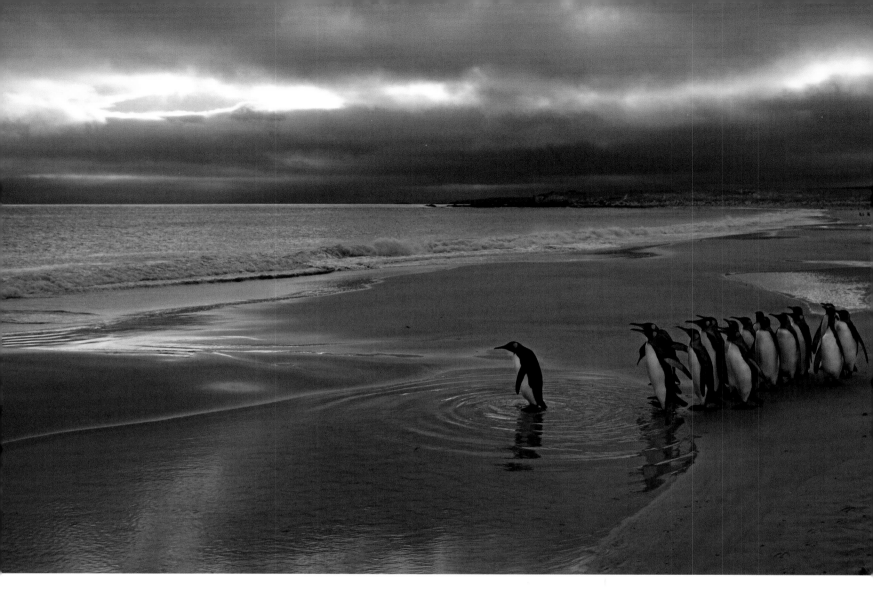

I call the image on the right 'Rival Kings' and it shows the courtship battle between three king penguins on the Falkland Islands. It was Christmas morning and I had camped on the beach for a few days to work; it proved to be a great decision as the weather was superb and the colony was buzzing with activity. Many of you will immediately recognise this image because it received a Specially Commended award in the BBC Wildlife Photographer of the Year competition. Its appeal is totally anthropomorphic and everyone has a different idea of what one penguin is 'saying' to another. I don't mind anthropomorphism in images provided that it does not ridicule the species or form negative impressions of the natural world. This image has certainly made a lot of people sit up and take notice of penguins and illustrates the power of photography to influence public opinion.

Rival Kings came as a big surprise to many who had followed my work previously as it showed a wide-angle style with atmosphere combined with a landscape element. As you will see throughout the remainder of this book my images have come on in leaps and bounds since those early days but it is only in the past few years that I have really started to shoot in the style of 'Rival Kings'. To be honest, there

is no specific reason for this; it just seemed the logical thing to do; to combine my passion for light with my passion for nature, and continue to develop my own style in a totally natural way.

Rival Kings was taken at the beginning of a new phase of my photography, inspired by visits to the Arctic and Antarctic. A sense of concern for extreme environments came to me together with a desire to portray them in the best way possible in light of the ever-increasing threats they face in the near future. The fact that I had the chance to present my interpretation of these environments and the animals and birds that live in them was in large part due to the Royal Navy, which assisted me over the following three years in documenting these extraordinary places, particularly in the Falkland Islands, South Georgia and the Antarctic.

In order to tell these stories I knew I would have to raise the bar for my photography and creativity so as to produce a visual story that was different to anything that I had ever done before. As I mentioned previously, setting challenges for yourself is the only way to do this, so the gauntlet had been thrown down, it was now up to me to succeed.

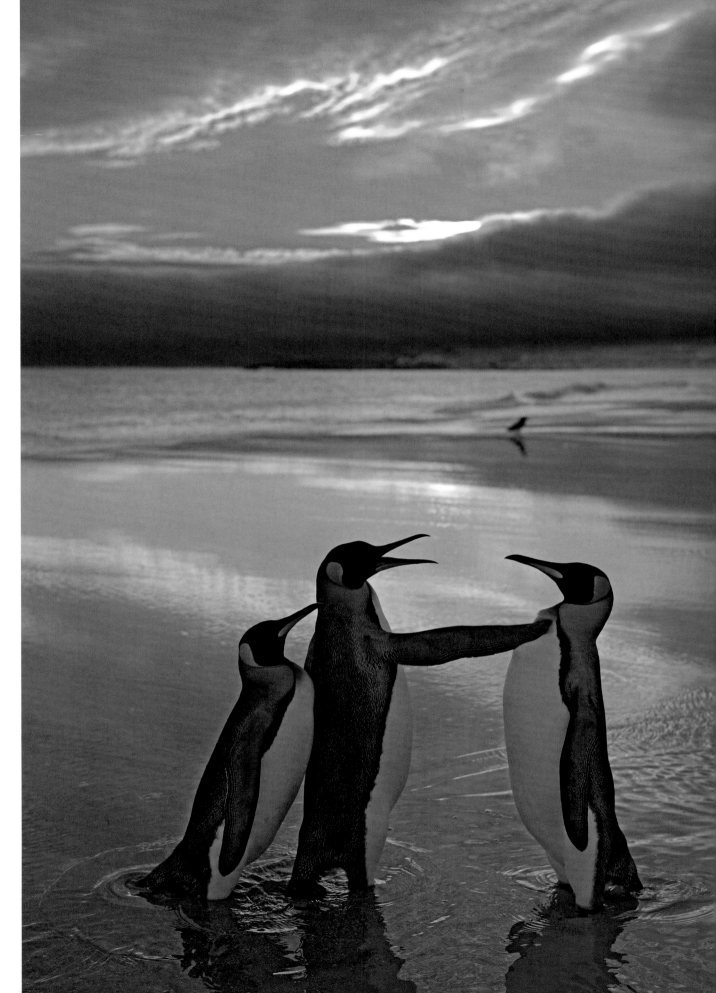

Opposite: **These days** I try to let my pictures tell a story for me and this one depicts 'leadership' as one king penguin starts to lead the group towards the sea. Images like this require precise timing and total concentration to capture the exact moment.

I used a slight amount of fill-flash to balance the exposure on the penguins with the background in this image, as I did not want them to be in silhouette. The essence of this image was all about giving the subjects space and resisting the temptation to crowd the shot.

JOURNEY SOUTH

South Georgia & Antarctica

Spending several months in some of the last wilderness areas on Earth, namely the Falkland Islands, South Georgia and Antarctica was a dream come true for me. My Falklands work had already been well documented, having won various awards and been published worldwide, but personally I think that the really innovative work was done later on the island of South Georgia and the Antarctic Peninsula. This work has not been seen in the public domain… until now. Both of these areas are incredibly difficult to work in; the climate can be life-threatening because you are a long way from home without any kind of backup. I had already worked in a number of extreme climates but this was another ball game. Luckily, for most of the trips I was in the safe hands of the Royal Navy's icebreaker HMS *Endurance*, its captain, Commodore Nick Lambert, and his crew whom I could rely on 100%.

To be honest, no set of pictures can do justice to these incredibly hostile environments but I think that this body of work shows that I have now come full circle and developed into a much more creative photographer compared to those early days of lying in front of elephants. I still take what I call 'the big shots' when the situation dictates, but now feel that I have a wider range of tools in my box. Now, if the light is there I can use it but equally I can still use poor light to create something different, too. My landscapes are improving and my good friend, Joe Cornish insists that I am a natural, an opinion with which I beg to differ. A natural landscape photographer I will never be, as my landscapes will always play second fiddle to my wildlife, but I do think that combining the wildlife and landscapes together leads to a new and exciting genre of wildlife photography, representing the 'living landscape' as I see it. This genre shows how the wildlife and landscapes can interact, with each element having a valid part to play in telling the story. This story begins with wilderness South Georgia.

Rather than shoot this full-frame, and miss the wonderful leading lines of the skiing runs, I used a 70-200mm lens to allow myself a much wider view. Then it was just a case of waiting for the penguin skiers to arrive in formation and to time it right, to get a nice composition that was a balance between the three of them.

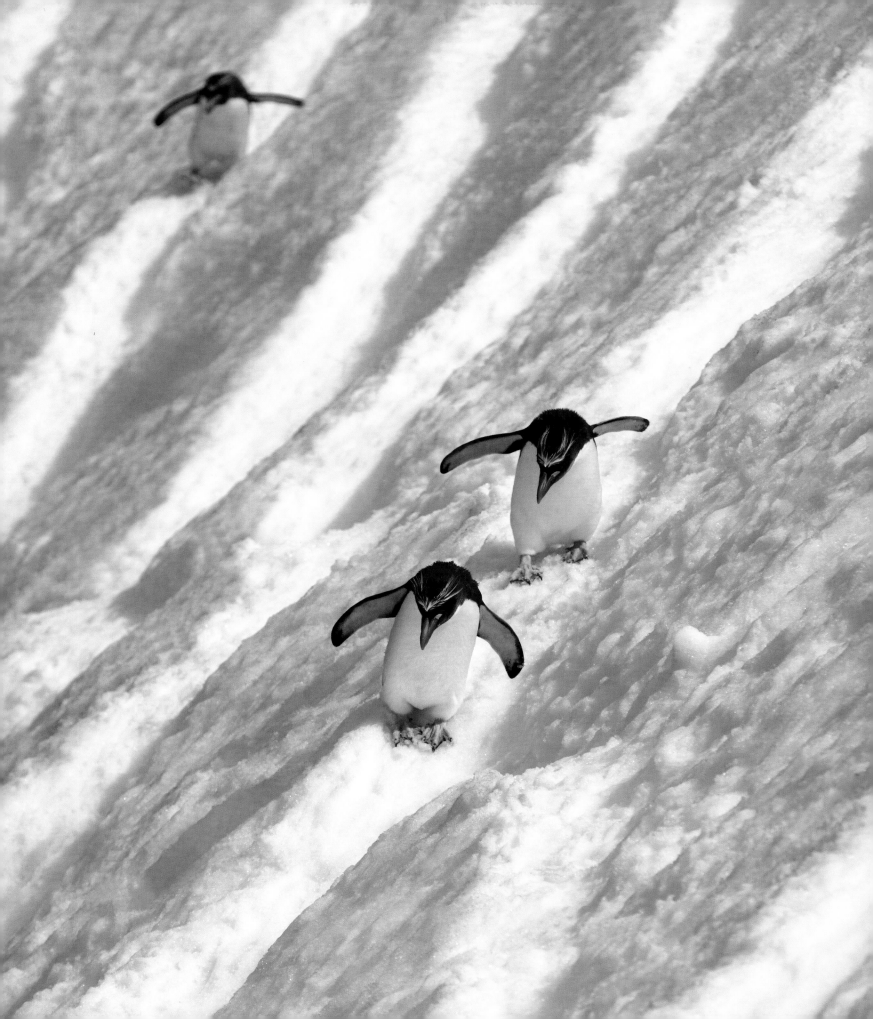

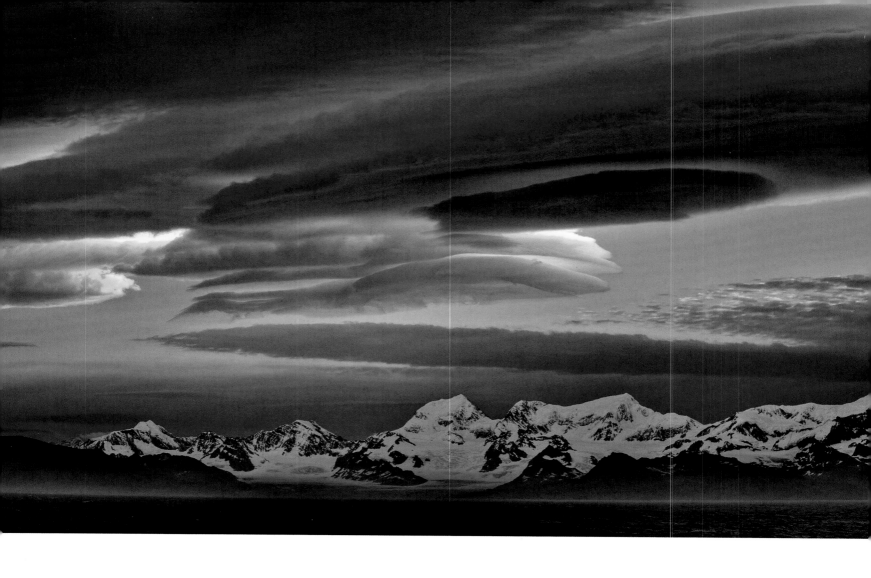

South Georgia

South Georgia is famous for its weather *and in particular for the lenticular clouds that you see here; they are formed when mountains obstruct high winds and create upward turbulence. This sunset was taken from the deck of a ship and, like most of the landscapes taken in these areas, is hand-held. A tripod would be impossible to keep steady in these situations, as the seas are never calm in this part of the world.*

South Georgia is a land of extremes where huge king penguin colonies, numbering tens of thousands, contrast with the critically endangered wandering albatross of which just a few hundred survive. The landscape is severe, with towering peaks and spectacular glaciers, like the Nordenskjold, dominating the fjords. Both the wildlife and landscape are, in turn, dominated by the Antarctic weather, which is especially unpredictable on South Georgia where 100mph winds called 'williwaws' can whip up in an instant and trap the unwary. On South Georgia the weather gets total respect from everyone and everything.

South Georgia is inspirational for me on so many levels, both as a photographer and a human being. The wilderness inspires me to drive myself to achieve new levels of excellence that will express my own desire to protect this place and inspire others to share my feeling. As a human being, I am inspired by the great journeys of explorers such as Ernest Shackleton, who fought the elements for three days to reach help for his men stranded hundreds of miles south on Elephant Island. It was an epic journey of incredible hardship, some of which was documented by the great photographer Frank Hurley, whose work in such conditions should be an inspiration to all photographers.

For its sake and that of its wildlife, we must hope that South Georgia will continue to be the land that time forgot..

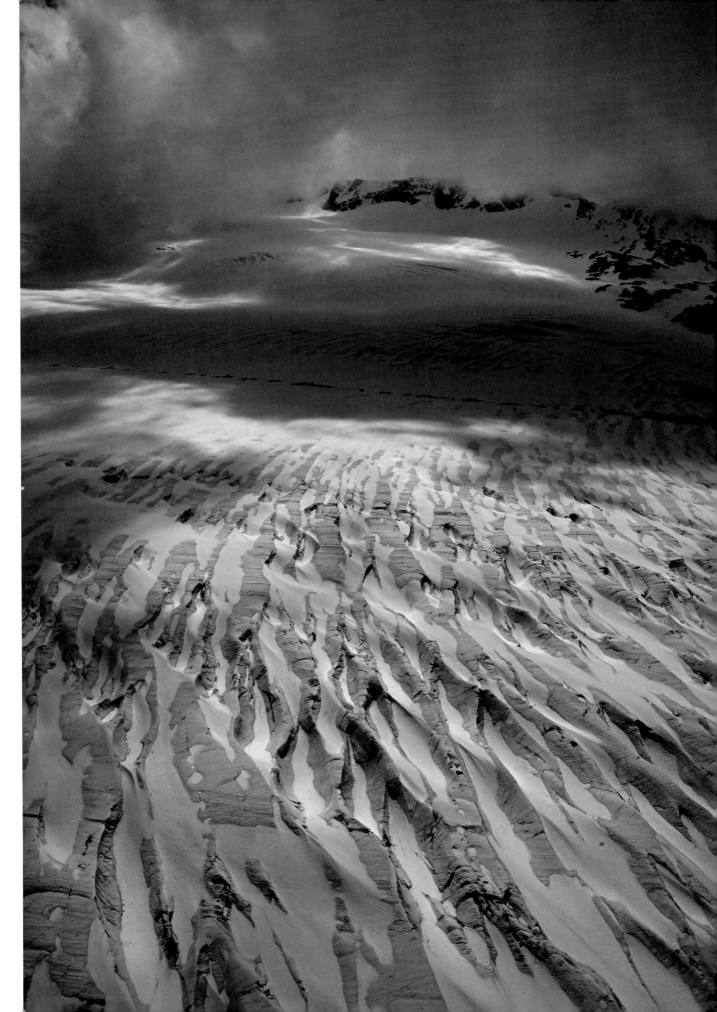

I was lucky enough to be flying in helicopters over South Georgia with some of the most experienced and talented pilots in the world; as a result I managed to get some pretty unique shots. Working from a helicopter takes a lot of practise as you literally have seconds to compose, expose and shoot. The helicopters had other missions to achieve that were more important than satisfying the whims of a wildlife photographer and could not afford to hang around. This is one of my favourite aerial shots, showing the top of the Peters Glacier in King Haakon Bay. I just love the patterns in the blue ice and the diffuse light from the clouds that casts shadows on the glacier itself. It is not a picture that the old Andy Rouse could have taken.

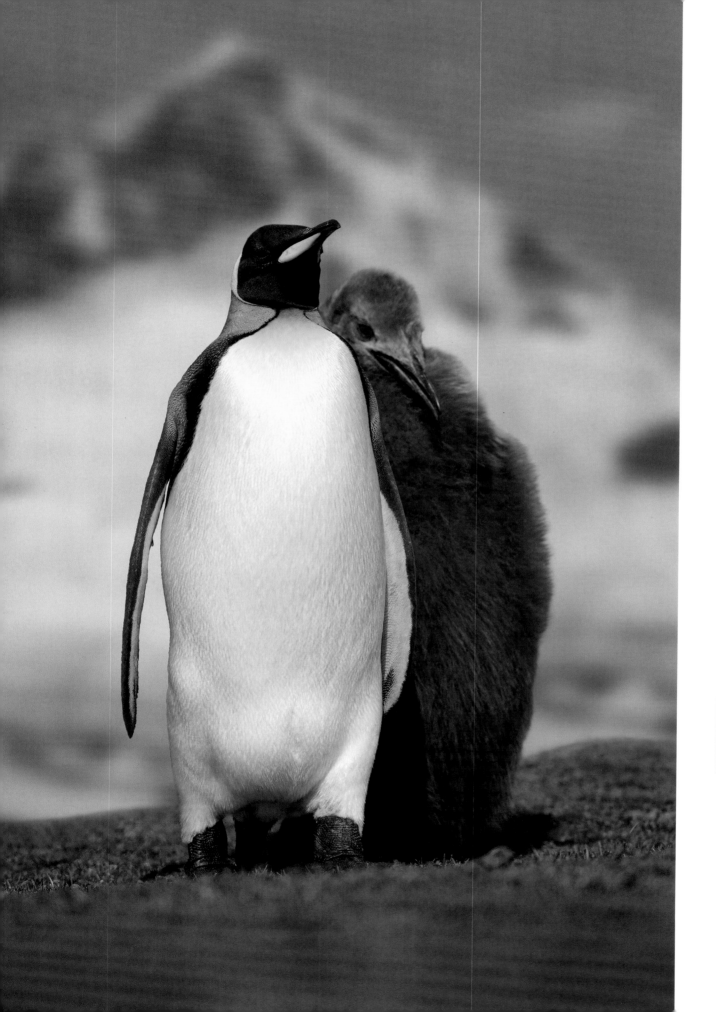
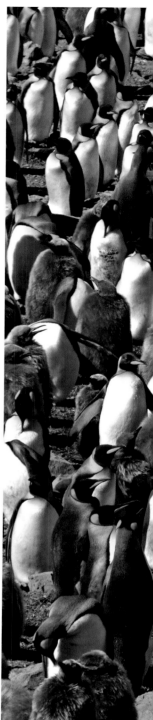

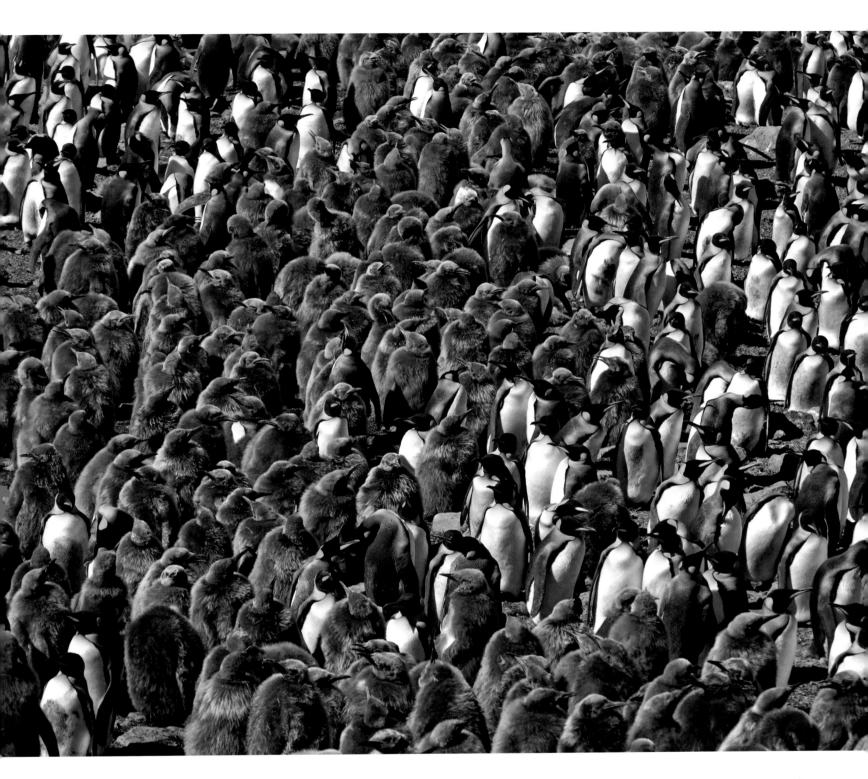

A typical South Georgia shot of a juvenile king penguin trying to get a meal from one of its parents. You could also say that at this stage it was a typical Andy Rouse shot, low angle, including the habitat but with the focus straight on the wildlife. Using a zoom I played with several compositions but decided on this, as I liked the shape of the mountain in relation to the penguins. Any closer and it could have been taken anywhere; any further away and the mountain would have overwhelmed the image.

King penguin colonies like this one at Salisbury Plain are feasts for the senses – especially the nose. They can be overwhelming for the photographer as there is just so much to see and take in. On this particular trip to South Georgia I wanted to illustrate how the penguins formed natural shapes and patterns within the environment and so climbed up one of the surrounding hills to look down on the colony as a whole. Quickly, my attention was drawn to the patterns of the brown youngsters in their various crèches and I singled out this one in particular as it had a good curve that leads the eye naturally through the image.

A slightly different view of the king penguin crèches; this time from 2000 feet and taken whilst I was hanging out of a helicopter. The penguin colonies were amazing from the air, the shapes and contrast of the young brown penguins gives the image depth and texture although the thing that is lacking is a sense of scale. This for me shows a real living landscape. At first glance you might think that these are just rock formations or trees and would probably never guess that they were penguins until you looked a little closer.

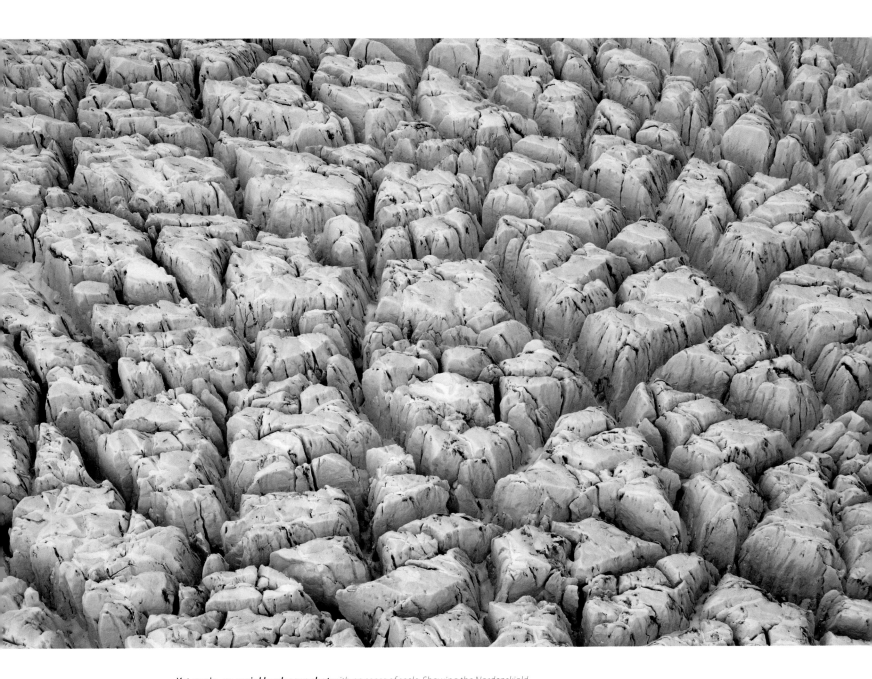

Yet again, an aerial landscape shot with no sense of scale. Showing the Nordenskjold Glacier at the point where it dramatically changes from ice to sea. The tremendous pressures generated by constant movement within the glacier have created the cracks. Composition here had to be simple and quick, I focussed on the centre of the frame, used a wide-angle lens and a reasonable aperture to keep the shutter speed high enough to negate the vibration of the helicopter and my rapidly beating heart!

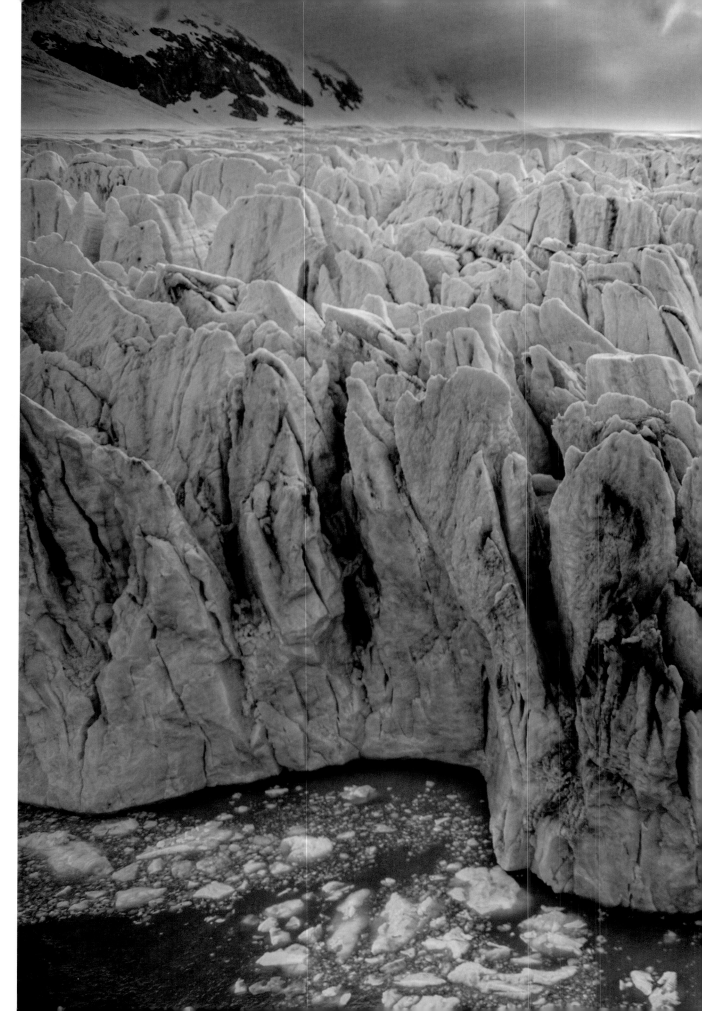

This is the beautiful front edge of the Peters Glacier on South Georgia. I was glad to be in the helicopter rather than on board a ship underneath this wall of ice as the glacier was cracking off, or 'calving', all the time. Glaciers are said to flow like a viscous fluid and can move as much as 150m per year. The colours inside the glacier were variations on an amazing electric blue. I enhanced this by shooting backlit and into the light; the strip of black colouration is the terminal moraine which consists of small fragments of rock that have been brought by the glacier from the mountains that you see behind, a process taking many, many years.

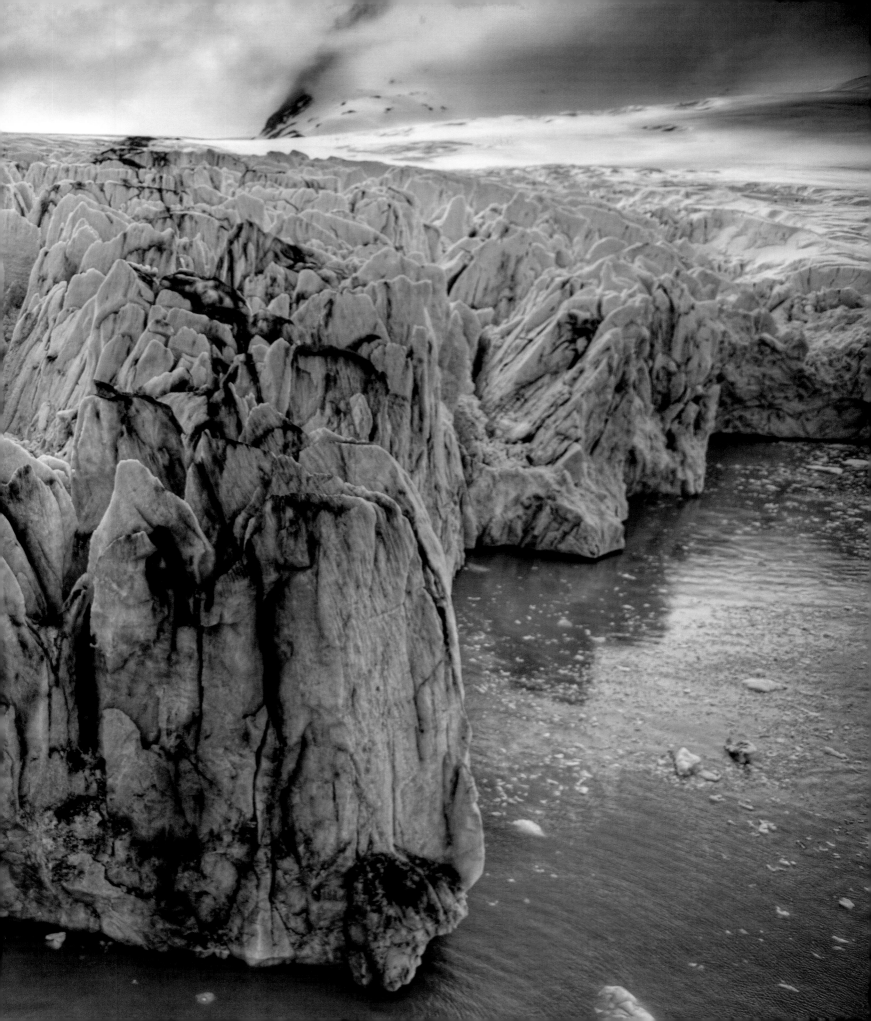

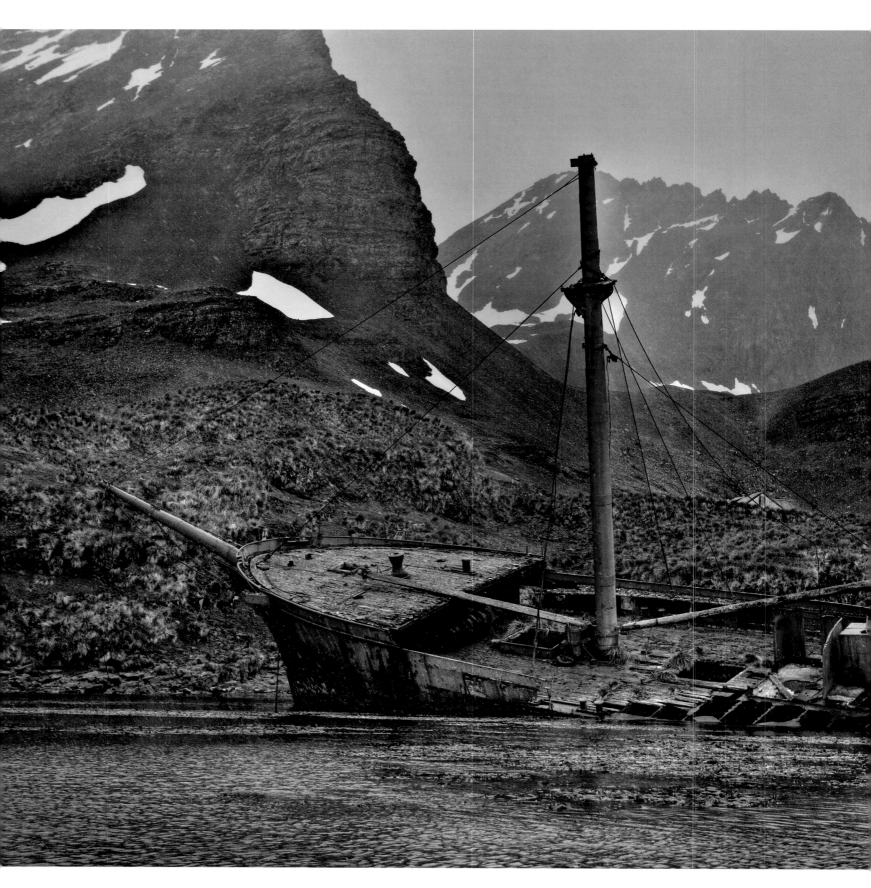

The wreck of the whaling ship Brutus *in Prince Olav Harbour now provides a handy beaching point for a handful of individuals from the enormous fur seal population on South Georgia.*

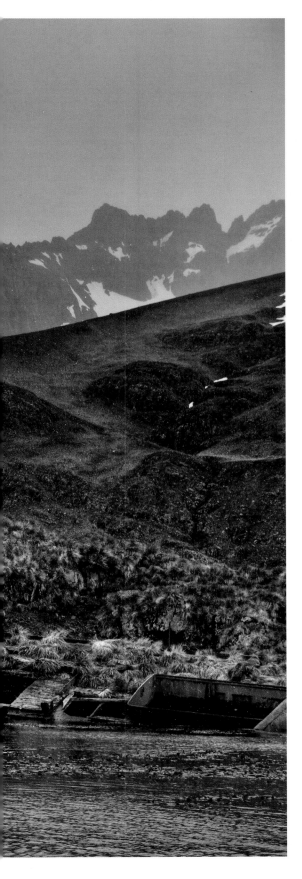

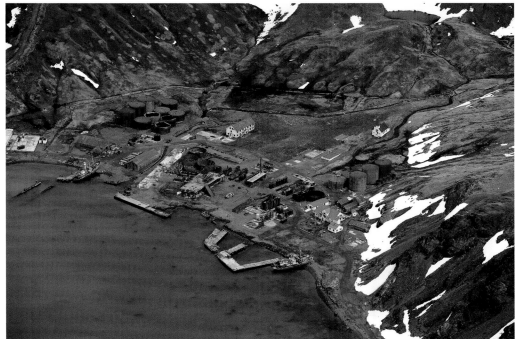

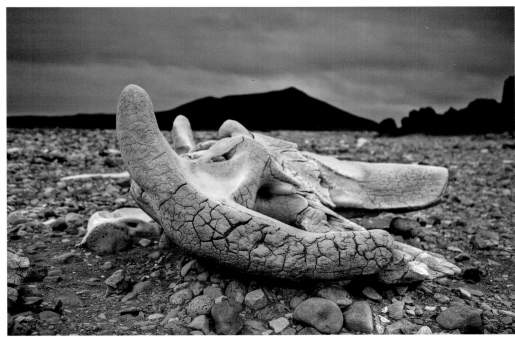

Top: **South Georgia is not entirely devoid** of man's footprints; it was the centre of the southern ocean whaling industry until relatively recent times. The whaling stations are thankfully now in decay and have been taken over by the wildlife (usually fur seals) and seafaring tourists. Seen here from above, Grytviken, is a now a popular tourist landing site complete with a museum, Shackleton's grave and a British Antarctic Survey base. It even has its own post office.

Above: **The whalebones from South Georgia** have long since disappeared but some can still be found on the South Shetland Islands. I found this fragment of whalebone whilst wandering along a deserted beach; I could tell it was ancient as the ends had calcified. I was intrigued by the pattern they made and, like a professional golfer, pondered my shot by walking around it and studying it from every conceivable angle. In the end I settled for taking it from a low angle and putting the volcanic peak, dark and moody, in the distance to give a sense of the place and the hostility of the environment. On a sunny day it just wouldn't have worked, as it isn't a picture postcard but a message from our past and a reminder of why we should never return to whaling again.

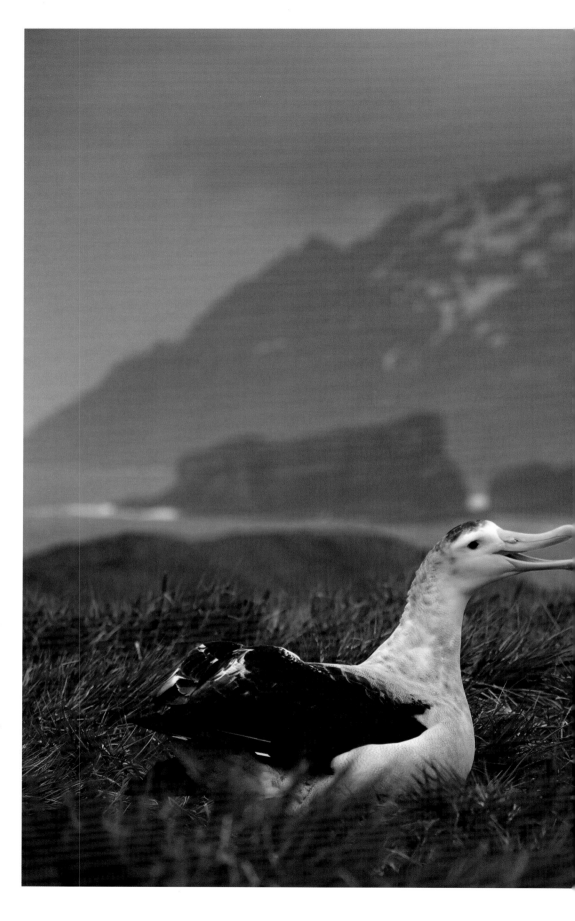

A classic shot of the courtship between a pair of wandering albatrosses, the largest of the albatross family. Spending long periods at sea and flying incredible distances, the wandering albatross returns to land only to mate and raise its single offspring. Here you can see the male on the right giving his characteristic whistle at the penultimate moment of the courtship, it is a sound that I will never forget and working with the wanderers left a lasting impression on me. In the past I would have taken this image with a much tighter crop but now I wanted to show the unforgiving habitat that is the wanderers' home during their brief landfall and this demanded a wider view.

I spent several days at the British Antarctic Survey (BAS) base on Bird Island, the main wanderer colony on South Georgia, working alongside and learning from the resident team of dedicated scientists. BAS research indicates that the albatross population on South Georgia is declining by between 2% and 5% per year, which is a terrible state of affairs. The reason for their decline is that the birds are competing for food in the same areas as many long-line fishing vessels, with the result that many albatross get caught up in the lines and drown. However, unlike many conservation stories, the situation is not all doom and gloom as many fishermen are now limiting the damage they do by using bird-scaring streamers and/or fishing only at night to cut down the losses to the albatross population. The test is to get all the fishing fleets to act before it is too late, which is difficult when much of the fishing is illegal. Fortunately, with the dedication that I witnessed on Bird Island and with the work of the Save the Albatross campaign, there may be hope for the future survival of this magnificent ocean wanderer.

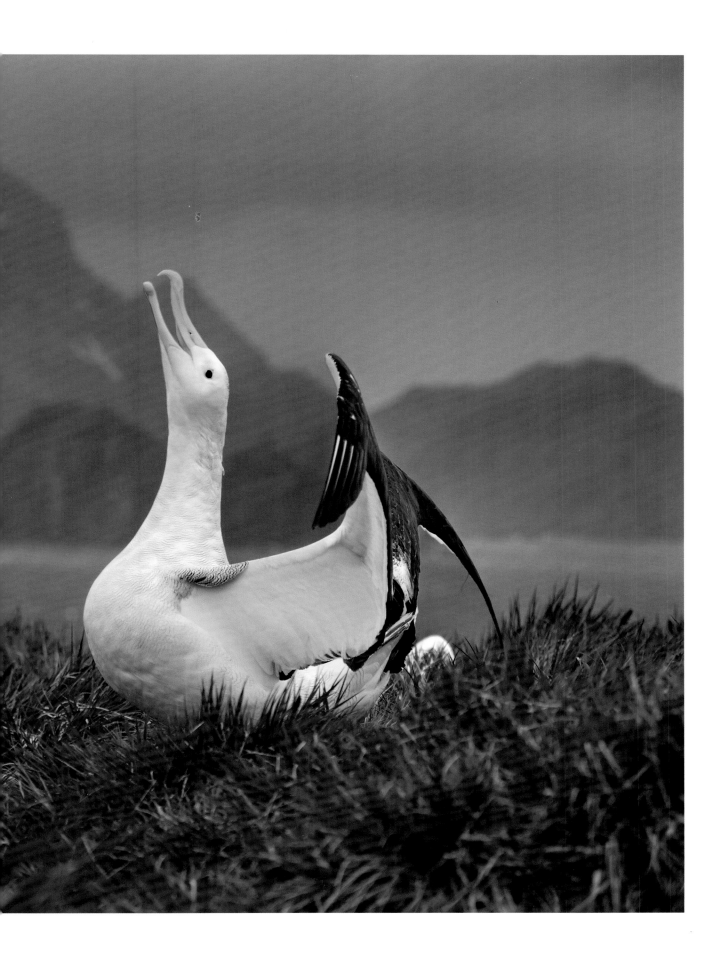

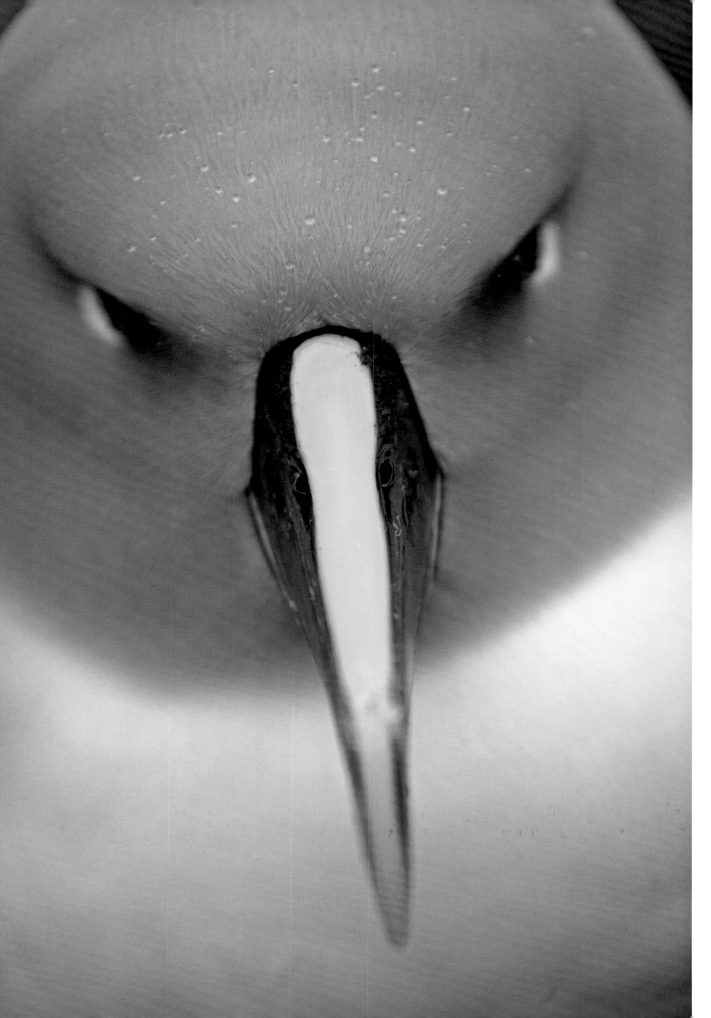

This is the grey-headed albatross, another real beauty that BAS studies on Bird Island and another that is threatened with extinction. As I have said before, the climate is a real issue on South Georgia and more often than not I was shooting pictures in the rain, snow or sleet and often all three. As a photographer, I like these conditions because they give the pictures an edgy feel. Here you can see the raindrops on the face of this albatross; this is hardly surprising as it rained almost every minute of every day I was on Bird Island. Personally, I don't care about the weather as my Paramo gear protects me against everything, but the camera gear took a real hammering. On this trip I lost one camera which became soaked through to its microchips despite its allegedly 'waterproof' jacket.

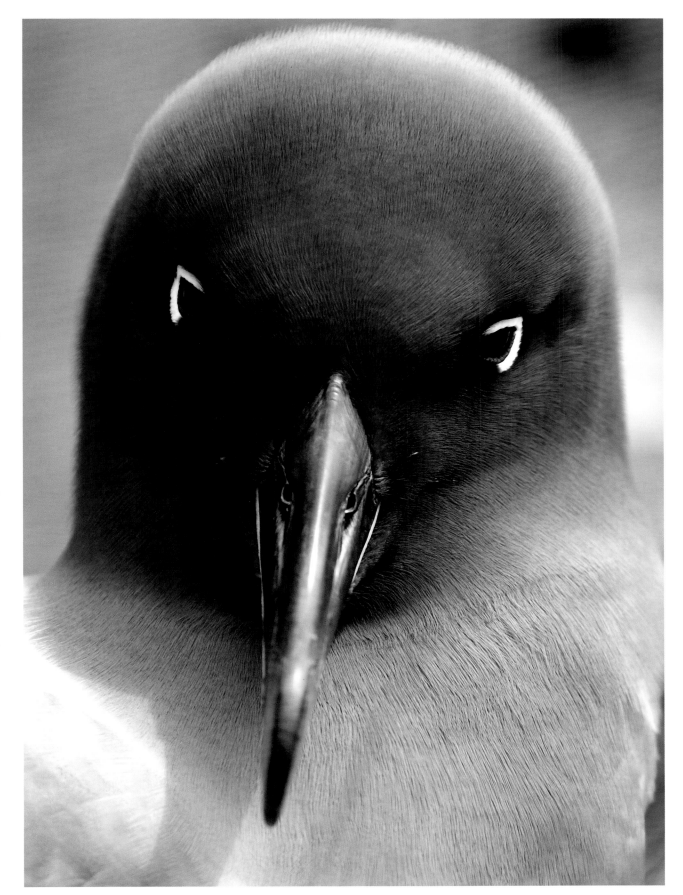

To complete the trio, here is the most elusive of the albatross family on South Georgia, the light-mantled sooty albatross, the Holy Grail for anyone visiting the island. To be honest, I can see why: those white rings around the eyes are simply amazing and give this albatross an intriguing facial expression. Photographing them is difficult as they live in colonies of twos and threes and are therefore very hard to find; they also tend to inhabit steep cliffs with limited access, if you don't fly. They are also very shy and do not tolerate disturbance so I had to remain at a discreet distance with a long lens and limited my stay to just five minutes. Taking this shot was more than a little precarious for me as I was hanging onto some tussock grass on the cliff by one hand whilst trying to use the camera with the other. This was taking challenging myself to a new extreme.

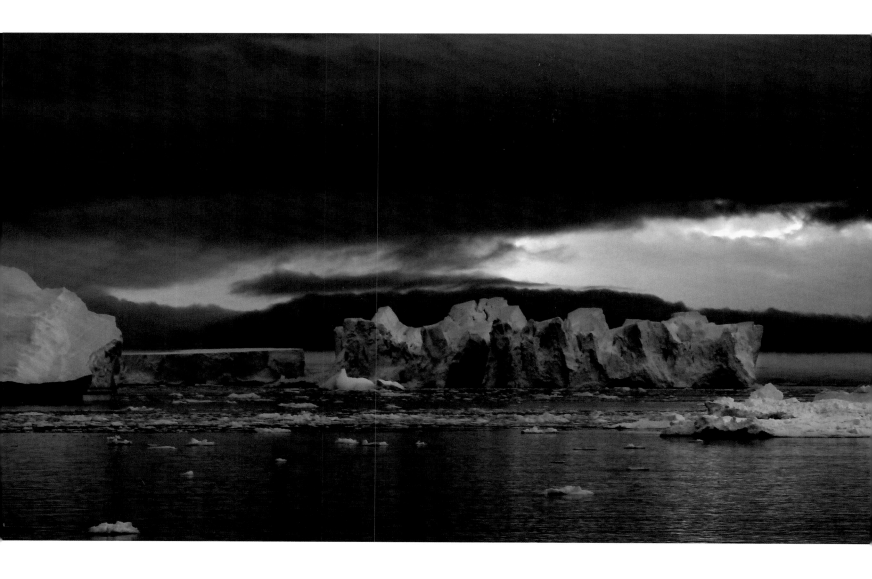

Antarctica

Nothing prepares you for your first visit to Antarctica; it is a magical place with light that defies belief. I have only ever had one sunny day in Antarctica, generally it has been stormy weather and, bizarrely, for that I am really grateful. It gives the landscapes an extra dimension and tests me to the limits of my techniques and imagination. Extreme weather can spur me on to try to produce something exceptional, in other words it stops me becoming complacent about my photography. You can't fail to be inspired by this location but it is easy to become overwhelmed by the enormity of what you are seeing; huge tabular icebergs float serenely by, leopard seals rest on small 'growlers' waiting for unwary penguins and spectacular ice cliffs with virgin peaks greet you at every turn. It is an ice wilderness and it cannot but appeal to any red-blooded landscape photographer.

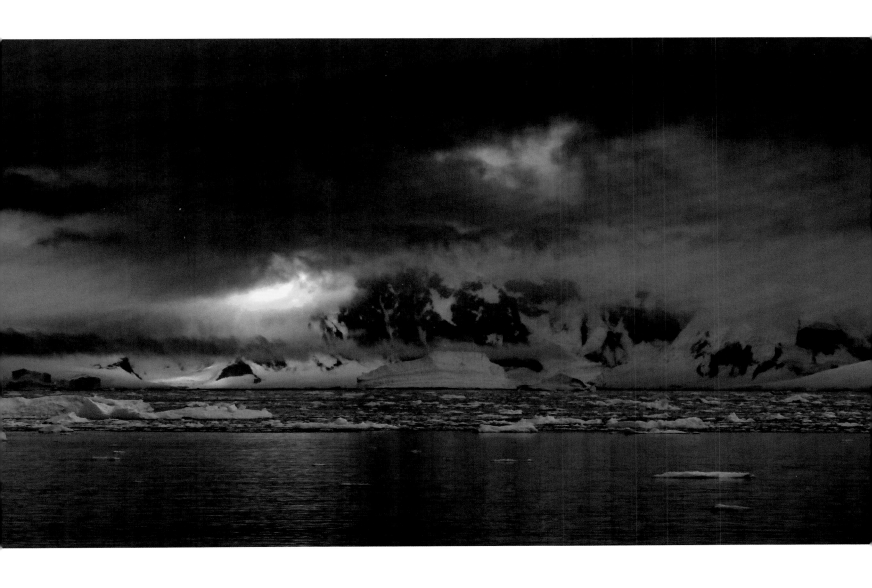

Any sunrise in Antarctica *is a good one, but this was something special. The sun never poked directly through the clouds but instead I was treated to a fire in the sky that contrasted perfectly with the dramatic ice landscape. It was just magical, that is all I can say and, to be honest, all that needs to be said.*

This is taken at the iceberg graveyard at Plennau, where icebergs are grounded against the land by the prevailing winds and pounded by the sea until they break up and 'die'. The place has a strange atmosphere, it is utterly lifeless and I really struggled to take anything worthwhile here despite the incredible shapes presented to me. The pounding rain did not help. By this time I only had one camera and I was nervous lest something should happen to it. As the rain continued to fall in front of this iceberg I knew that it had the makings of something special. I hadn't used the flash during the trip so decided to risk it in the rain; I set a very slow shutter speed of 1/30th second and second sync flash. The slow shutter speed blurred the falling rain and the flash illuminated the droplets to make them look like shooting stars, a really creative image and something that would have only occurred to me recently. Ironically, in Antarctica, where it should be literally freezing cold, my most inspired image came from the rain that was falling. In fact I have rarely experienced snow in Antarctica and if you ever need proof of global warming then here it is for all to see.

In Antarctica, I was surprised by how few penguins you come across sitting on icebergs; just a few here and there taking a rest before heading back to the colony. Working from a small rubber boat made for good photography as it forced me to use a shorter lens. This meant that the shots of penguins I took were all wide-angle and showed as much of the habitat as I could fit in, in fact with this image I deliberately shot it very wide-angle so that the penguins would be dwarfed by the scale of the iceberg behind. I have no idea to this day what they were looking at, probably the leopard seal that we were to encounter later that morning, but I am glad that they did as it helped the composition no end.

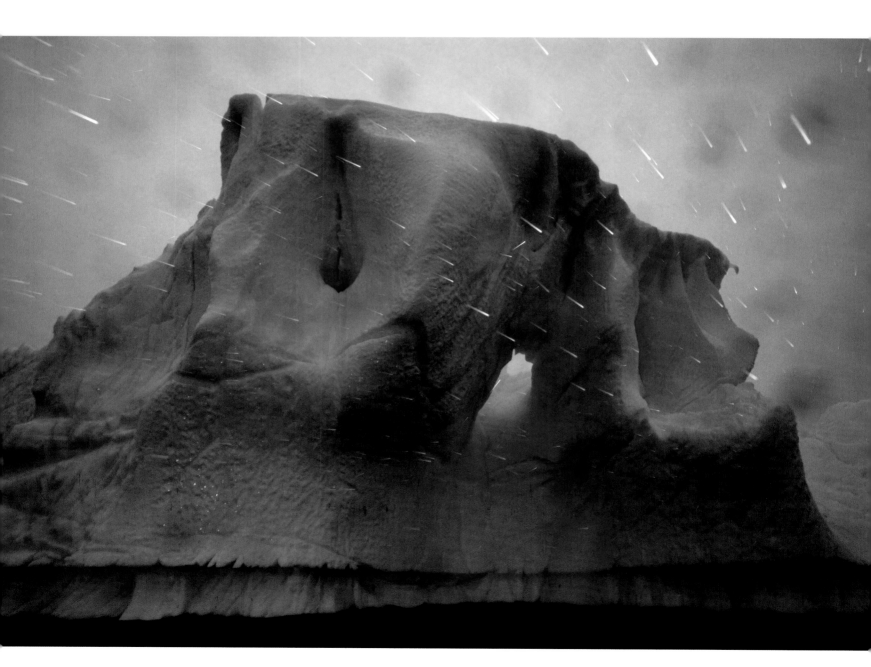

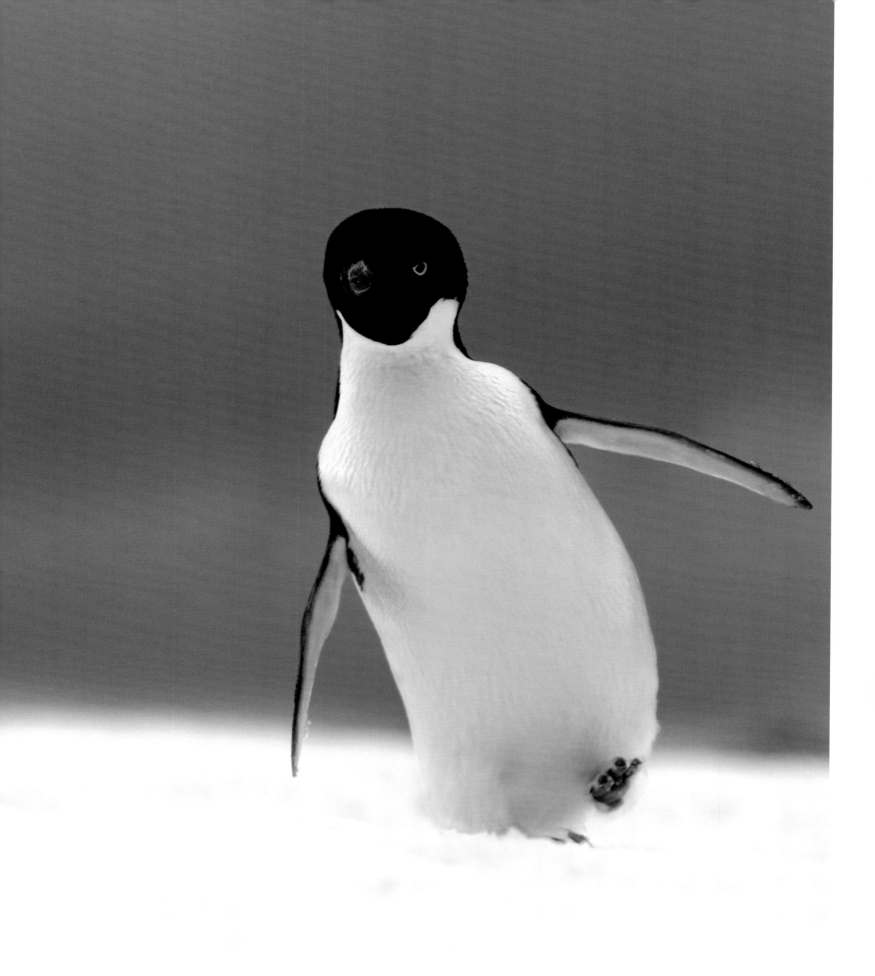

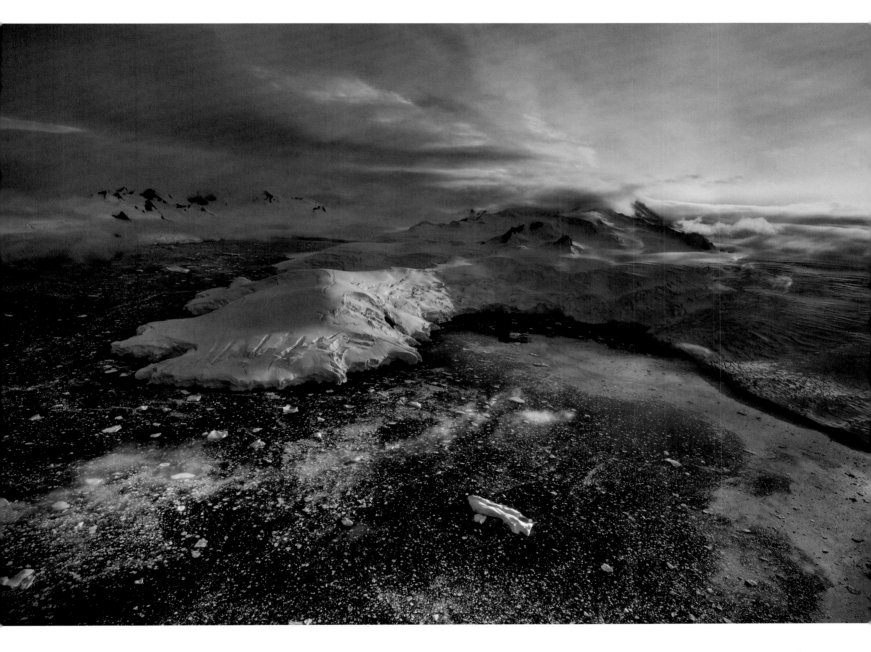

Penguins are fantastic characters and I have spent so much time with them over the past few winters that they have a really special place in my heart. What is it that makes them so appealing? Quite simply, they have the ability to make you laugh out loud regardless of the kind of day you are having. The day I took this image had not gone well, I had fallen through the ice twice and had struggled to get back out again with my pack; I was soaked to the skin, frozen and shattered. My goal was to get to the top of a hill so I could photograph the scenery but eventually I got fed up with continually falling down and had a rethink. Out of nowhere an Adelie penguin appeared and walked right up to me, observing me, as they do, with the most comical expression on its face. I cried with laughter, I don't know what it was but the penguin had cheered me up instantly. Such is the power of penguins and nothing could spoil my day after that.

This shot was taken on my last night in Antarctica. I finally managed to see a sunset (of sorts) after months of trying. The helicopter flew around the bay; at low level to begin with so that I could get a sense of scale; the big, blue iceberg near the centre is the size of about three football pitches! The sheer scale of the landscape in Antarctica is completely mind-blowing.

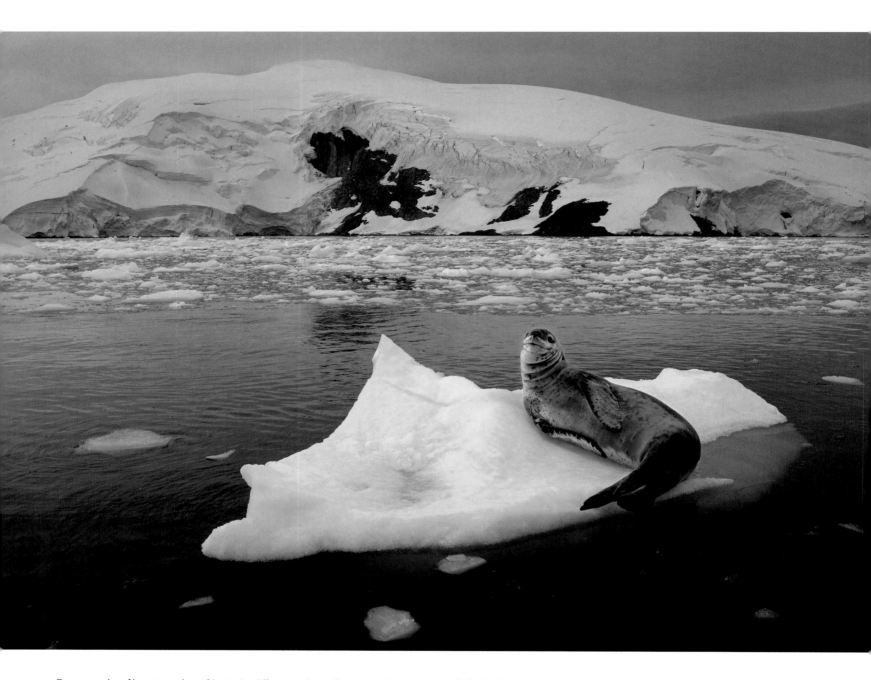

Two examples of how to work a subject *using different angles and lenses to achieve vastly different results. Both show a leopard seal; the ultimate Antarctic predator. This image shows one of my living landscapes; shot with a wide-angle lens as I wanted to show how the leopard seal interacted with the environment. Behind it, that dark patch in the distance is a penguin colony that provides the seal with a source of food. I chose this composition to make the most of the lovely curved shape as the seal relaxed on this growler (small iceberg).*

A classic 'big shot', *this is a much more sinister image, taken with a decent 70-200 mm lens as we drifted closer to the leopard seal. It is a classic portrait using all the techniques I have learned from professional portrait photographers – put the subject as the main focus, keep the background simple and use composition to lead the viewer right into the eyes. The 'Just Plain Beautiful' collection later in this book will explore these techniques in more detail.*

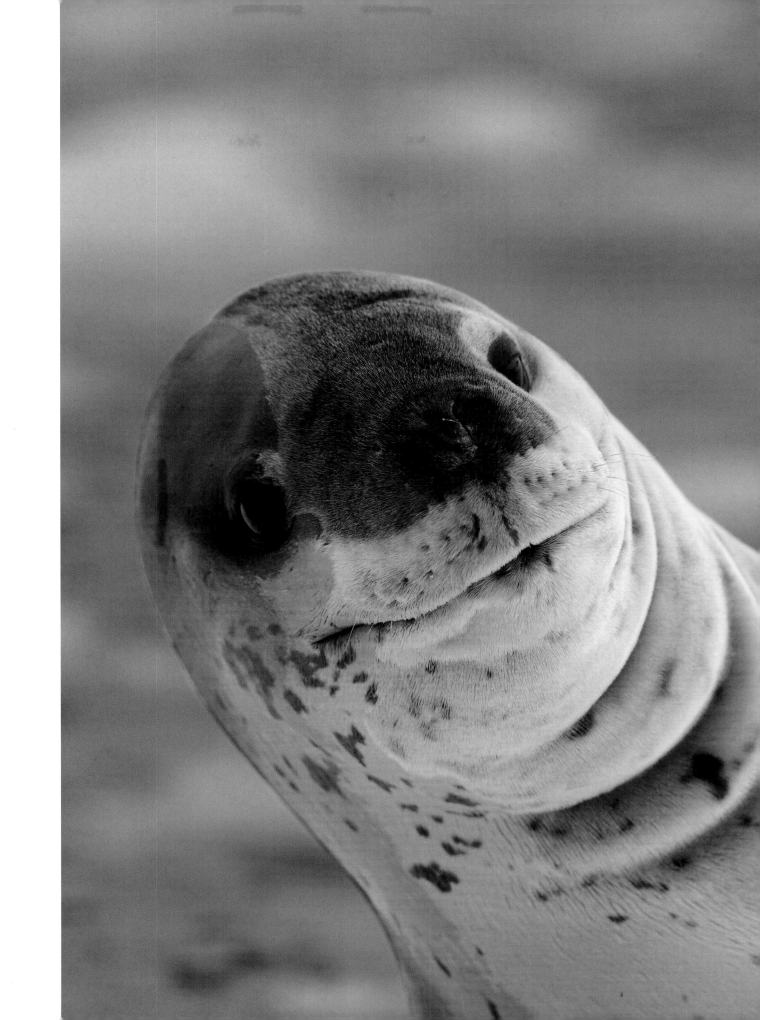

Yes, the ice was really that blue, *a combination of a freshly upturned iceberg and some soft backlight through the ice. Shots like this are surprising difficult to take as you have to see them ahead of time and take the shot at exactly the right moment before the boat drifts by; usually there is no second chance. Having the crabeater seal offset to one side gave the ice colour and formation more of a central role within the shot and I think made it much more appealing than just slapping it in the centre as I would have done previously.*

Icebergs make fantastic subjects *for photography as they come in all manner of weird shapes and sizes. This one was right on the verge of collapse and when we returned a few hours later it was gone. Call me a broken record, but if we don't do something soon then all the icebergs will be gone – period.*

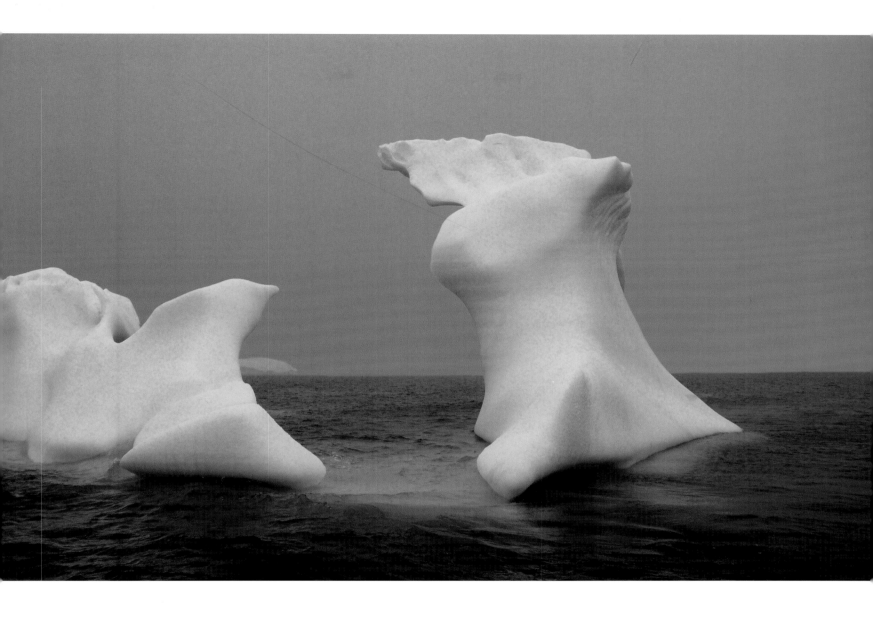

I hope that the previous few pages have given you an impression of the amazing wilderness locations of South Georgia and Antarctica. For me the light is now the controlling element in my work, not the subject, this is a principle that any photographer can apply to his or her own genre of photography. Now, the time has come to move from my *Vision* to my *Expression* and explore, via a series of themed portfolios, how I use the various elements of light and composition to achieve my goals. The themes I discuss here in relation to my own wildlife work are relevant to all photographic genres including portraits, action, atmospherics and reportage. These styles are the tools of the trade for any photographer and I hope that they inspire your creativity and make you want to get out there and tell your own stories of the world that we love.

RED5

Being able to 'see' the light is the mark of a great photographer and all the great professionals, no matter what their genre, use light as a tool to captivate and inspire. One of the big advantages of wildlife as a subject is that many wild creatures are most active at the beginning and end of the day when the light is at its most dramatic. Personally, I find myself most inspired by the conditions in the five minutes after dawn and again immediately before dusk. At their best these few minutes in each day create a condition I call Red5, a time when everything can be bathed in an amazing red glow. Red5 can occur at any time of the year and can be triggered by extreme weather conditions too. In my opinion this is the time when light is at its most intense, and by definition its most pure. It is a time when shadows are always flattering and details, hidden by the harsh light of day, are visible for all to see; saturation turns to subtlety and photographs are full of emotion and atmosphere. Red5 triggers something demonic inside me and I become totally and utterly obsessed. My collection of Red5 images is small since the opportunities for taking shots are so fleeting and success depends upon an intricate combination of factors. It doesn't happen every day and when it does the main challenge is finding something that will hang around long enough to be photographed!

The key to taking advantage of the brief period while Red5 lasts is seizing the opportunity when it presents itself. I was gazing out the window of my cottage, admiring the amazing sunset across the valley, when I saw the golden flash of our local barn owl hovering in the field. One glimpse of the light through those wings was enough to send me running for the door grabbing the nearest camera I could. Quite frankly I would have used a disposable one, so desperate was I to get the shot. Once outside, my experience took over and I paused to work out how I was going to achieve my goal. To get close without being seen is the perennial problem for all wildlife photographers. The wind was in my favour and the barn owl was moving away from me, allowing me to sneak up and use the cover of a hedge without disturbing it. The exposure was easy, shooting into the sun I knew I would get some slight under-exposure which is exactly what I wanted. I did not want to over-expose the detail in those beautiful wings. The result was a series of three pictures, this one being the clearest and the best. It breaks many rules of composition and you cannot even see the barn owl's head (which is fixed on its potential prey below) but that is the great thing about Red5. The image is defined not by the subject but by the amazing luminance of the light through the wings; it is not just a portrait of a species it is art.

A second of hesitation can be the difference between a winning shot and a 'near miss'. Shooting for me is now instinctive; I don't waste time worrying about the exposure in situations like this. I just use whatever I need at the time to get me the shot. In this case I knew that I had to keep the shutter speed up, as it was camera shake that would ruin the shot in low-light conditions. Having worked with barn owls for years, I knew that there would come a moment when the wings would stop beating and it would hang in the wind for a few seconds, the rest was down to timing and a steady hand.

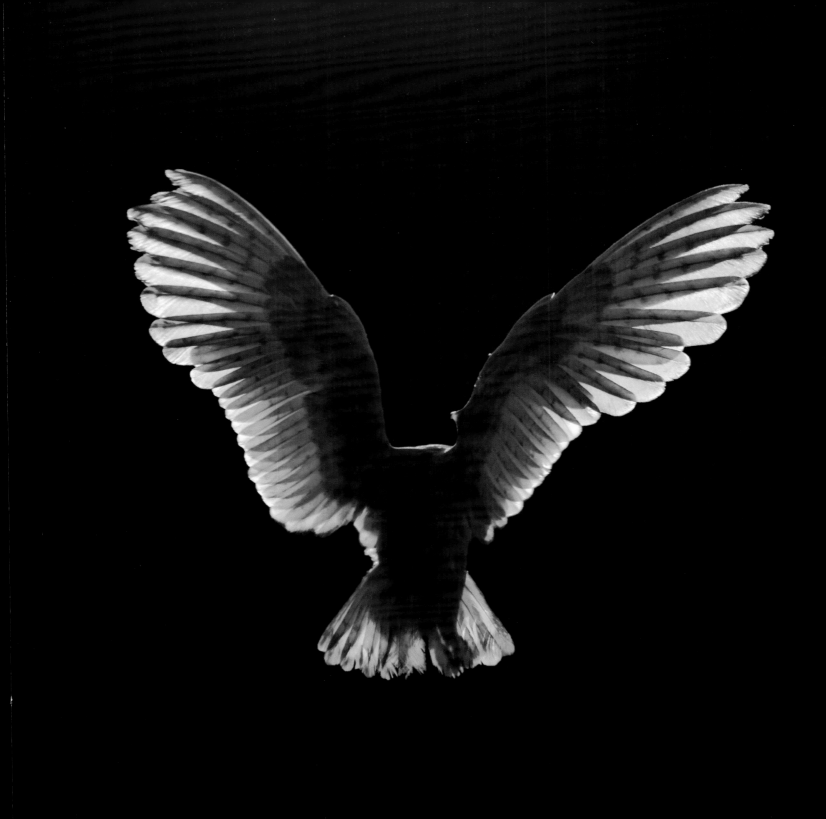

On the prowl

Big cats are perhaps the most common subjects that I photograph in Red5, as this tends to be the time when they are actually doing something other than snoring. I particularly seek out lions in Red5 and these shots shows just why. I love the way that the intense colour and deep shadows at this time of the day really accentuate the mood and give that extra definition to a lion's face. The picture on the right was taken just before dusk when lions are gearing up for a night of hunting. The intense look on this lioness's face suggest that some animal is about to have a very bad night indeed. The slight red glow on the grasses behind puts her into context in terms of both place and mood, which is why I gave the image space above the subject.

The problem when shooting motion in such low light is to keep the shutter speed high enough to ensure a sharp image. Shutter speed can be increased by either using faster lenses (to give a lower aperture) or increasing the ISO; the former is fine if you have the budget and arms like a marine to hold a heavier lens steady; the second can introduce noise into the image. This noise will also be increased by poor exposure technique and too much under-exposure

will cause blocked shadows (a histogram with all its peaks against the left-hand axis) that provide a happy home for noise. Noise only becomes apparent if you are brightening the shot, and the beauty of Red5 is that you are keeping the blacks dark and moody, so noise should not be a huge issue. I have never been overly concerned about noise and get very frustrated at the way photographers and the industry in general seems to be obsessed with removing it – this seems particularly ironic given that in the days of film we loved grainy looks. Just take a look at any scanned transparency and you will see that it is the noise that makes up the detail in the image, so why remove it from a digitally captured image? Noise gives feeling to an image and makes it look real, just removing it makes the image look plastic and lifeless and removes the texture that makes the image appealing in the first place.

When you are presented with an opportunity to take a Red5 shot, don't be afraid to bump up the ISO to 400 or more in order to get the shot. Remember you are creating art and for this the rules are totally different…in fact there aren't any.

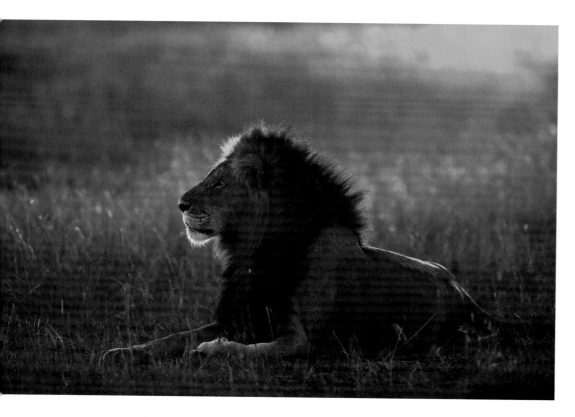

We found this amazing looking male lion early one morning. Knowing that the situation was good for a Red5 shot I decided to shoot into the light for the first few minutes as the red glow on the grass and his mane was too beautiful to miss. My ideal composition would have had the lion further to the right, but the tail was spread out behind it and I simply could not cut it off. Nature loves throwing up these little conundrums. In the end I decided to just go with the original framing and give it a bit more space to reduce the obvious effect of the dead space to the right of the picture. As I have said before, I can only shoot what I see.

I would wager a lot of money that the cause of most out of focus and missed shots is camera shake. Even the coolest customer will have an adrenaline rush when this close to a lion, a reaction that probably remains instinctive from long-forgotten times when lions would have been hunting us. To reduce the effects of shake in low light, I always select the fastest shutter speed available and just accept that the final picture will have a shallow depth of field as a consequence.

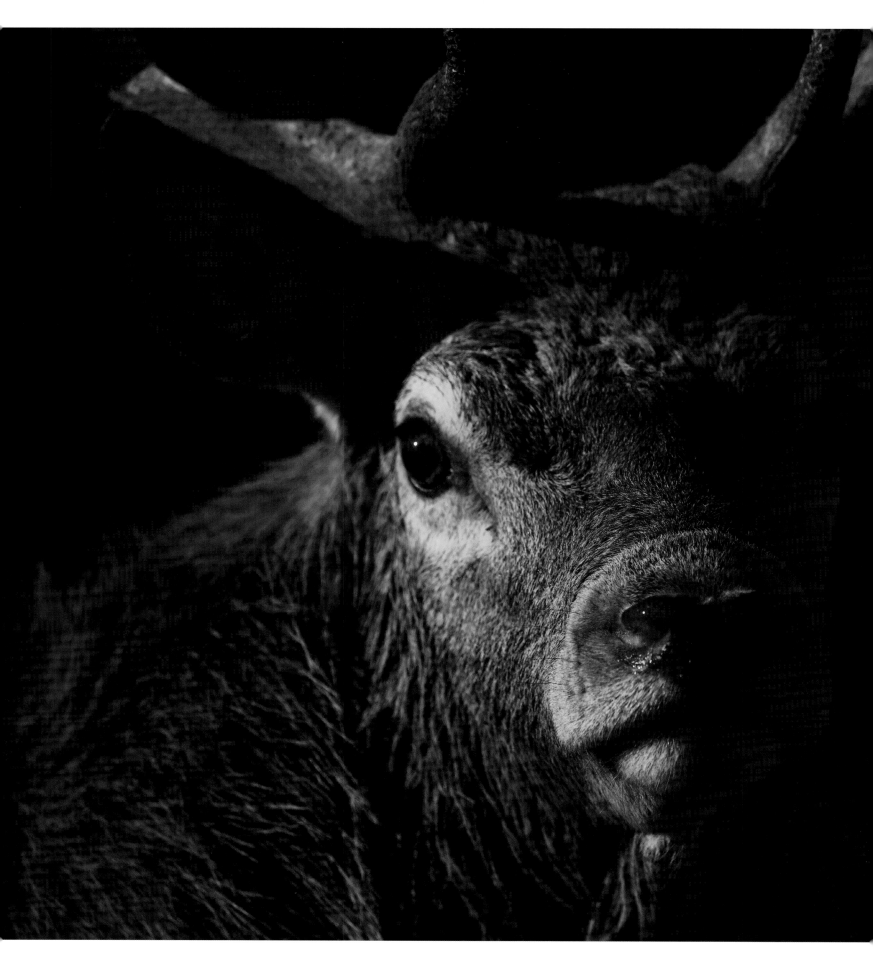

Angles create mood

Great portrait photographers like the late Lord Lichfield created something extra special in their portraits. In particular, I remember seeing a shot that he took of the former heavy-weight boxer Frank Bruno; it was shot from behind with one side of the face in darkness and a fresh layer of sweat on Frank's body. The use of shadow and lighting generated such mood and menace that I knew I never want to meet Frank in a dark alley; it left a lasting impression on me. Ever since, I have had this style of photography in the back of my mind when using similar techniques with wildlife and using natural light. Just a minor adjustment of your position to the left or right can make your subject look completely different and it never ceases to amaze me how many photographers fail to look at their subjects from different perspectives.

This red deer's expression perfectly captures the animal's fight-or-flight dilemma in an unfamiliar situation. Like all Highland stags at this time of the year it is pumped full of testosterone and has an arrogant air that is a portrait photographer's dream. I had the idea of trying to capture this intense expression from the start. But initially the light was just too flat; I moved around him, calculating the angles carefully and working to put the shadow of a dark hillside behind the stag whilst the raking light of Red5 did the rest.

Purists would criticise the fact that I cropped off the antlers and that they can't see both eyes, but they are not essential elements of the picture. What makes it work is the determined look in the stag's eye and the raking light that creates the sense of mood and atmosphere. I have taken plenty of red deer record shots, with the deer looking majestic with all of their racks, but in this case I had the chance to take something that said so much more.

Many photographers rely on the camera to select the focus point of the image for them. I think this is a mistake as the camera is a machine and has no idea what you are hoping to achieve. I always select an individual focus point that is nearest to the eye of the subject. Meeting the eye of another creature, especially a mammal, is an inherent part of our behaviour, so the eye is the first thing we look at, even in a photograph: hence the need to have it sharply in focus in a portrait image. Even if everything else is blurry and out of focus, get the eye sharp and it will hide all manner of sins!

The Red5 ring of fire

There is no doubt that in the early days of my professional career I missed some great Red5 shots because I took the easy option. We are all tempted to take the easy options in life and I firmly believe that the great photographers are great simply because they reject that temptation and are always looking for new ways to challenge their skills and abilities. The easy option with Red5 is to shoot with the light over your shoulder; it takes a real confidence in your ability to shoot *into* the light. If your subject has a lot of hair or fur, and the light is low enough, then shooting into the light can give a new perspective to an image and a red 'ring of fire' – I like this but I have to admit that it is not to everyone's taste.

On the right is my favourite cheetah, Amber. One evening we found her in very late light, just as the sun was setting, and I was faced with the choice of front light or back light. There was only time for one or the other. Experience has taught me that you have to make one decision and stick to it, so I opted for the backlit shot. I think that this was the right choice as the 'ring of fire' around her really shows off her lean physique and you can clearly see that she is built for speed. The only problem with taking this shot, which often arises when I am looking for such atmospheric work, is that other photographers working with the same subject do not see the shot and you are in danger of photographing a photographer, much to the annoyance of all parties. In this case, I was in the company of one of my great photographic heroes, Anup Shah, and we were on the same wavelength – seeing the backlit option as the best in this situation. In this increasingly busy world, even in some of the more wild areas, it is important to respect your animal above all else and also your fellow photographers. Working alone, I have to say, is always best for me, it leaves me free to experiment and to discover new and exciting creative possibilities.

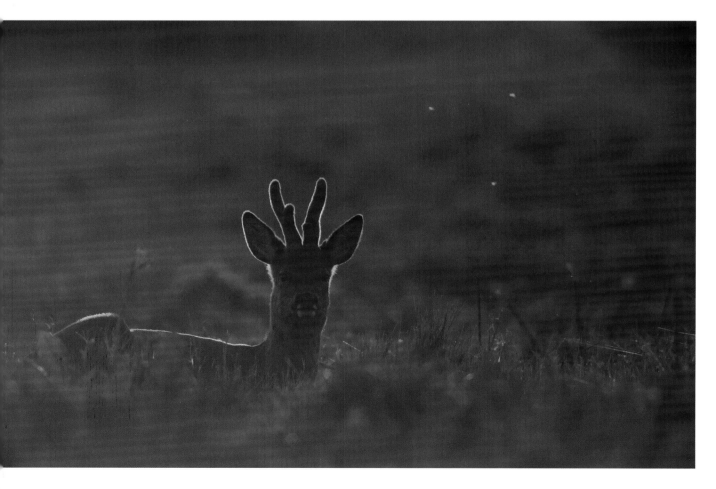

When I came across this roebuck chilling out in the morning light I had little choice but to shoot into the light. The deer had already seen me and it would only be a matter of time before he smelled me too and headed for the hills. Having the confidence to shoot Red5 backlit takes self-belief, but sometimes it is the only option and you have nothing to lose by trying it.

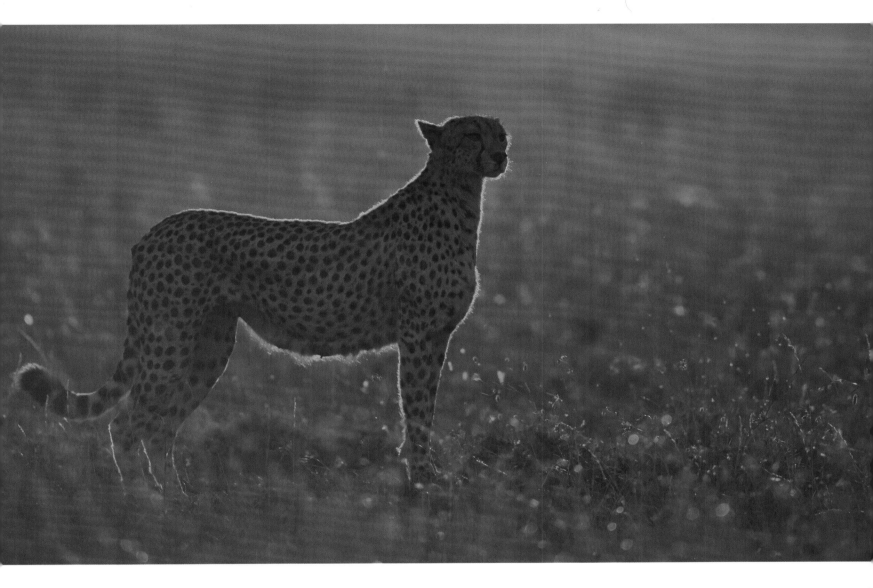

This kind of image is not difficult to expose as the camera will naturally under-expose when it faces into the light. The secret of achieving an image like this is to control the exposure so you can retain some detail in the subject; unless, of course, you want to achieve a pure silhouette. In this case, I feel that the surrounding grass gives some lovely backlight and shape to the image, so to have created a silhouette from this would have been a crime against nature's beauty.

The main problem when shooting into the light is glare, luckily this is simple to avoid whilst shooting (it is never easy and very time-consuming to cure during post-processing). All you need to do is to create a shield across the top part of the lens hood; if you have a small lens then use your hand or a makeshift sunshield using tape to stick a piece of cardboard across the top quarter of the hood. This will cut out the glare completely and, provided that you don't make it too low, will not affect the image one bit. If you don't believe me, try it. It certainly worked with the early morning shot of this spotted hyena.

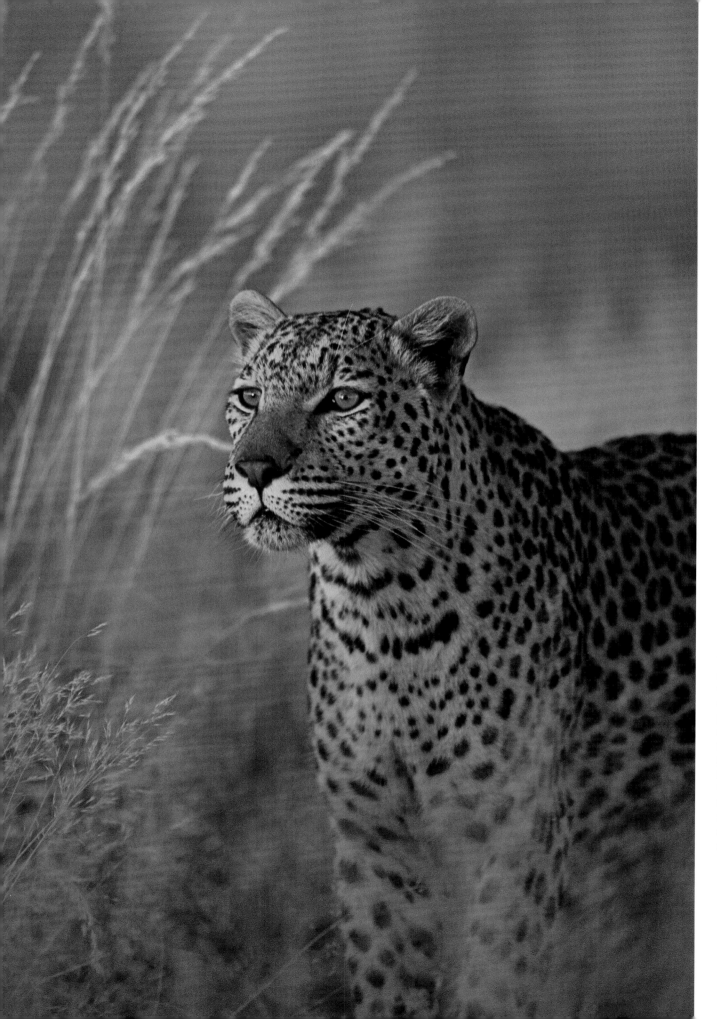

The eyes can make or break a shot. It is definitely the eyes that give this image a sparkle; in fact, if you look closely you can actually see the reflection of the sun on the horizon. Shooting big cats in harder light will often result in 'half moon' eyes which are very unsightly. Red5 eyes are something else, as they come alive with fire during this magical time.

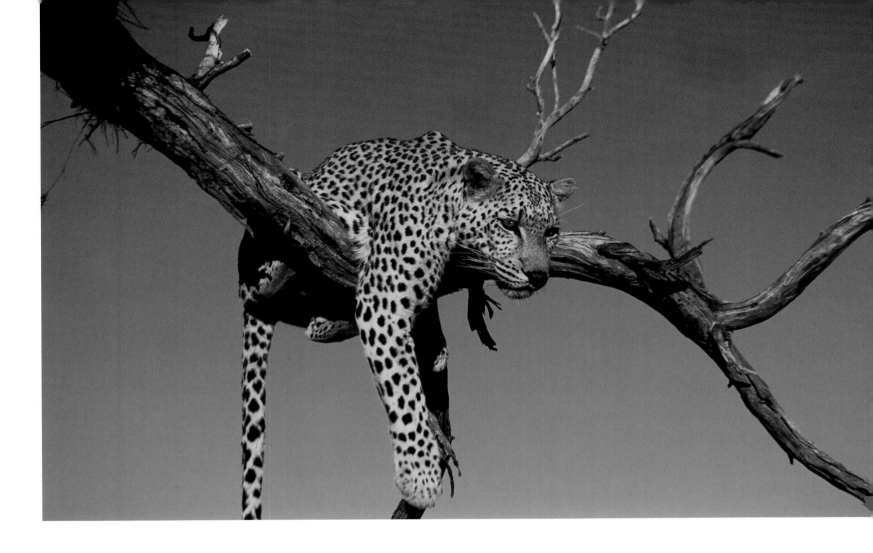

Old Red Eyes

There are times when the simplest picture works best and here are two shots of the same leopard (taken over a week apart) in Red5. Both images work because the late light brings out the amazing colour and tones in the cat's coat. Very importantly, you can see the eyes clearly (which are a lovely shade of red). The portrait shot is my personal favourite of the two, as it was taken literally seconds before sunset and shows a ghost in the grass, a beautiful animal at home in its native habitat, capturing the essence of the species.

The shot on the tree has amazing fire-red eyes that are complemented by the extreme blue of the sky. Now, you might well think that I used a polariser to get the sky so blue but I did not, it is simply the result of looking skywards at this time of the day. In my opinion, filters are the territory of those wizened, bearded individuals who wander around on remote beaches with their wooden cameras, trying to get two rocks in focus that are several miles apart. As a digital photographer I have the best collection of filters in the world, they are called Photoshop plug-ins and I am not afraid to use them if I need to. I can create Velvia-like warmth or turn an image into a monochrome classic, all with the click of a mouse. Some purists might regard this as cheating, but in my opinion it takes as much skill to use a filter properly in the digital darkroom as it does on some deserted beach. The bottom line is that no matter how you use a filter you still need skill in applying it well to get the effect that you want. That is what self-expression is all about.

Exposure for full frontal Red5 shots like this is easy as there are no harsh tones to confuse the camera's light meter. You do need to know your camera well because, despite the old saying, they do lie on occasion. This image was taken with my old favourite medium-format Pentax 645 NII so I knew that the metering would be spot on.

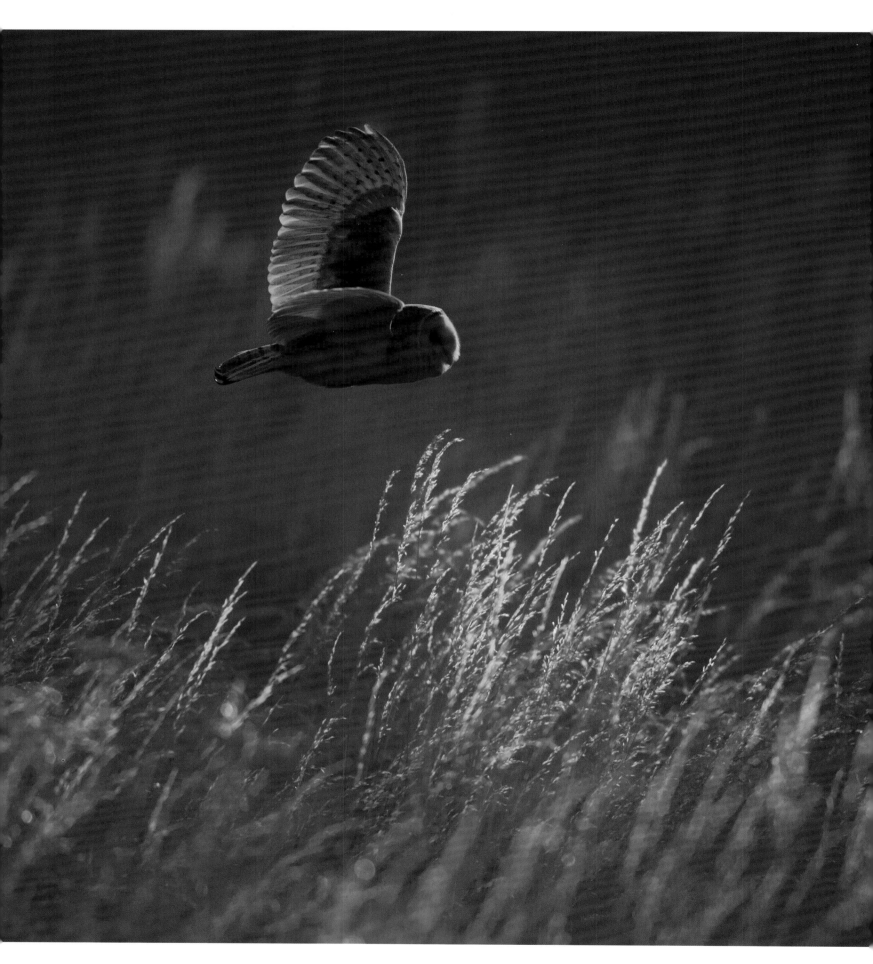

Fire in the grass

So far in this collection we have seen how I use Red5 to create mood and atmosphere and images that are focused on the subject itself. The cheetah image did hint at something else though; that Red5 can also be used to bring attention to the habitat. This barn owl shot has a completely different story to tell from the one we saw earlier in the book. It is the light falling on the grasses that creates the mood and atmosphere of this image; in fact the barn owl itself is very much the supporting act. The problem for me with showing people this kind of picture is that they are all-too-often interested only in the technical issues. But the real skill in this picture is in the weeks of fieldcraft that went into getting into the right place, at the right time, with the right light and the right composition. Observing from my car, I watched this barn owl regularly come out from its nest and head off in a variety of different directions to start the hunt. A quick call to the gamekeeper (someone whom I trust 100% to know what is going on) gave me a clue as to where to start. A nearby field was being cut for silage and I knew that a couple of days later it would be the site of peak barn owl activity due to the disturbance of the birds' favourite snacks – voles. Having spent many years observing barn owls, I knew that this individual would work the field by flying directly from the nest. Working out the best place to lurk was all that was needed, along with a good bit of camouflage gear. Then, it was just a waiting game – but that is the story of my life…

The purposefully balanced aspect of this image, with the barn owl flying into dead space, makes it work – it tells you that the bird is on the move and flying somewhere with a purpose. The image is quite unusual in that it is very difficult to get such a leading composition with a flying bird. We all tend to use the central autofocus point for flight focus since this is the most accurate, but it can lead to the subject either being too central in the shot or, even worse, clearly flying out of the picture leaving dead space behind it. However, we all have to remember that it is not the composition that makes the image work; again, it's all about the light.

Fight Club

Hippos are very active during the period of Red5; in the late afternoon they begin to wake up from their daylong slumber and tend to hang around in the water until well after dusk. I love working with them during this time as the intense light on the water can create some beautiful shots, particularly if you have a still day and a cracking backdrop. During the night, hippos wander round feeding on the grasses on the river banks and further afield, generally making a nuisance of themselves to anyone camping nearby. As dawn approaches they make their way back to the river and as the sun slowly rises the pods begin to re-form. This often causes spontaneous fights to break out as they try to bag the best spots in the river. Being on dry land is important when you are around hippos, fights are common and dangerous, and there is also a good deal of dung flinging which should always be avoided. Hippos, like hyenas, are the real unsung heroes of any African safari; they may not be as attractive as their big cat neighbours but they are always doing something! I love lying in my tent at night hearing the hippos calling to each other with their peculiar 'wheeze-honk', it is as much the sound of the African bush as any lion. I always wonder what they are saying and to me it always sounds like they are telling a joke, obviously sometimes it is a real corker as they can't stop honking for minutes on end.

Without the beautiful light of Red5 this would be a very ordinary reflection and it shows Lilly – yes, my friend from a previous chapter – as she moved away from the others in the group. Deliberately, after looking at all the options, I chose a very boring and straight composition as I wanted to put the focus squarely on her relationship with the water, me and the late, red light. The sinister eyes really add something extra to this – well, it certainly felt like it.

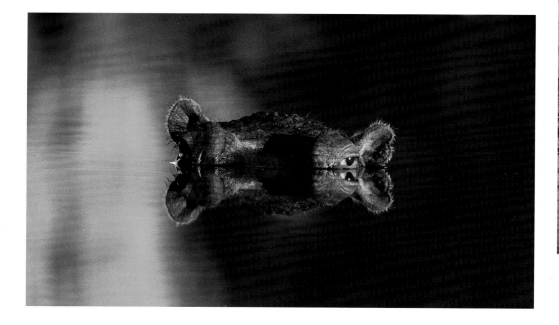

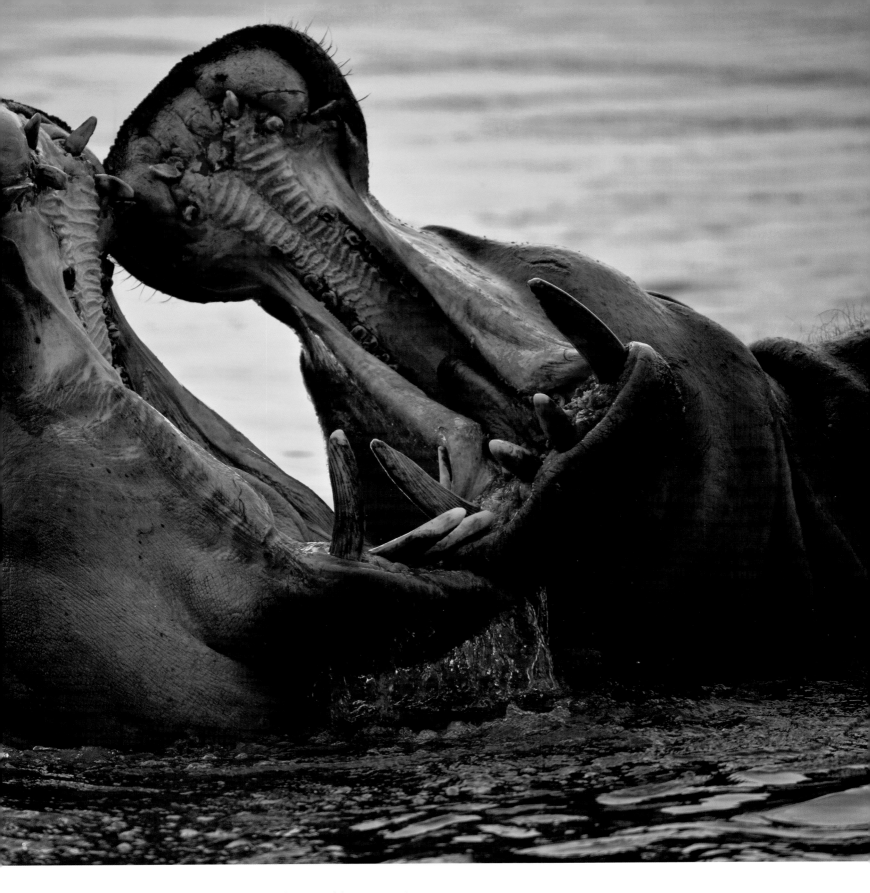

This fight was spectacular, golden water sprayed in every direction and the intense morning sunlight cast a glow on the water that added a greater intensity to the drama unfolding in front of me. I kept a single autofocus point over the hippo on the left to put it in the centre of the frame otherwise the camera would be likely to track off onto the water…which we all know it secretly wants to do.

Rouse on grouse

Another example of my low-angle photography; this time combined with the stunning light of Red5 and the gorgeous red grouse. I love photographing red grouse as they are real characters. They are difficult to work with and don't readily cooperate with attempts to photograph them. They have a tough life too; predators such as birds of prey take their toll of adults and young alike, whilst wet summers can decimate broods of young birds. However, if you can find a willing one then they make beautiful subjects for anyone's photography and are completely underrated, being one of our most beautiful native bird species; their red plumage really shines in red light.

To get close to this grouse I used a bag hide, which is a camouflage cape that covers me from head to foot and provides a small slot to poke my lens out. This is a very useful piece of kit as it is light and breaks up my human shape into something less distinct. Getting close to this bird required thirty minutes of careful crawling through heather, which was difficult enough without the bag developing a mind of its own. Time and time again it wrapped itself around me in an unwelcome embrace, each time I cursed silently, carefully unwrapped myself and crawled a few feet closer to the increasingly bemused grouse.

The image that you see here is much as I took it and I have resisted the temptation to saturate it any more. Super-saturation would ruin the ethereal feel of this picture as it would give the plumage of the grouse the wrong colour and would probably introduce banding into the out-of-focus background. I really love this shot as it has an impressionist feel. It is composed of very simple elements – beautiful grouse, simple composition and beautiful light. What else do you really need?

A little saturation is fine *in most images, just apply it carefully in Photoshop using a layer and back it off using the opacity slider until you have a natural result. It is always better to add saturation at the post-processing stage as you can control its affect; leave lens filters for the beards. Caution is the name of the game with wildlife and it is important to keep your image as true to the subject as possible.*

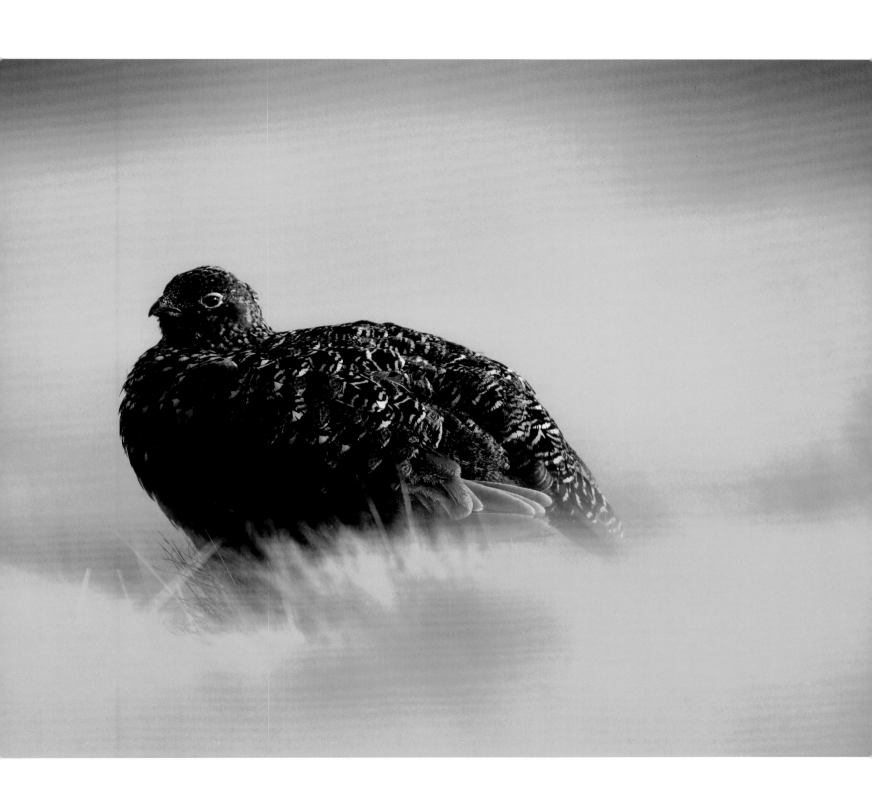

JUST PLAIN BEAUTIFUL

Nature is often beautiful in its simplicity. We can use evocative light, award-winning composition and perform all manner of software wizardry but often the best pictures are those constructed of the simplest elements. That philosophy is shared by the great portrait photographers of our time; like all photographers they use light to tell a story, but the focus of that story is the subject itself and nothing else. I justify the selection of images for this portfolio using the same rationale – these pictures and the creatures they portray are 'Just Plain Beautiful'. The key to these shots is to keep every element in the picture in its most basic form; lighting must be direct and complementary, the foreground and background diffuse and the composition must lead the viewer straight to the subject. There isn't much of a story to these pictures, apart from the underlying fact that nature is inherently beautiful just as it is.

There can hardly be a more striking bird than the puffin. The combination of that huge, brightly coloured beak and the sorrowful look gives the puffin all the ingredients for a Just Plain Beautiful portrait. The key when photographing puffins is to avoid all confusing backgrounds and foregrounds; keep the picture uncomplicated and focus squarely and unapologetically on the puffin. I really love this image, as it is a straightforward one to understand; the impression of the sea pink (thrift) and the beautiful deep blue background combine to frame the puffin perfectly. Using a fixed focus lens helps, too, as it compresses the facial features and I personally think gives a much more pleasing effect than a zoom lens.

Like many wildlife images this one has a hidden message. Over the past few years the puffin's main source of food, the sand eel, has declined to such an extent that I have seen them entering their burrows with beakfuls of unpalatable pipefish, which are insufficient for feeding hungry chicks. Unless we do something to curb this decline and eliminate its causes then a puffin with a beak full of sand eels will become an increasingly rare sight and images like this will eventually only be seen in museums. I would like to be remembered for many things, but certainly not for taking the last shot of a puffin in the wild. Being beautiful does not necessarily guarantee survival in the modern world.

My lens was held parallel to the puffin itself and I could afford to focus on the eye directly whilst selecting an aperture of f4 to keep the background and foreground diffuse and indistinct

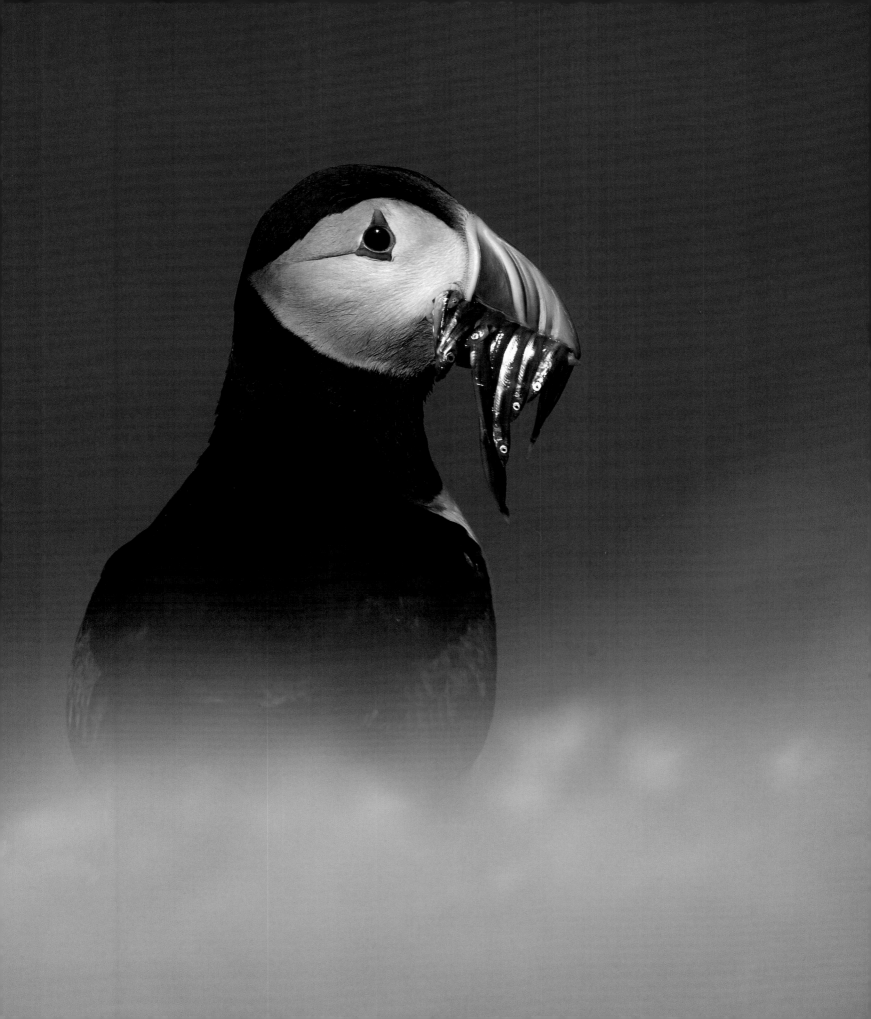

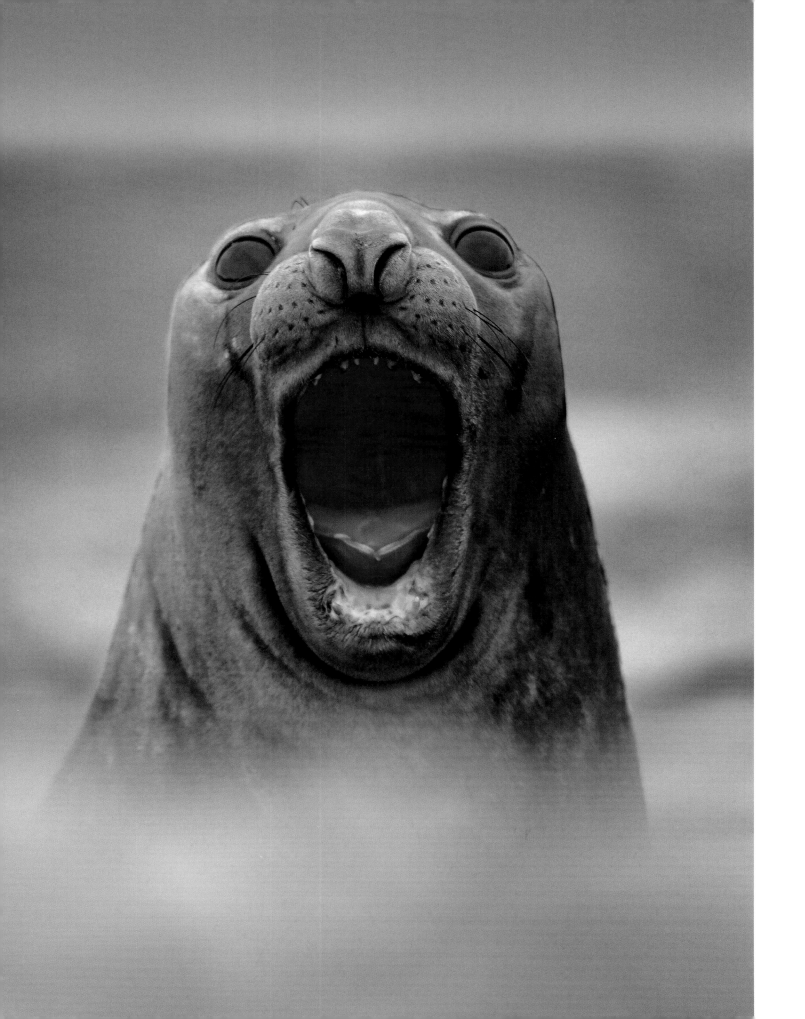

Capturing personality

Just as humans have differing personalities, and a wide repertoire of facial expressions, so do many other animal and bird species. Portrait photographers, and paparazzi for that matter, look for an expression in their subjects or a hint of personality and attitude that they can capture. It personalises the shot and makes more of a visual story; we can easily apply the same logic to wildlife photography.

Elephant seals have a very simple yet appealing life; they basically fart, belch and sleep. This elephant seal was a little disgruntled with me. I had spent an hour crawling up to it on my belly and had gone to great pains to avoid waking it up only to see a sleeping neighbour roll over and belch loudly in its face. One eye opened, then another, as it realised that I was lying down in front of it. Although I was outside its comfort zone, I knew that a threat yawn would follow and sure enough it did, I was glad that I wasn't close enough to smell it.

Albatross are very demure and usually present a very bland expression; they can appear stuffed in photographs if you aren't careful. But this particular albatross was looking slightly quirky because another one had almost landed on top of it; this is one reason for the letterbox crop as there are some intrusive wings and a beak that spoil a good proportion of the original picture. In fact, one of the main challenges I face when working in an albatross colony is trying to avoid the clumsy creatures as they come in to land; ocean wanderers they may be but landing gracefully is not their greatest skill.

The low angle really works well with this image. It creates some foreground interest that helps to lead the eye straight to the seal. The focus point is above the centre and I deliberately placed it right on the nose as I thought this would give a more pleasing result than getting the eyes sharp and the nose slightly soft.

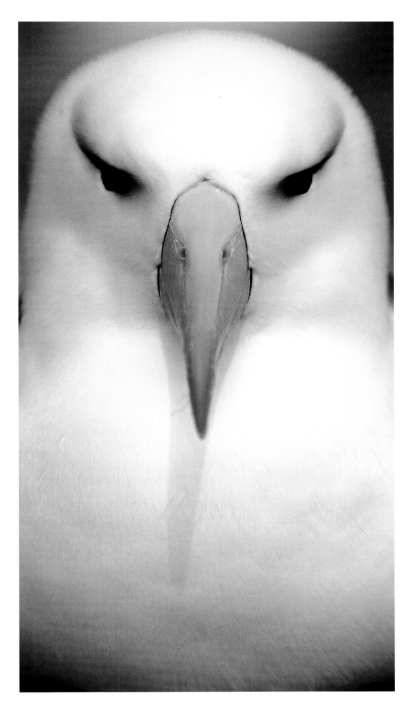

The black-browed albatross is a beautiful example of the race. What is remarkable is not just the purity of its colours but the fact that it manages to stay white at all. What you cannot see in this shot is that this female is sitting on a nest of mud, surrounded in very close proximity by many other albatross sitting on similar nests. These nests have to be constantly tended and rebuilt which is a very muddy process, yet I have rarely seen an albatross that has any dirty marks on its gleaming white chest, which is quite a mystery to me.

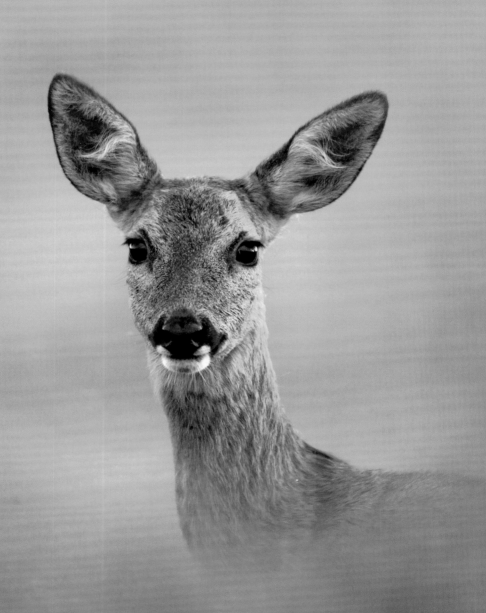

No place like home

Getting a shot of a shy mammal like a deer or hare has nothing to do with your skill at manipulating images on your computer, or even how good a photographer you actually are. It is a test of your fieldcraft skills, how much you know about your subject and how well you know your local patch. I am so lucky that while I get to travel the world I can also enjoy trying to get close to my local wildlife without being detected – something that gives me just as much of a kick. I love the test that fieldcraft provides, pitting my wits against the animal's senses; that are infinitely more attuned to their environment than my own (including the sixth one). Days and days of preparation are concentrated into an intense few hours of observation, and if by some fluke I manage to get close enough for a shot then I have to control myself and wait, and wait, and wait until the moment is just right. This type of photography is usually a one-shot deal. For some this will seem like a waste of time whilst for others it will provide a wonderful experience; there is no better feeling than getting a fleeting snapshot of an animal's life without it ever knowing you were there.

My local country estate has a great population of deer and hares and I spend a lot of time out and about just watching and seeing what is around. All animals have favourite places they like to be, whether it is for food, safety or just because it is *their* place. The only way that you can find these is to get out with binoculars and look. I have been taught everything I know by gamekeepers and deer stalkers, they are the real experts on the countryside. Take deer, for example, the most fun way to get close is to stalk them on foot, where every footstep is like walking on a potential minefield; one twig breaking underfoot and, game over, it is an early breakfast for me. To negate the deer's sense of smell I always walk into the wind and wear clothes that have never been washed with detergent. To fool deer's keen eyesight I wear camouflage gear that looks like foliage and walk slowly, erratically, stopping for minutes at a time to scan ahead with my binoculars. I use the forest edge to walk and never move across open ground. I try to think like I'm invisible because I am trying to outwit the ghost of the forest. If I get lucky then I will get a shot, perhaps two or three on a good day, but good days are rare enough to be memorable. Deer stalking is not a race but a test of patience and a great leveller – everyone is equally disadvantaged. Deer stalking is the most fun you can have with your clothes on, in my village anyway.

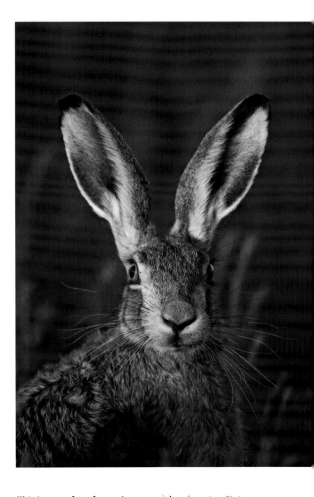

I have always liked this image because it uses the natural frame created by bushes in the foreground to make the serenity of the doe really stand out. To get this effect a shallow depth of field is essential, otherwise there will be too much distraction from the surrounding foliage. Accurate focus is also important. The focus of the image is squarely on the head of the deer and any technical imperfection will be obvious. Naturally, it helps if you can find a stunningly beautiful subject such as this one.

This is one of my favourite contenders for a Just Plain Beautiful award and I call it 'Head and Shoulders'. I tried to place the leading diagonal of the animal's shoulder from one of the bottom corners of the frame and then place the head and eyes slap bang in the centre. This allows the composition to flow as the eye naturally follows the line of the body direct to the face, which is the main interest point. Photographing hares is always a trial; the only way to get any shots is to find where they are feeding and stake them out by lurking in a bush. We could actually rename this composition 'The Miracle' as it is a miracle that I not only found the hare in good light but also that it did not instantly leg it!

Background colour

An essential element of any Just Plain Beautiful shot is to have a very simple background that does not detract from the main subject. Remember, we are not intending to show much habitat here, just a hint will do, so balancing the depth of field in order to get just enough of the subject in focus while keeping the background diffuse is vital. The stunning kingfisher and the prowling leopard are two examples of this.

I have so many pictures of European kingfishers now that every season I vow never to take any more. For such a tiny bird the kingfisher has an amazing density of colour, albeit mostly shades of blue. In any light it is truly one of the most beautiful birds in the world. The kingfisher is an easy bird to shoot as it looks good in any light and the element that ruins most pictures of them is a confusing background and emphasis on a messy habitat. In order to avoid such distractions, I provided a perch for this kingfisher to sit on and gave myself plenty of time to experiment, moving it around to get the best background colour and repeatedly returning to the hide to check through the viewfinder. I would not stop until it was perfect since the entire shot was under my control. On this particular day I had chosen a sandy bank for the background, as it set off the stunning blue of the feathers in the evening light. What really makes this image work, though, is that you can see the white of the eye; it is amazing how this one tiny feature changes the mood and feeling of the shot. This would be just another 'bird on a stick' portrait, were it not for the eye which gives the kingfisher a personality; to some people it looks wary, whilst to others it seems inquisitive. One of the reasons that I hate 'the bird on a stick' composition so much is that although many of the pictures (though not all) tick the box for being just plain beautiful they are also just plain dull. This shot, however, is alive, and not just because of the eye, but also due to the simple, yet colourful, background. Every element combines, for once, to make a compelling portrait that is far from dull but utterly beautiful.

The leopard shot uses a low angle to remove background clutter, which in turn brings the sky into the picture; this gives the image a warm feeling but also helps to frame the leopard nicely. Using the sky in this way is a great trick to use for this kind of shot but you have to get low to the ground to do it and that is not always possible. If you can use the blue sky in this way, don't be tempted to use a polarising filter, as it will probably create an unrealistic effect and will cut the shutter speed down by two stops which is likely to lead to softness. Keep nature pure and as you see it.

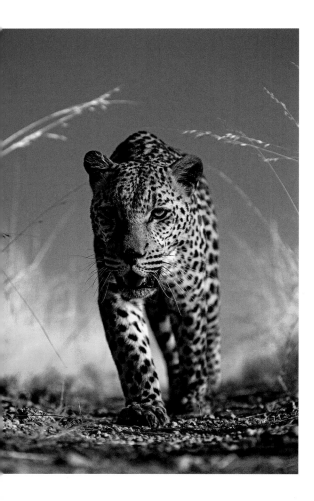

Low-angle shots like this are fun to do if you have a pressure pad or an infrared beam trigger. They can take time to set up and you will often look like an idiot crawling through the beam pretending to be a leopard, but the end-results can be superb as you can capture an animal going about its business with no fear of a human being close by. It is a risky business, however, as some animals find cameras quite tasty, as experience has taught me to my cost when working with hyenas. One evening I had set up the pressure pad overnight on a regular track and had the camera and flash surrounded by a ring of thorns. When I returned in the morning to check what it had captured the pressure pad was ripped to bits on the ground and all that was left of the camera was a chewed circuit board!

Kingfishers can be very boring to photograph; there are long periods of time to while away in the hide whilst staring at an empty branch. I use this time productively though, and my first job is to get the branch parallel to the front of the hide. This is vital in order for me to be able to control the depth of field and may take hours, if not days to perfect. There is nothing wrong with being a perfectionist and it always leads to better results in the long run.

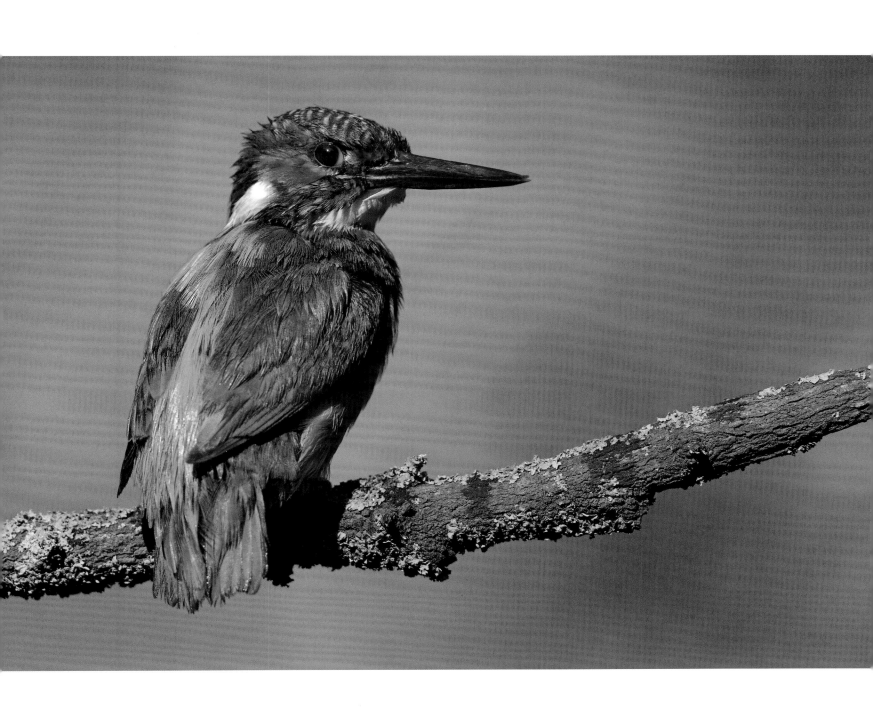

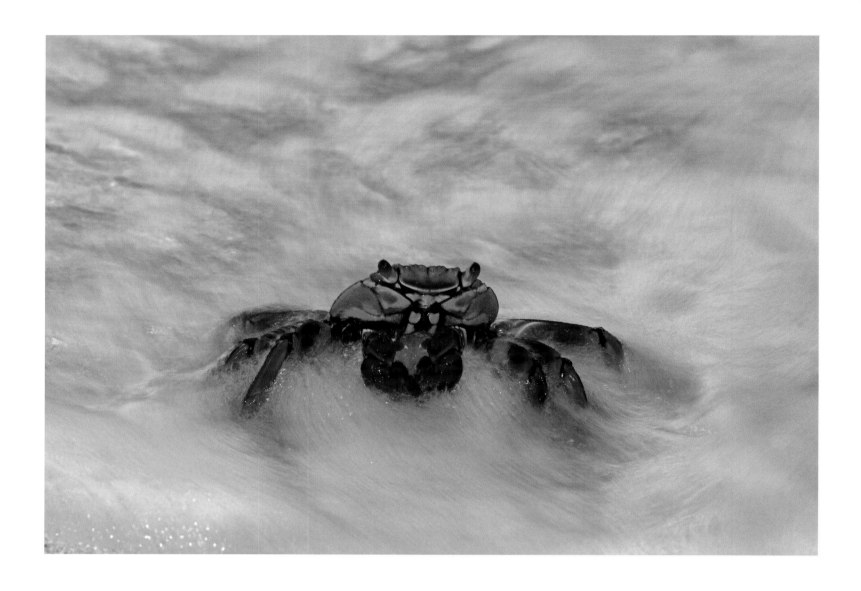

A wider view

Every morning on Ascension Island I would watch the Sally Lightfoot crabs filter-feeding on the rocks, clinging on for dear life as the incoming waves threatened to sweep them away. I wanted to capture this story so selected a slow shutter speed to blur the waves, a flash to bring out the beautiful colours of the crab and a tripod to keep it all steady. The story of the shot is still concentrated on the crab but the blurred water gives it that extra element. Typically, the crabs were better at clinging on than I was and more than once I was swept off my feet by the strong undertow of the receding waves.

So far I have shown some very conventional Just Plain Beautiful shots but sometimes it pays to be a little bit more creative. So long as you remember the basic idea of keeping the background simple and the main focus on the subject, you can afford to back off a little and give the subject a bit more room to breathe.

To protect her chicks from pike and other predatory fish the female great crested grebe carries them around on her back for the first ten days of their lives. The first-born gets an advantage over the others as to start with it has the warm, dry feathers of the female's back for its sole enjoyment; then two days or so later the second chick is hatched and two days after that the next; by the time a fourth chick is hatched space on the female's back is at a premium. I took this image from behind some netting in the shadow of a tree on the lake's bank; the freezing water was up to my neck and I could only stand it for a few hours at the most. The expression of the chick leaning out from the mother made all the hardship worthwhile and again a low angle makes the shot come alive, as it removes the water as a distracting part of the foreground and background, giving you a sense of being on the same level as the grebe.

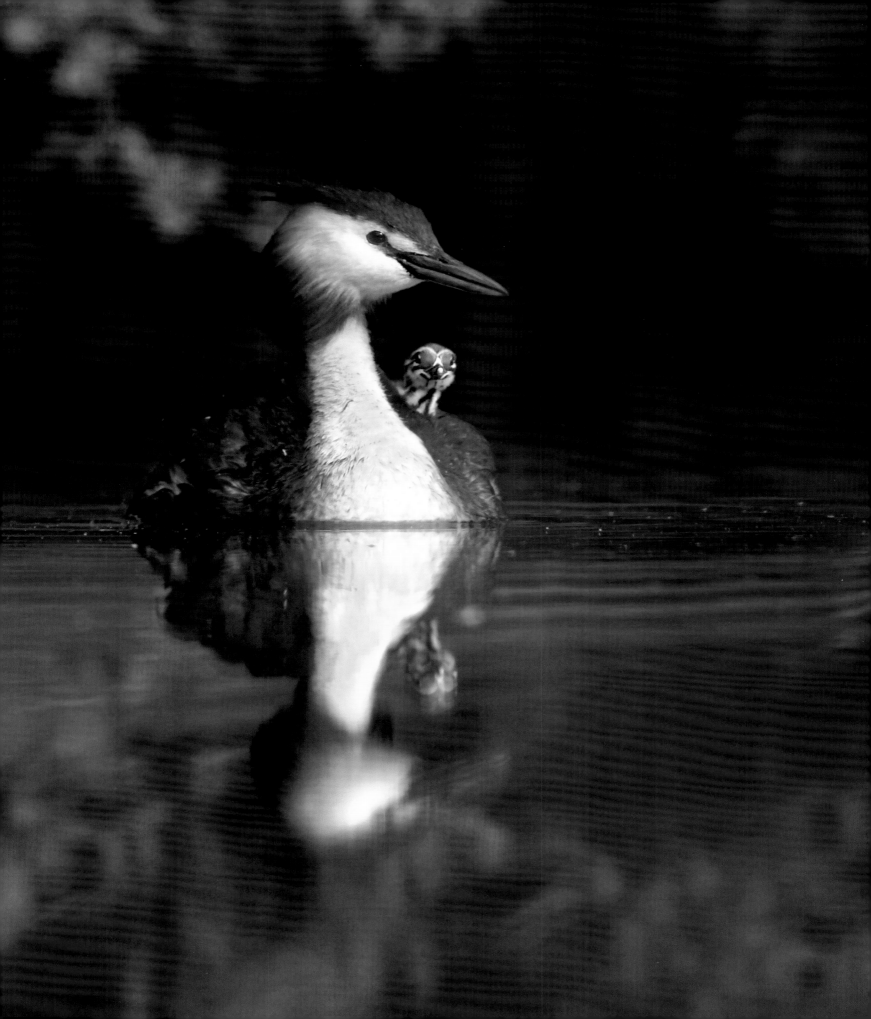

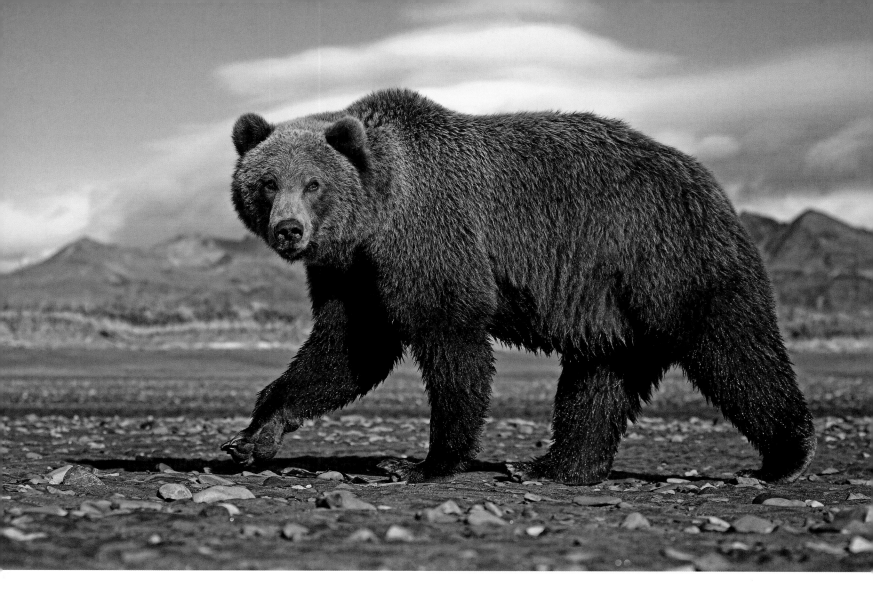

Just plain grizzlies

Meet Digger, so named for his ability to excavate all the way from Alaska to Australia in search of a single clam. Taken early one morning, this has all the classic hallmarks of a Just Plain Beautiful shot: focus squarely on the eyes, composition simple, low angle to reduce the effect of the background and a shallow depth of field. The image was shot with a wide-angle, purely because Digger insisted on coming so close to me and I struggled to stop the background from being distracting even at an aperture of f4.

We all have preconceptions about wildlife. In some cases these can be wholly unjustified and can lead to inappropriate behaviour when working with some species. Before I first worked with grizzly bears I was terrified of them, having heard countless tales of bears attacking humans and pulling unwary campers from tents; one glance in any Alaskan bookstore will reveal shelves full of books entitled *Grizzly Attacks: Volume 25* or *A Grizzly Ate my Hamster*. Now, several seasons of experience and knowledge later, I am no longer terrified; I am cautious; I don't take risks and I never give them the benefit of the doubt; what I do give them is respect and a little respect can go a long way. The grizzly survives in incredibly harsh environments, adapts rapidly to changes in its habitat and continues to defeat every attempt that we make to destroy it; all it asks for is to be left alone. The world would certainly be a duller place without bears.

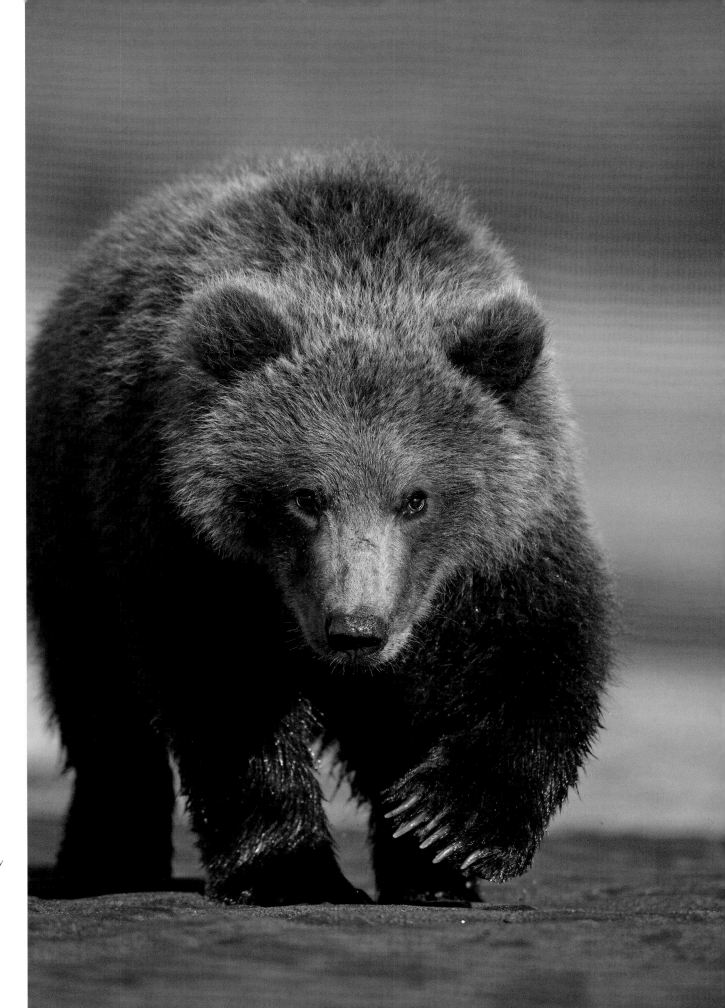

Cute, cute and cute.
I could have tried some trendy off-centre composition here but sometimes my old habits shine through and I just shoot it full frame, unashamedly bold and in your face. A typically 'big shot' for what was actually a little guy.

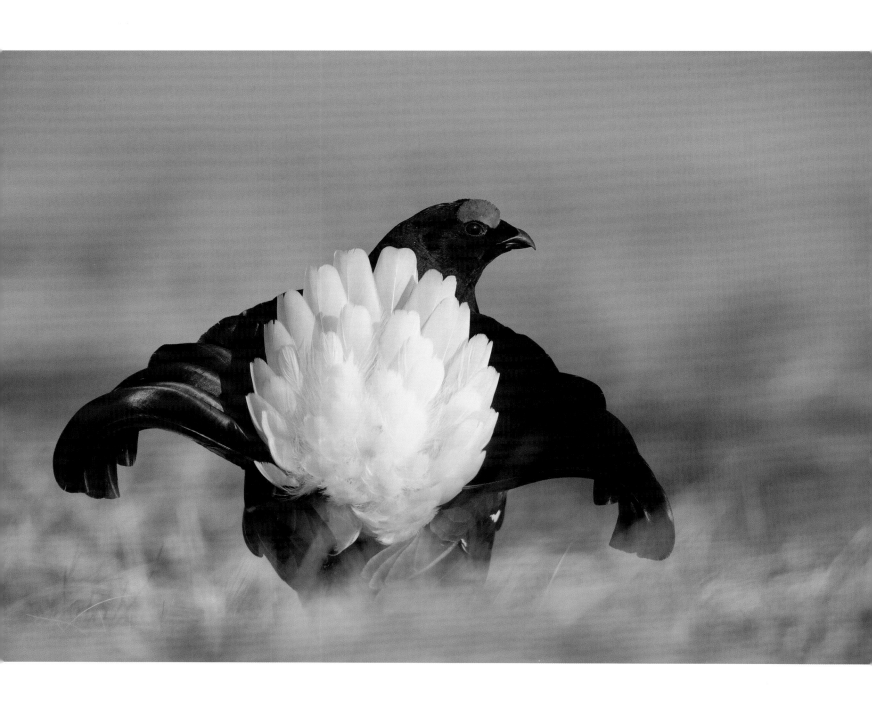

Hidden stories

How beautiful is this creature? This is a male black grouse, or blackcock, strutting his stuff to attract the females; each year they gather at a lekking site to compete for the right to mate. The females have their choice of blackcock and are looking for the most dominant. He will not necessarily be the biggest blackcock but his intriguing (and to be honest hilarious) antics can make him the most desirable one.

War photographers risk their lives; landscape photographers cart their gear to the top of mountains and wedding photographers…well they have the mother-in-law to deal with. I think most photographers will agree that the final image you see does little to justify the amount of work that goes into creating it. Wildlife photography is no different and the story behind each shot is usually one of meticulous preparation and long hours sitting in a darkened hide amusing oneself quietly. The blackcock lek is a good example; it took me over two weeks to get the hide close enough to the lek to photograph it, as it could only be moved a few metres at a time to ensure that they got used to it. Care is essential as the blackcock is easily disturbed (not to mention being endangered in the UK) and this is the most important few weeks of their year. I am only taking pictures, which doesn't really register on the greater scale of things. I would get into the hide at midnight, when the grouse were not active, using a red torch to light my way. Oh yes, I didn't tell you that this particular lek was located in an active military firing range, did I? Military activity was suspended during the lekking period in the interests of wildlife conservation. Once inside the hide each night, I would get some sleep for a few hours until something would land on top of the hide at 4a.m. sharp and wake me with that warbling call that blackcock addicts know and love. As darkness gave way to light I could see that that I was surrounded by a host of blackcock and from then on it would be full-scale action, with threats, intimidation and fights of extreme violence for a few hours until the sun rose too high and it was time for peace and love again…until the next day.

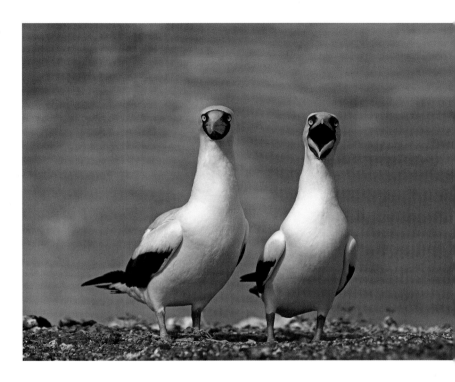

This shot hides the story that I almost died from heat exhaustion to get it. The equatorial heat of Ascension Island is incredible and these masked boobies were nesting on the most exposed part of the island, without trees or shelter of any kind. This shot was taken around 11a.m. with a flash to lighten up the shadows created by the harsh light. Carrying the photographic gear there in the first place was a real challenge but it was the journey back, climbing on my hands and knees 2500 feet back up the cliff in blistering heat that took its toll. I drank around ten litres of water during this time and prefer to forget the rest of the day because I can't actually remember it, as I was flat on my back in front of the air conditioner!

This image of the black grouse works well by combining a low angle, diffuse background, and a beautiful bird in Red5 light (see previous section). Exposure was a nightmare as the blackcock's plumage is limited to two basic colours: deep black and shining white. Luckily I had some medium-toned grass available nearby which was handy to take a reference meter reading from.

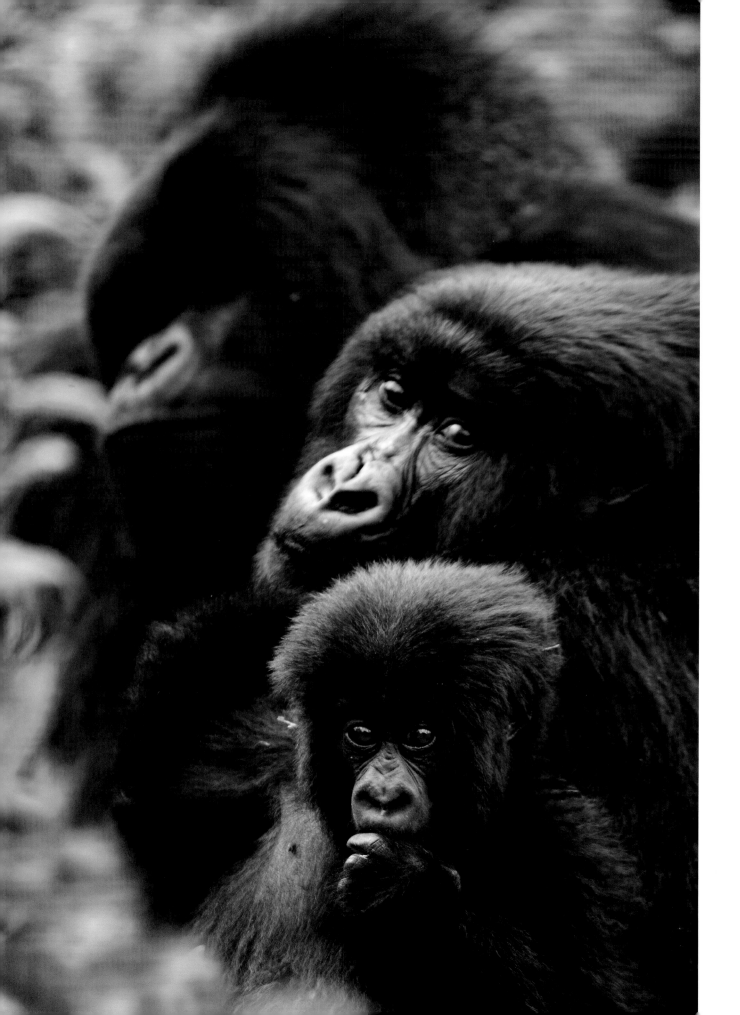

*Left: **One of the most beautiful and timeless images** in photography is a family portrait. Wildlife family portraits tend to be a bit more edgy than most, simply because none of the participants have paid to be there and the adults have a much more protective attitude towards their young. I am not a spiritual person, but spending time with the highly endangered mountain gorillas is an incredibly moving experience. I really love this image as it shows the family structure that makes the gorilla family so strong; the big chap at the back is the silverback, the largest pair of shoulders that you will ever see in your life. In front are a female and her very inquisitive youngster with an expression that is priceless. Since the light level was very low I had to keep the shutter speed up and therefore the aperture down, so my depth of field was very limited. I opted to focus on the youngster, who was the main focus of attention in the shot, and just convey an impression of the imposing silverback behind. This is one of my favourite and most compelling family portraits of all time and I hope that the gorillas will still be there in ten years' time for me to repeat it with another generation.*

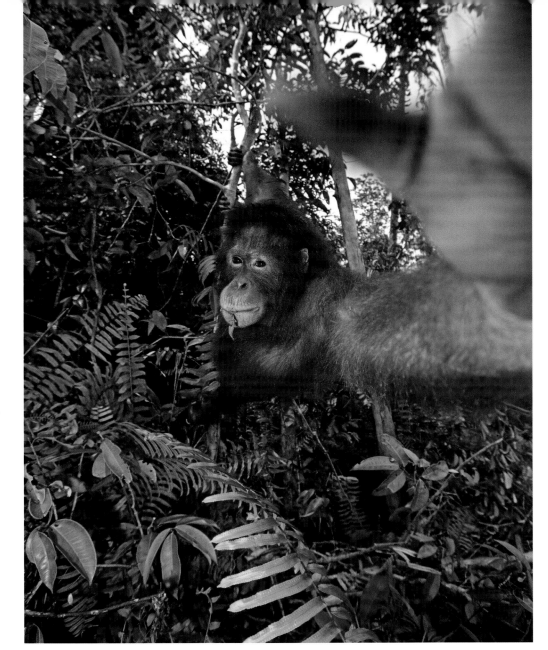

Primate portraits

Primates make great subjects for any photographer and two of my favourites are shown here. The only problem with primate photography is that the results can become anthropomorphic and I hate the way that they can be used to ridicule and create a cheap joke about our closest relatives. On the flip side, I see no problem in being anthropomorphic in order to make a specific point, or to illustrate some behaviour and make it easier for all to understand. I take this approach in my lectures and the way that I have written this book, and make no apology for it. Traditionalists, and those photographers threatened by this attitude, have always hated my approach, but I think that my passion for wildlife helps to get the message through to the normal, everyday person on the street. If it touches just one person then that is one more person who can make a difference; conservation only works alongside education and understanding of the natural world and connecting people with nature is one way to achieve this.

This is a unique composition, using the arm of the over-inquisitive orangutan to lead the eye straight into the main focus of the shot. I was using a 17-35mm zoom lens at the time and had a handheld flash to help illuminate the shadows created by the rainforest. With my other hand I was holding on to my camera for dear life as the orangutan had decided to grab hold of the lens and my neck was being severely stretched!

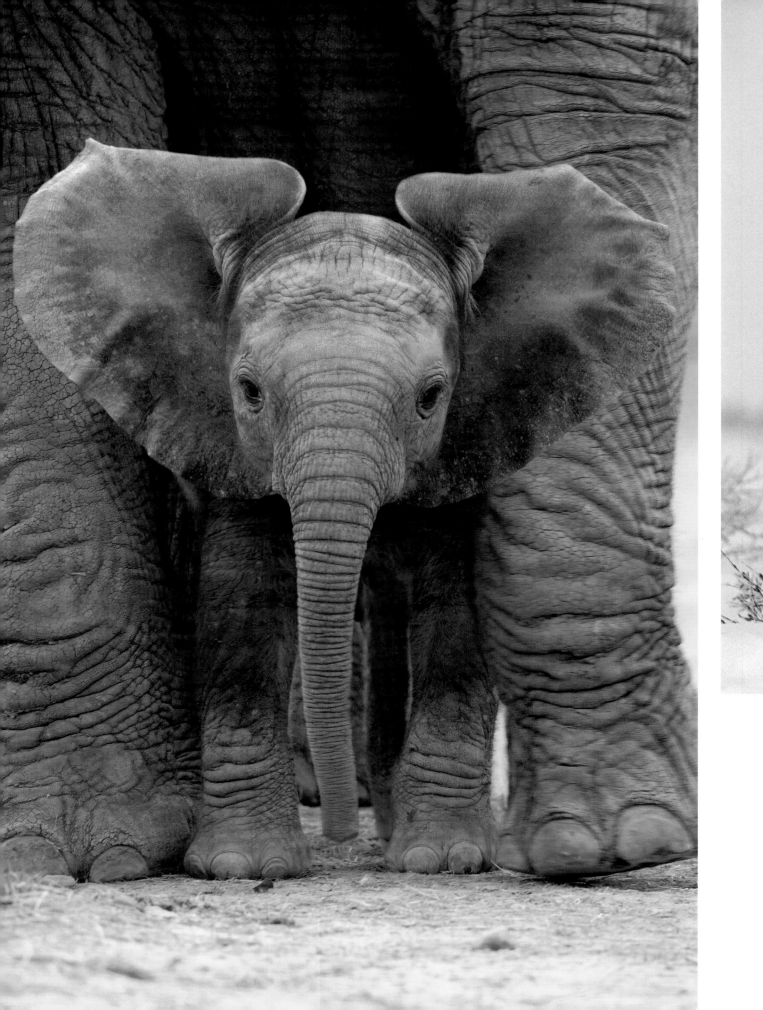

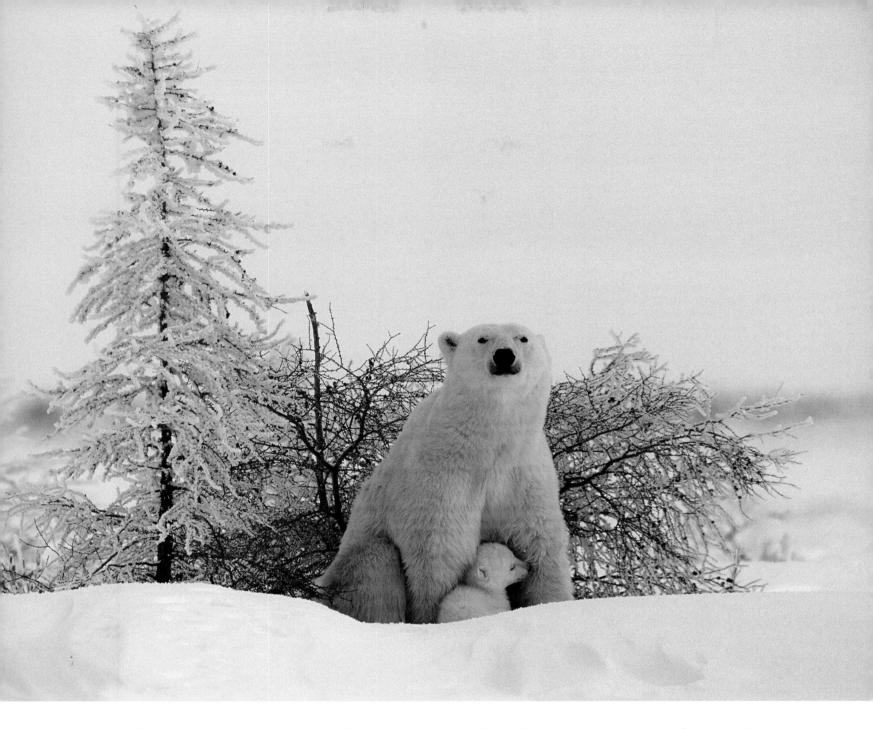

Left: **You would probably never guess** that this image was taken in a zoo, but it was. The picture works because the little guy is giving me some attitude and the contrast in scale between the tiny calf and his mother is made all the more apparent by the feet. The message portrayed in the picture is protection and nurturing, which is exactly what a portrait photographer would try to achieve in a similar situation. In my opinion, zoos have a vital role to play in conservation. In this day and age conservation is becoming more and more visual; by this I mean that it is very hard to convince the public to assist and support conservation programmes if they have never seen or experienced an animal. I am sure that most people who donate to tiger conservation projects do so because at a young age they saw tigers in their local zoo and the experience stuck with them into adult life.

Another shot showing a sense of scale, this time a tiny polar bear cub nestles between its mother's legs for protection. It was a beautiful moment and made extra special by the fresh haw frost on the trees and the overcast conditions that gave some details in the shadowy areas. I shot a few close-ups of this situation but this wide-angle composition was by far the most effective and gives me special memories of an amazingly privileged few days.

ATMOSFEAR

The images contained in the portfolio 'Just Plain Beautiful' are simple, full in the frame and easy to understand. Above all, they are very beautiful shots and they radiate a positive feeling; happy animals in a happy world. Unfortunately, much of the time the natural world is not a happy place but the setting for a daily struggle for survival. As photographers we can illustrate this by adding a little mood and atmosphere into our work, some of which has already been seen in the 'Red5' portfolio. However, that collection of pictures is unique because Red5 light is very rare; usually we are forced to shoot in much more challenging light and weather conditions. As always, it is how we visualise this kind of shot and how we use the light to express it that defines the message that we are trying to convey. What follows is a portfolio of atmospheric pictures to show some techniques that I use to try to achieve this under some of the most inhospitable of environmental conditions.

The shot of a leopard having a quiet groom was a random opportunity. It was getting close to dusk on a very thundery day in Samburu National Park, Kenya, when we found this leopard in an old, dead tree. The thunderclouds behind the leopard were almost pure black and the sun was behind clouds, too. The scene was about as dull as it could be. Through binoculars I spotted a small gap between the cloud and the horizon and knew that if the sun came out, even momentarily, it would be an incredible shot as the light would be so intense. We opted to stay and wait, as any time spent in the presence of leopards is to be savoured and even if it came to nothing it would still be a nice end to the day. We waited…and waited…and waited and then the first rays of incredible light started to illuminate the uppermost branches of the tree. I glanced back and could see the bottom of the sun popping below the cloud and already nearly touching the horizon, if there was to be any light it would be over quickly. All of a sudden, someone high above flicked the light switch to on, the tree turned gold, and the leopard was bathed in intense sunlight. The contrast between the leopard and the threatening black sky behind was unbelievable. I deliberately shot the image with room to breathe, using the natural curve of the tree to create the composition and give balance to the image. In a few seconds the light was gone and we reluctantly left the leopard to continue his preparations for the night's hunting ahead of him. Job done.

Revisiting this shot, I have often wondered if I would have liked it as much if the leopard had made direct eye contact with me. I think the peaceful mood created by the leopard going about its business contrasts well with the deluge which is about to descend from the sky behind him. Meaningful eye contact on this occasion would have ruined the atmosphere of the shot completely.

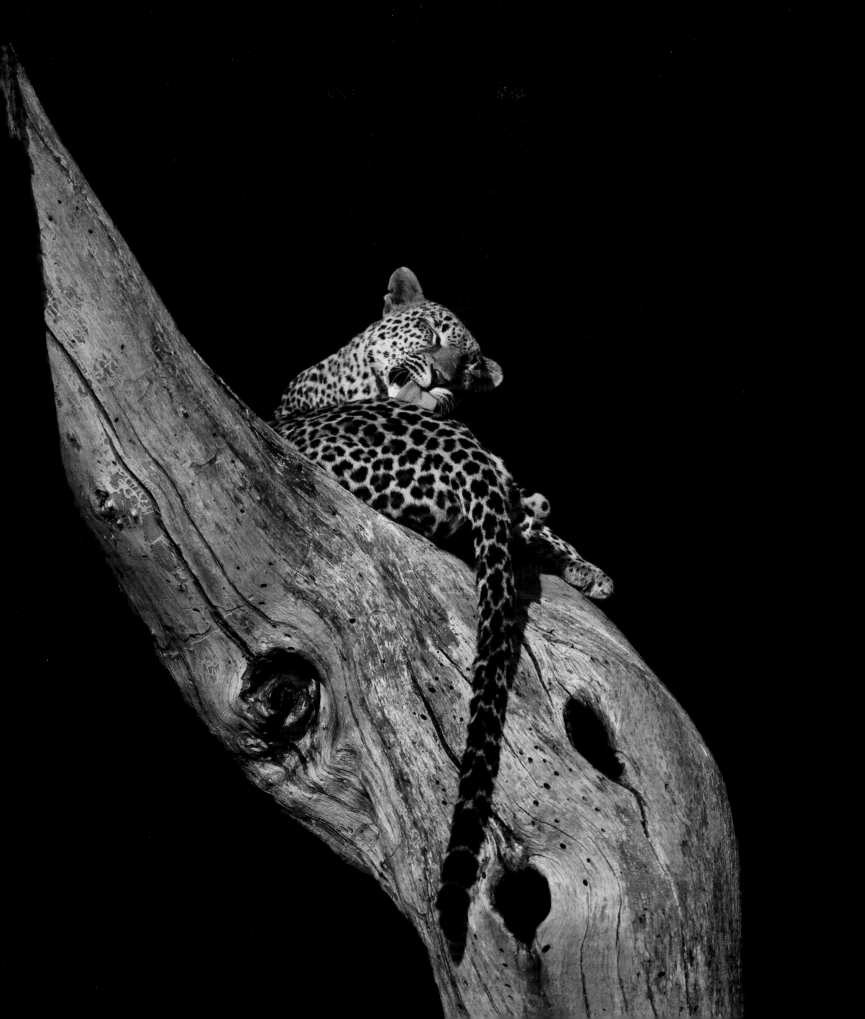

A glimmer of light

Light is malleable, it is a tool that can we can warp and bend to create mood and atmosphere. We can't control it but we can, as photographers and observers, learn to use it to our advantage. Even stepping two paces to one side changes the way that light falls onto a subject, it may reveal more texture and detail, or it may create an impression of anger or calm. Sometimes, forgetting the over-the-shoulder rule, I prefer to shoot at an angle of 90 degrees or more, as it gives the picture an extra edge and a depth which makes it more than a mere record. In making this choice I have been influenced by exposure to the work of fellow professional photographers from France and Finland, who use light in his way to create an amazing atmosphere in their work and who see their image as the expressions of an art.

The light was stunning when this Arctic fox was running around but I saw the real picture as soon as it lay down to rest. The blue of the ice, the last ray of light gently touching the top of the head and the single eye looking warily out combine to make this image something a bit more special than a routine portrait. It has an atmosphere and feel that would be lost in direct sunlight. It also tells a story about the way an Arctic fox lives; in an intensely cold place and in a state of constant alert. To be completely honest, the image isn't the sharpest picture in the world either because I was hand-holding my 500mm lens at a shutter speed of 1/30th second. If this were in 'full light' or was intended to be a Just Plain Beautiful portrait then anything less than razor sharp would be instantly deleted, but since it is an atmospheric shot different rules can apply. It is the light that tells the story here.

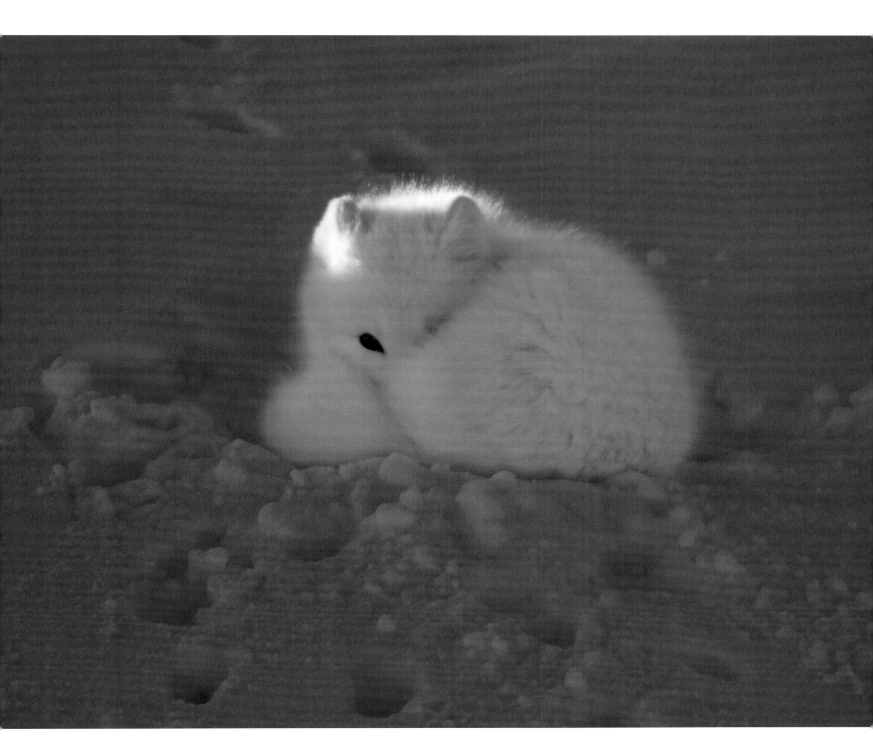

I don't shoot a 500mm lens hand-held by choice; I am skinny as a rake and not built to support a heavy lens for a long period of time. Image stabilisation technology helps a lot and when hand-holding I will always bump up the ISO to give me a little bit more shutter speed to counter any camera shake. Like a sniper, I also hold my breath when taking the shot as I find this really helps counter any shakiness on my part.

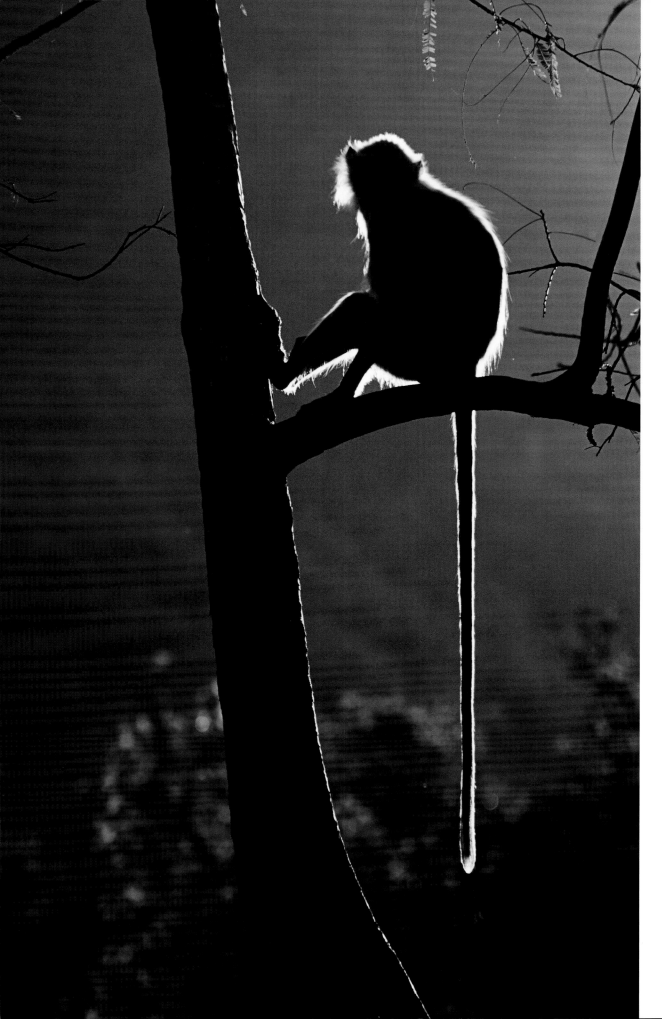

Right: **Little things can give an image** *that extra edge, as I have said many times throughout this book. In this instance the bear had just shaken its head to dislodge the biting flies that were surrounding it (and me in the hide too). It was those annoying little insects that made this a lovely shot, again telling us plenty about the situation despite a lack of background detail.*

Exposure for backlit shots *is pretty easy, as your camera will naturally shoot them under-exposed in this situation. Try to keep the aperture to a low value like f5.6. You want the subject to be the main focus of the shot and not the background so you need a shallow depth of field.*

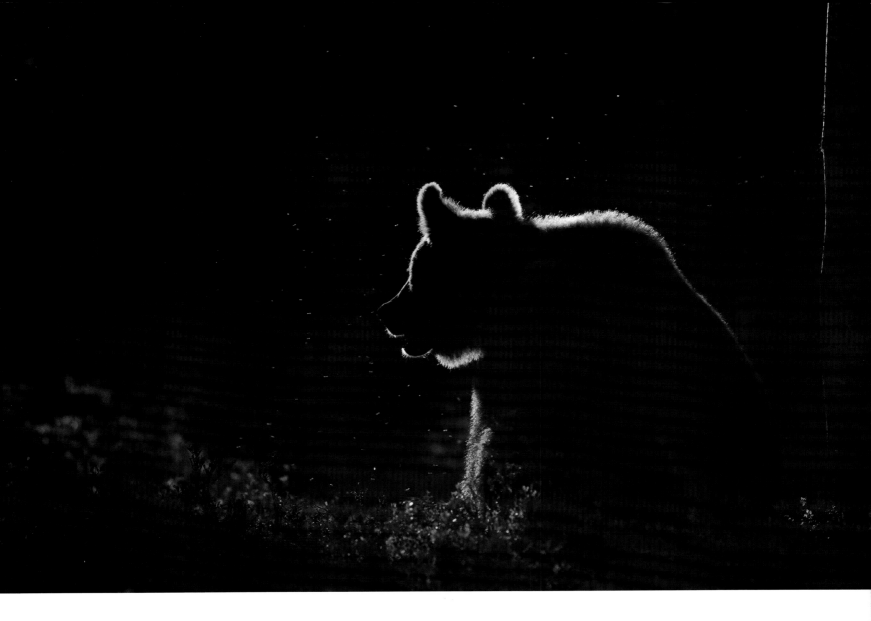

The atmospheric 'ring of fire'

The 'ring of fire' technique (also known locally as the 'Bradford curry'), is a great way to enhance the mood and atmosphere of a shot when you have a subject with fur (or one having a bad hair day). The obvious idea would seem to be to shoot straight into the light but this is a mistake as it causes too much lens flare and spoils the clean look and mood of the shot. The best angle to take is slightly offset to one side, just enough to keep the 'ring of fire' while avoiding lens flare. This technique only works when the sun is low and earlier, in the 'Red5' portfolio, you may remember the cheetah, deer and hyena which used a similar style.

Whilst locked inside a small wooden box overnight in a Finnish forest, I took the above image of a European brown bear. It was taken in the last rays of the setting sun and I have always loved the atmosphere and peaceful mood that this creates. The fact that the bear is sitting and relaxed assists the mood and feeling of the image.

When in the field, you often have a choice of backlight or front light; I will generally choose backlight to give the shot a greater sense of place and moment despite the fact that detail from the habitat is missing. When I approached the langur monkey (left) in India the light was far too harsh from a conventional viewpoint, but from behind it has this evocative 'ring of fire'. It would have been a crime to cut the tail off so I chose a vertical composition which I felt did the most justice to the animal and gave some much-needed space.

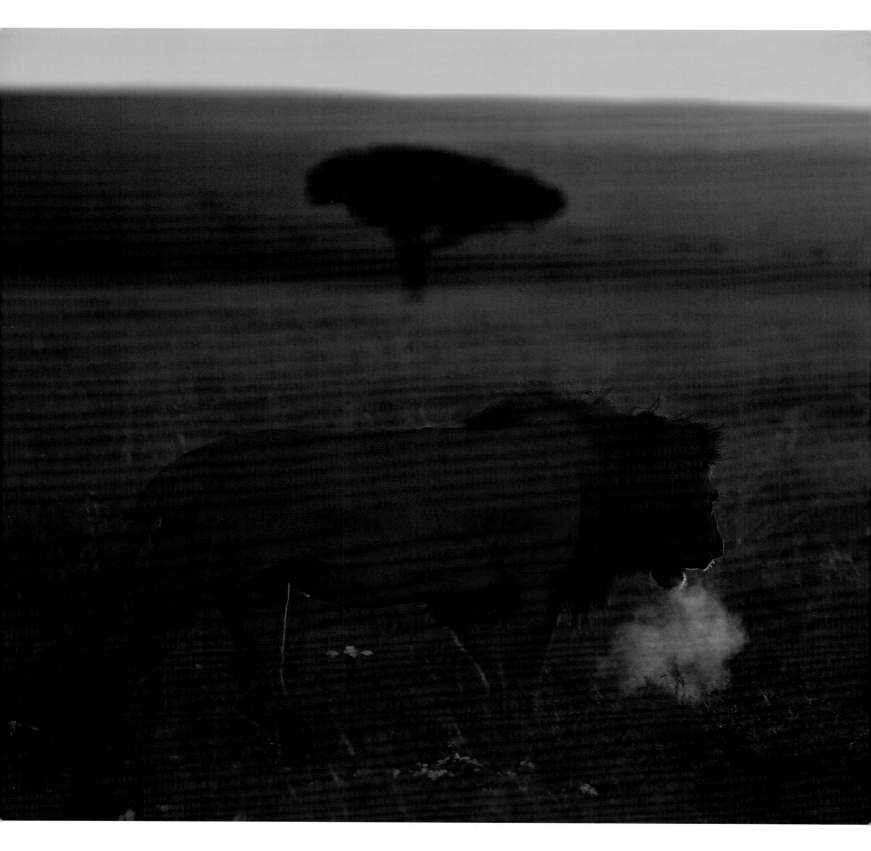

Instinctively, I took this shot so that the lion seems to be walking into the picture, a composition that has commercial as well as aesthetic advantages. Editorial and advertising clients like to have space in which to add some text and this can be the difference between getting a major sale or not. It seems a shame, I know, to bring such a beautiful shot down to this level but I it is a completely different game when it is also your livelihood, and one which is so precarious.

A cold morning

Partial 'rings of fire' (or shooting slightly backlit) can also provide you with different advantages. By now, you will have understood that I am obsessed by Red5 light and that, for my photography, these are the defining minutes of the day. There have been occasions when I have taken one or two pictures during this time and nothing for the rest of the day, because it was only during those magical five minutes that, for me, the light was good enough. To other photographers this may seem strange, as a group we naturally want to snap at anything that moves; but I have taken a lot of photographs in my time and today I am really trying to say something special with each and every image that I take. If I am not fortunate enough to find amazing light, extraordinary behaviour or just simple beauty to inspire me, then I switch the camera off and just enjoy watching wildlife for what it is. My passion for seeing animals in their natural habitat has only increased over the years and just because I don't feel inspired to photograph it, doesn't mean that it isn't amazing to watch and enjoy. This is an important point for any wildlife photographer to remember: wildlife first, photography second.

In the Masai Mara a couple of years ago we were out just before dawn trying to see what was moving and, if my luck was in, to get a Red5 shot. A male lion was wandering across the plains and caught my attention. Like all male lions he had arrogance about him but as he got closer I could see that he was an old guy and panting heavily with exertion. His breath condensing in the cold air fired my imagination immediately as it was golden in the morning light; quickly we manoeuvered the vehicle into position so he would walk slightly in front of us. The result is one of my best lion shots to date, and one of only five images that I shot that day. The only change I would make to this, if I had my chance again, would be to recompose without the tree in the background, although part of me likes this as it gives the picture some depth and sense of place. Had this image not been shot backlit you wouldn't be able to see the lion's breath and it would have ended up being another boring lion portrait and, let's face it, anyone can do that.

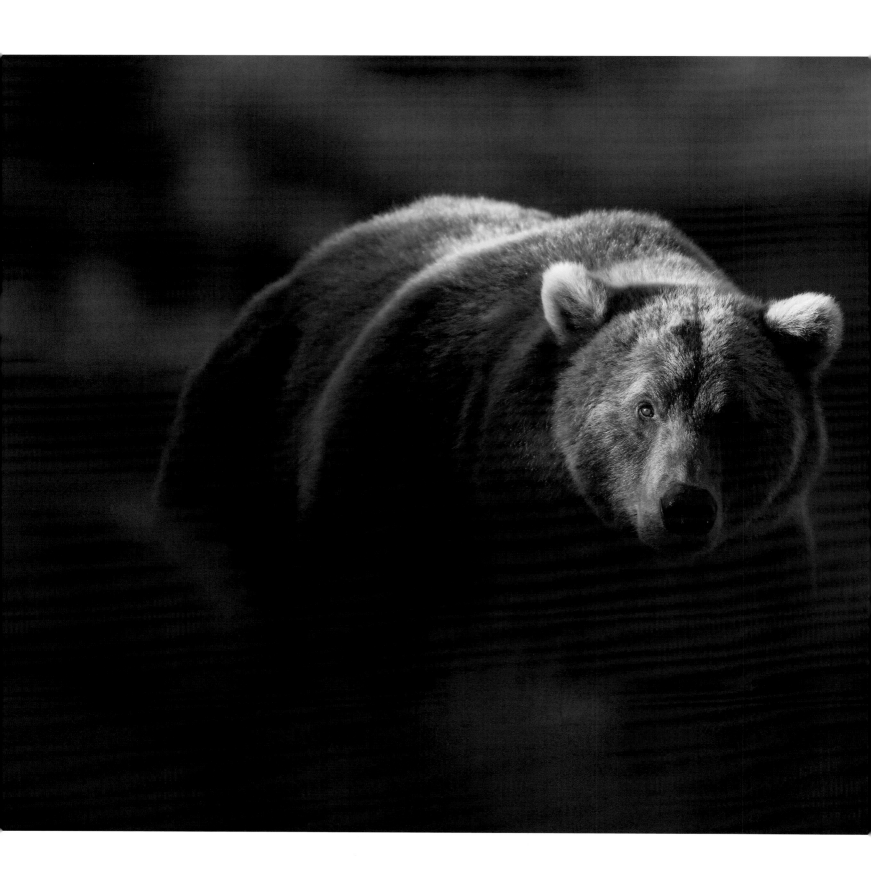

Raking sidelight

Meet Ursula, the most photographed grizzly in the Rouse archive. Taken late one September afternoon in autumnal light, she was following the meandering path of the river glancing from time to time into its depths for any sign of a migrating salmon or two. Through the viewfinder I could see the breathtaking sidelight, and after a minute or so I could just see the top of her ear as she started to come into view. I allowed her to wander into the centre of the viewfinder before taking the shot that you see here, that way I was assured of the strong sidelight catching the eyes and the side of the face. Three pictures later I was finished and gradually raised my head to watch her pass slowly beneath us with the subtlest of side-glances before carrying on up river. The exhilaration of getting so close to such an impressive animal in its own habitat is one that never fades for me. Grizzlies evoke great sentiments and are seen as spiritual animals and being allowed to share even brief moments in their lives is something I find highly addictive.

I have always loved this image because it really bends the light to create an image with real atmosphere and drama. Using raking sidelight in this way is a great technique for creating atmosphere in an image, as it can really add something special and evoke a more emotional response in the viewer. Of course, it breaks a lot of the traditional rules of composition: for example, you can't see the feet, but that is entirely deliberate. It is not a 'for the record' shot of a grizzly bear (where every detail needs to be visible) but instead an atmospheric shot that is meant to trigger emotions; therefore it is the interaction of the bear with the light that tells the story and nothing else.

I could not lie flat on the ground for safety reasons but wanted to get a low angle for this shot. Putting my tripod to its lowest setting and attaching an eye-level finder to the viewfinder allowed me to get the camera a little lower while remaining on my feet, a back-breaking yet necessary compromise.

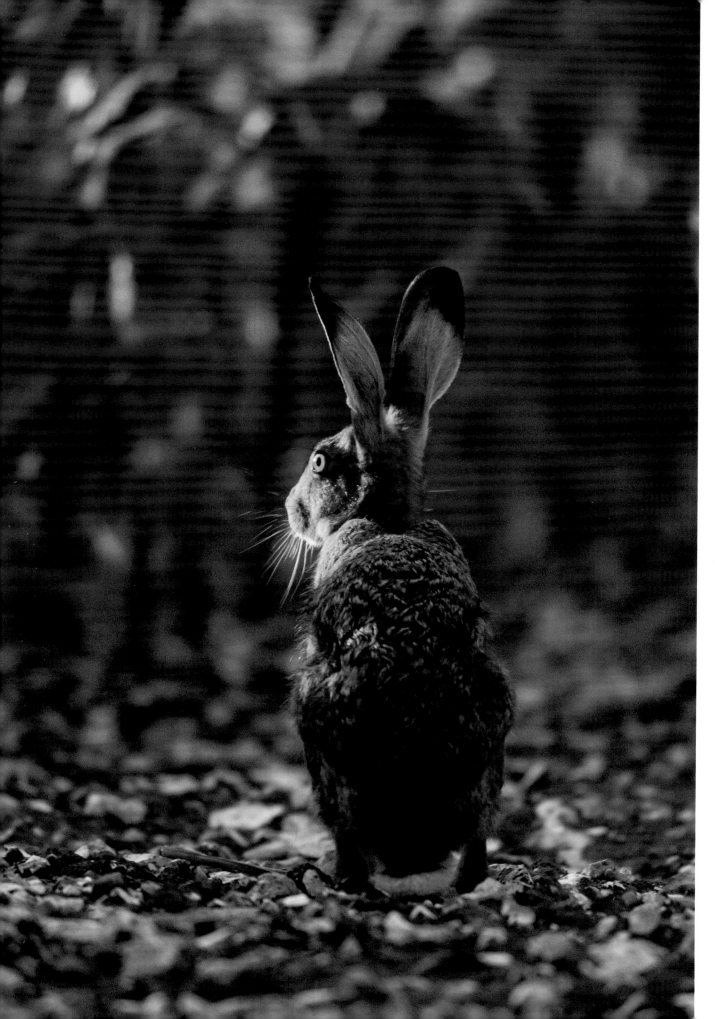

In the days when this hare image was taken I used a 600mm lens which sometimes seemed like overkill; but I am glad I had it for this shot as the composition is just about right. The framing gives the impression of the animal's habitat and shows a little of the light hitting the top of the maize. Whilst you may not consciously recognise this, because your eye will be drawn to the hare, your subconscious will register it and it adds significantly to the overall impression.

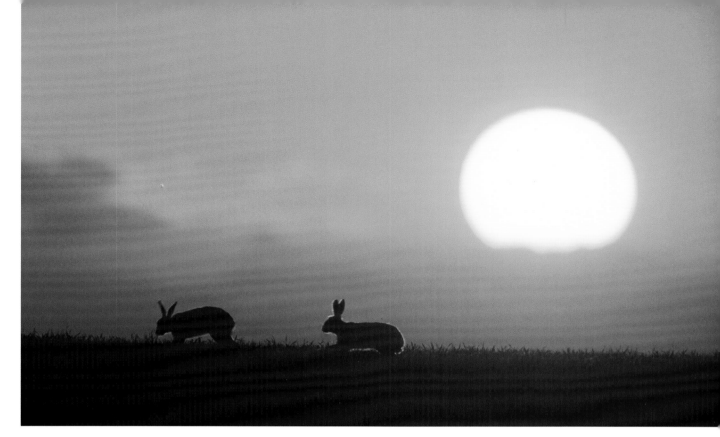

Taken on the fields *across from my house, the low winter sun and the low angle of the shot combine to make this a very different hare image from that shown opposite. I often use my 4x4 for getting close to animals like this as they are used to the local farm vehicles and provided I cover up my window with some netting they should not be overly alarmed by the smiling presence inside.*

Elusive hares

One of the first shots I ever took of a brown hare in Britain and I think still one of my favourites. The shot works because the strong side light turns a very ordinary hare portrait into something more…

I had been told by a local gamekeeper that a group of hares emerged every night from a maize crop to feed on the kale nearby. Hares have incredibly well developed senses of smell and sight, so the only way I could get near was to put up a hide in the hedge that bordered the field. Setting up a hide may seem like a simple task but it does take some planning. Firstly, you have to work out where to put it in relation to the light that you want, and this means watching from afar through some decent binoculars at the same time of day as you plan to be photographing. You need to site the hide in a way that no suspicious eyes can see you entering or leaving it and then, after setting it up, leave it for several days so it becomes an accepted part of the scenery. I did this to the letter, burying the hide in the hedge and covering the front with branches which broke up the man-made shape; I cut a path through the crop behind and wrapped a plastic bag around the barbed wire fence I had to climb over to protect my privates. A week passed before I revisited it, hoping that the crop hadn't grown so much that I couldn't find it again!

I got into the hide on the first day about three hours before I estimated the hares would emerge. It was a boiling hot day and hares, hating the heat, would be hunkered down in the natural air conditioning of the maize crop. A few hours passed and just when I thought that the hares were having an impromptu sleep-over, I detected the twitch of ears in the maize which instantly demanded my attention. Out bounced a hare, then another and another, followed by a youngster. Most dispersed out of my view but one adult came slowly up to feed near to the hide and I didn't move an inch; I had my lens poking out of the hide and the hare knew that something was different. One mistake now and that hare would be too suspicious to come close again and all that work would have been in vain, so I made the decision to wait rather than grabbing the shot. The hare continued feeding and slowly, oh so slowly, I edged the lens round to the right position, stopping whenever the head was up and only moving when the hare was busy munching. When the hare looked up again its eyes caught the strong side light from the setting sun, I needed no more encouragement and took my shot – just the one, then I froze, hardly daring even to breathe. Shy mammals like hares are incredibly suspicious and you have both give them respect and exercise enormous restraint when photographing them; I always work one shot at a time – but if you are careful that's all you need.

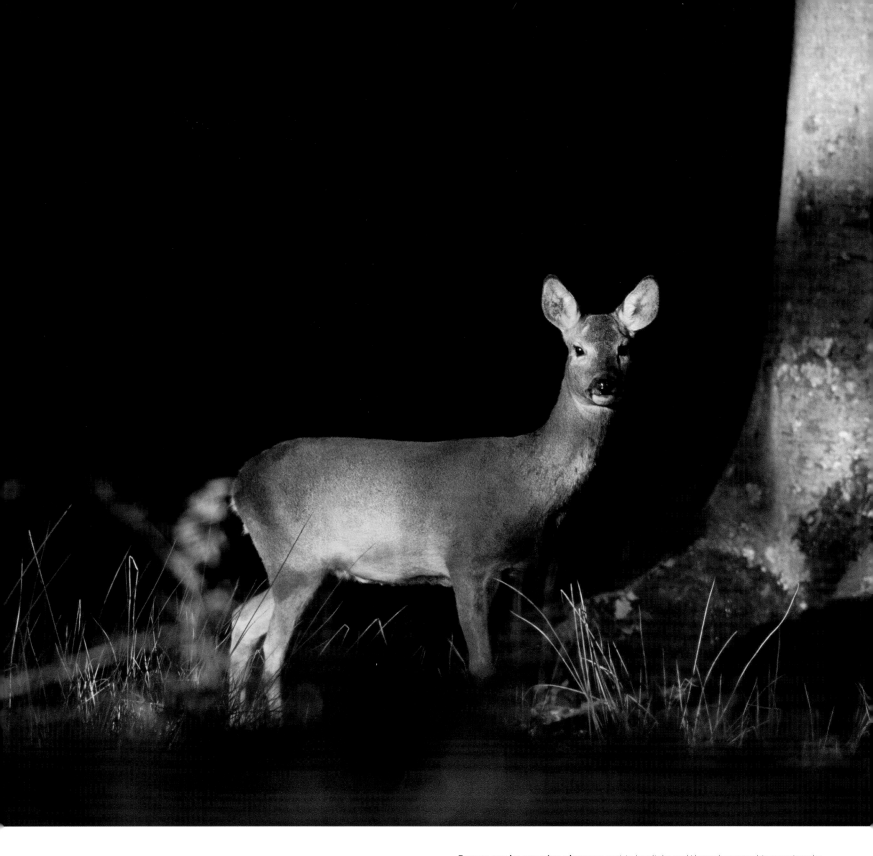

Forests can be amazing places to work in low light and I love photographing against the dark shadows. I took this roe deer after finding a forest track with lots of fresh and interesting 'slots' – the name for deer footprints – which indicated that it was a regular route. All I had to do was to sit and wait for something to use it. Concealing myself in a bush and dressed head to foot in camouflage gear, I waited. Waiting is not boring and I really love this time with nature, when I can be alone with my thoughts. For the first few minutes I am a stranger and the forest is deathly quiet, but gradually my presence is accepted and it comes alive again. Getting a shot like this is just a bonus.

The old black background trick

One way to really enhance mood is to shoot against a dark background. Studio photographers use a black background to absorb stray flashlight and create a sense of depth in their shots. Nature's black backgrounds are slightly different; they may be anything from the dense shadows in a forest late on a summer's afternoon to the intense threat of an approaching thunderstorm. Using black backgrounds creates contrast, makes the subject stand out more, and creates an impression of last light; in other words it adds atmosphere and helps to set the scene. I know that my work challenges what a lot of people think is the norm in wildlife photography; sure I take Just Plain Beautiful shots in straight light, but what I really love to take are shots that push the boundaries of photographic and artistic tolerance. Using dark backgrounds to accentuate mood is just one of the ways in which I like to stretch the boundaries, personally I think they look dead cool.

This fox visited the same garden *every night; I knew this because the garden was mine! For a few weeks I placed food in this spot, I knew that the final shaft of light from the setting sun would hit here. Although I couldn't dictate exactly where or when the light would be right, the one thing in this situation that I could manipulate was where the fox was likely to go. The background to the image was a hedge, which I knew would appear black against the intense warm light on the fox. All I had to do was to wait for the fox to play my game. One evening in the late autumn sun both the light and the fox were present in the same shot at the same moment! I love working with autumnal light, it has a special quality and temperature all of its own and is especially suitable for this kind of warming effect.*

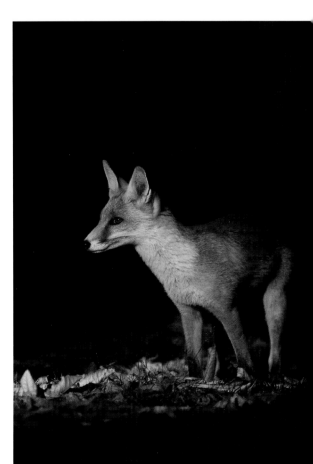

Black light

The same black background trick can be applied to water. Trees surround most lakes and rivers and the shadows they create give rise to areas of dark water; in certain cases they can be pure black and this is what I always try to look for. Using these areas for photography helps frame the subject, makes it stand out more from the background and gives a totally cool atmospheric effect.

This was one of a group of herring gulls that were diving around our boat; my friend Ole Martin had deliberately steered the boat into one of the areas of black water that Norwegian fjords are famous for. I love the challenge of photographing the moment of take off and capturing the bird as every muscle strains to pull it into the air. After watching the gulls for a few minutes I locked onto to one particularly active individual who was taking off and landing all the time. With the autofocus on single point and right between the eyes I waited until the gull erupted from the water before shooting; one time in five it worked and the result is what you see here. I love working with water as it not only adds drama to the take off but also acts as a natural reflector to give the underside of the gull some light. Of course the backlight and the black water make this picture, but personally it is the light through the wings that draws me to the image, together with the knowledge that this bird is doing something that I cannot and never will be able to do. Or not unless I strap some false wings to my back and leap off the end of a pier in front of a cheering audience who think that I am utterly mad. Which some days undoubtedly I am.

__Exposure for this kind of image__ is a nightmare; you have to strike a balance between keeping the water black and capturing the detail in the gull. In the end I settled for a spot meter reading from the gull, which I knew would under-expose the final image. This was corrected by less than a stop of positive exposure compensation, and once this was done I did not touch the exposure again or look at the LCD. I see so many shots that are missed by photographers watching the LCD when they should be shooting; you have plenty of time to look at the pictures after the shoot and you should not make decisions on deleting images in the heat of the moment. Practicing to ensure that you are technically proficient at the time is paramount. Only by keeping your eye on the action at all times and never getting distracted will you be able to seize the chance to turn a fleeting opportunity into a shot of which you can be proud.

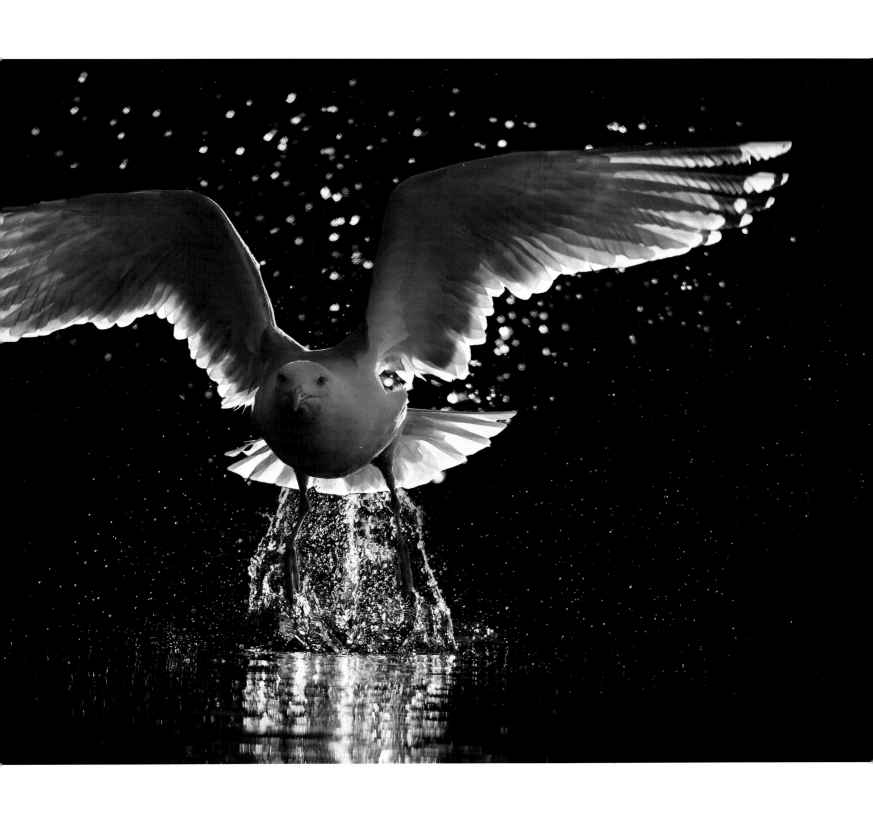

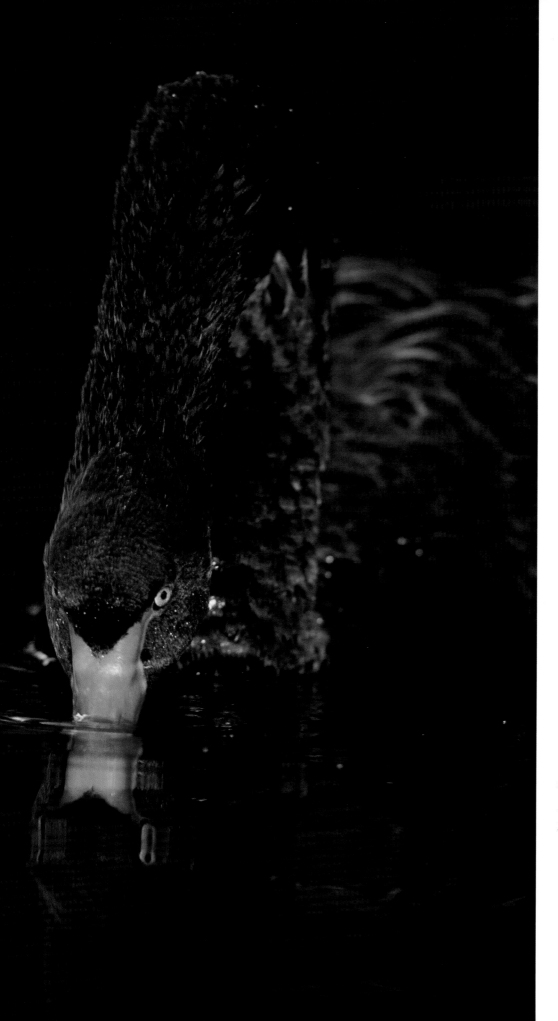

Black swan on black water. I wanted to create something very different to the familiar 'swan swimming on a lake' image, to emphasise the dark nature of the subject and to convey a feeling that contrasted with those fluffy, soft-focus white swans we are used to. Gradually, the swan moved into an area of intensely dark water and I had my chance to grab a few shots. This was back in the days of film, so I had no idea what the pictures would look like, but I guessed that they would be dark. To counter this I attached a tele-flash adaptor unit to my flash; this is basically a lens that fits over the end of the flash and increases not only the range but also the accuracy of the beam. The result is a totally different view of a swan reflection. It works because it is odd, if not a little sinister; clean-cut lines and colours give it something completely unique. Many people don't get it at first glance but then it suddenly dawns – gotcha! Remember, if your picture creates interest then it works!

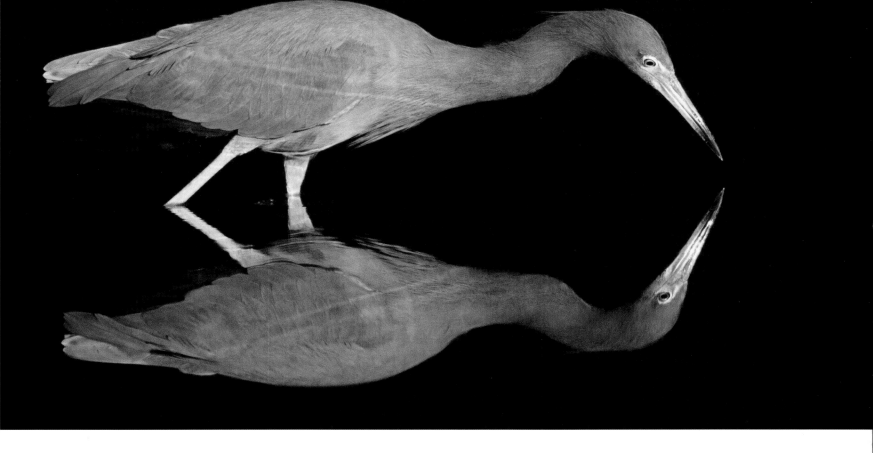

Black water reflections

Reflections fascinate all of us, and are perhaps one of the most photographed natural phenomena. But the reflections you see here are a bit different from the obvious ones we can all take. The black water, as seen with the gull on the previous page, creates mood but the reflection itself gives a very peaceful message. Reflections are never planned, they just happen, but there are a few tricks that you can use to maximise the effect when you see it. The first is not to shoot flat to the water; you need to be slightly higher than usual to get the best reflection of your subject, and, most importantly, do not cut the bottom off the reflection. This may sound obvious but in the heat of the moment it is very easy to do!

The merest breath of a breeze can ruin a good reflection. Usually, I find that the best time for reflections is in the morning and so I always check the weather forecast the night before, if there is going to be any wind at all then I find another subject to photograph. Situations like this shot of a little blue heron taken in the Everglades need perfect conditions to get a perfect reflection and also take split-second timing; once the heron moves the reflection is over.

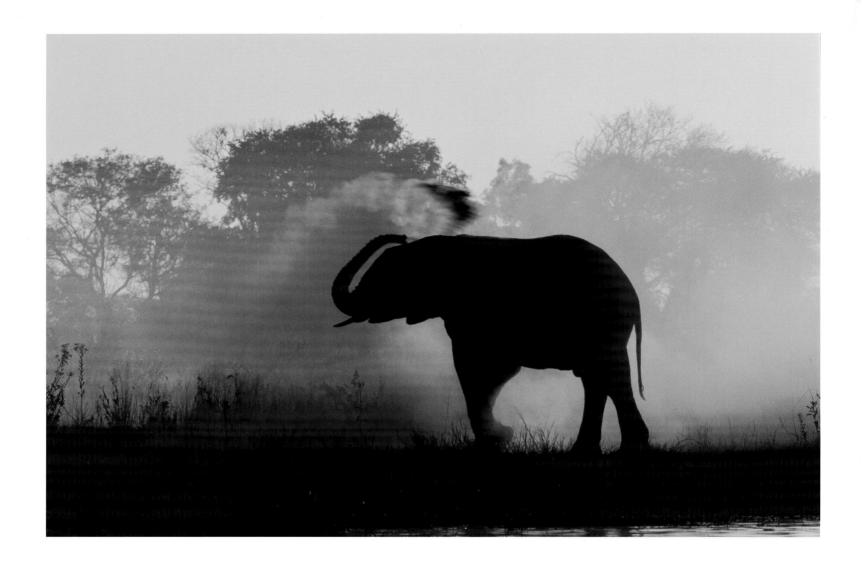

Stunning Silhouettes

This has been a very successful shot for me over the years and was one of many that I took in an amazing ten-minute period of frenetic activity. Two breeding herds of elephants had come down to drink at a river, stirring up the dust and creating an incredible spectacle in the setting sun. Trying to keep the silhouette clean-cut and simple, I waited until an elephant split from the herds, giving me the basic, familiar outline that you see here. Exposure for silhouettes is easy, you just point the camera at the brightest point in the scene, take a light reading and voila! you have a silhouette.

Shooting in silhouette is a great way to introduce atmosphere into any picture. A silhouette works because it uses the outline of an animal as the main focus of the shot; the body of the subject should be pure black without any detail. Seems strange, doesn't it, when we spend so much of our time as photographers trying to retain all the tiniest details in our images; but this is the antithesis of what we need for a silhouette. A silhouette works because it reduces the subject to its simplest form, the outline, and hides any blemishes, deformities or scars. The result is that whatever you are photographing stands out against the background, especially if you take it against a sunrise or sunset.

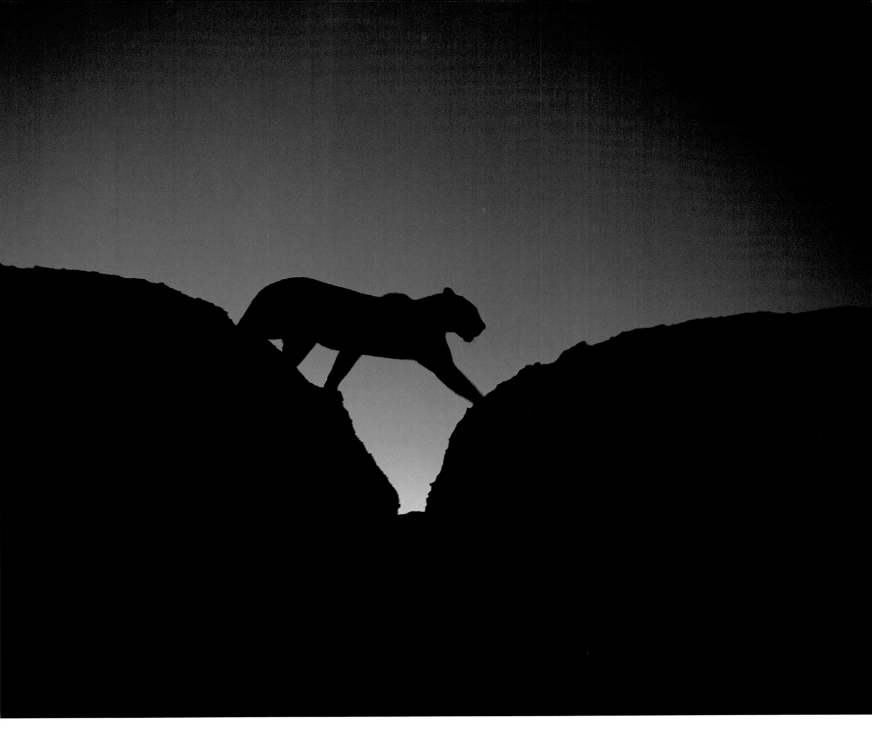

This leopard was taken against the twilight *as it crossed between two rocks; it had been a long day and I was about to quit when it showed up. That is what I love about wildlife photography, just when you are about to give up nature rewards you in some way. In this case it was with the briefest of sightings, but one whose beauty I can remember to this day. Since I was using the medium-format camera, timing was all-important and I waited until the leopard had placed its front foot on the rock before taking the shot.*

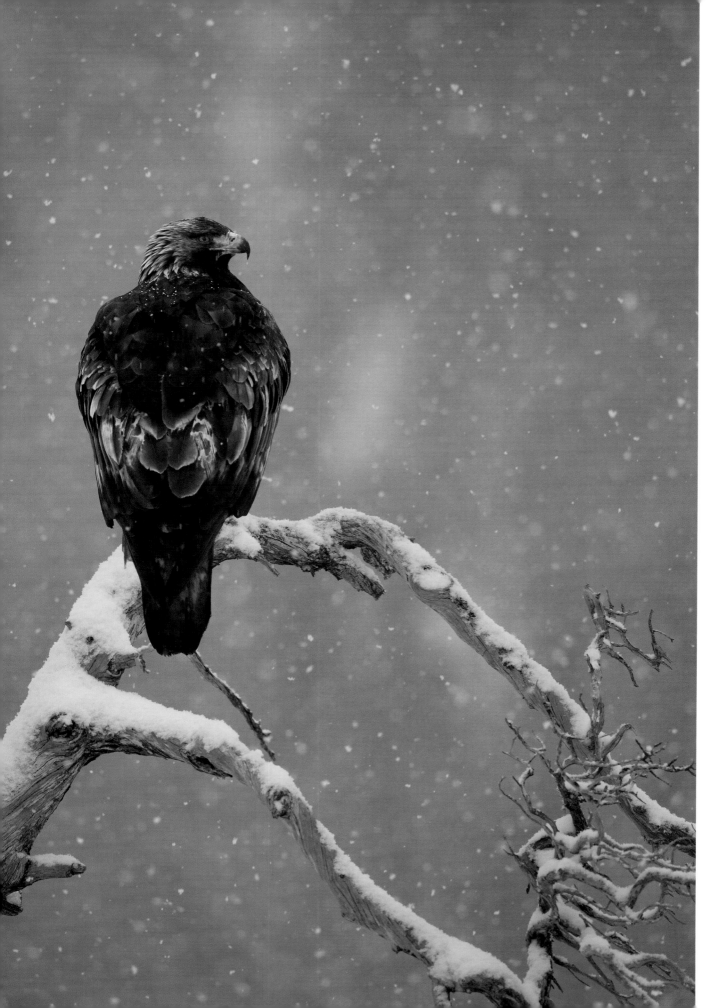

Sitting in a hide from five in the morning until five at night, hardly daring to move for fear of being heard and in temperatures as low as -20°C, requires some dedication. But the prize, to see a golden eagle in the wild, was worth almost any amount of suffering. A few minutes spent in the company of such a magnificent predator can fulfil a lifetime of dreams. I spent a total of five days waiting for this moment, and it came in the middle of a snowstorm when a male eagle perched directly in front of the hide. It was such a wonderful shot. I decided to give it some space and offset the composition rather than adding a tele-converter and needlessly filling the frame. I kept the shutter speed high, and therefore the aperture low, so that I could stop the motion of the falling snow and ensure that the background did not distract from the final image. Compositionally, this really works for me as the story is not solely about the eagle but illustrates the harshness of the environment in which it lives.

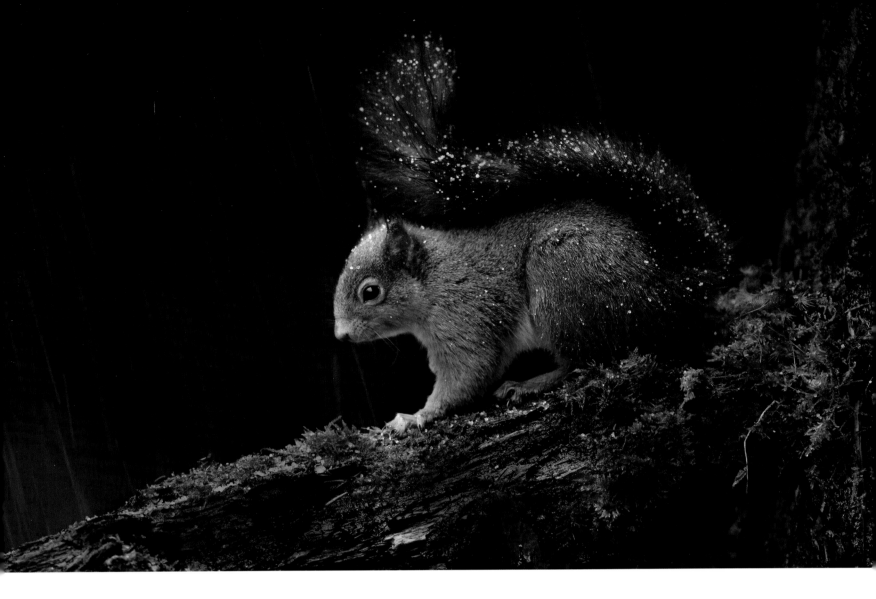

Extreme weather

The weather is something that none of us can control and it can be frustrating or it can be a blessing. I used to be a real sun-worshipper and would only photograph in sunlight or with a diffuse overcast sky, anything that would cast a shadow; you can tell that because a lot of the pictures in this book were taken in good light of some kind. One set of pictures which is a departure from this are those taken in the Falklands, South Georgia and Antarctica, where good weather is defined as anything that you can stand up in. Working in such an extreme climate taught me to use whatever weather I had at the time, which meant adapting my style and curbing my natural tendency to look for Red5 and atmospheric light; if it was there, I could use it, but if not, I had to find a different interpretation. I quickly learned to use the weather to tell a story, to depict hardship and struggle, to show cold, heat or driving wind. Gradually, I began to see that using weather in your images can add some real drama and atmosphere as well as depicting the real story of life in the wild.

Working alongside my good friend *and great photographer Keith, on his red squirrel feeding site, it had been a week of good but not great photographic opportunities. The promise of snow had failed to materialise and although I had the usual collection of picture postcard shots I was lacking what I then had come for. We moaned as it began to sleet, but, with the wind driving it down hard, I saw the shot I wanted straight away. I tried several combinations of shutter speed and inspected the result each time on the LCD screen; this is one positive use for the LCD screen. In the end I chose the one that gave a slight blur to the falling sleet. This image is again something a little different, highlighting the resilience of these little chaps who are out in all weathers.*

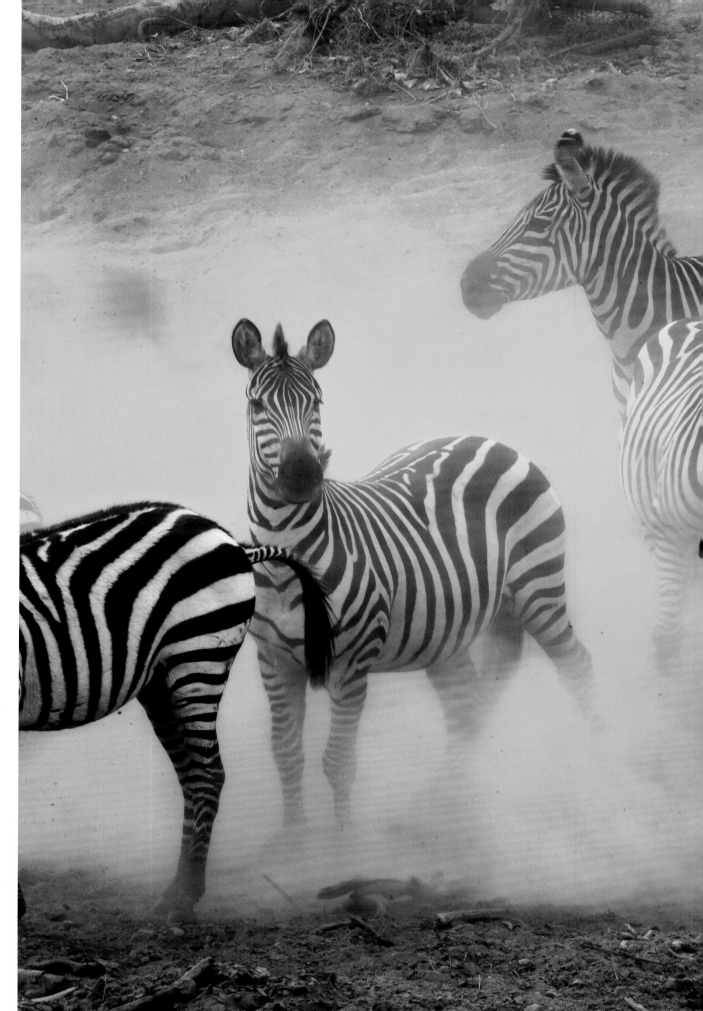

Dust clouds are a great way to create atmosphere as they add an element of drama to the shot. The best way to shoot them is slightly backlit, as you can see with this group of Burchell's zebra. One minute they were merrily running down towards the riverbank to cross when, suddenly, the leader saw something that it didn't like on the far side; a pair of lions waiting in ambush. The brakes came on and the family group all came to a screeching halt, creating the dust clouds that you see here. I think it adds a nice element to the shot; sure, I wish it was a little more edgy in Red5 light but I can only shoot what I see in front of me.

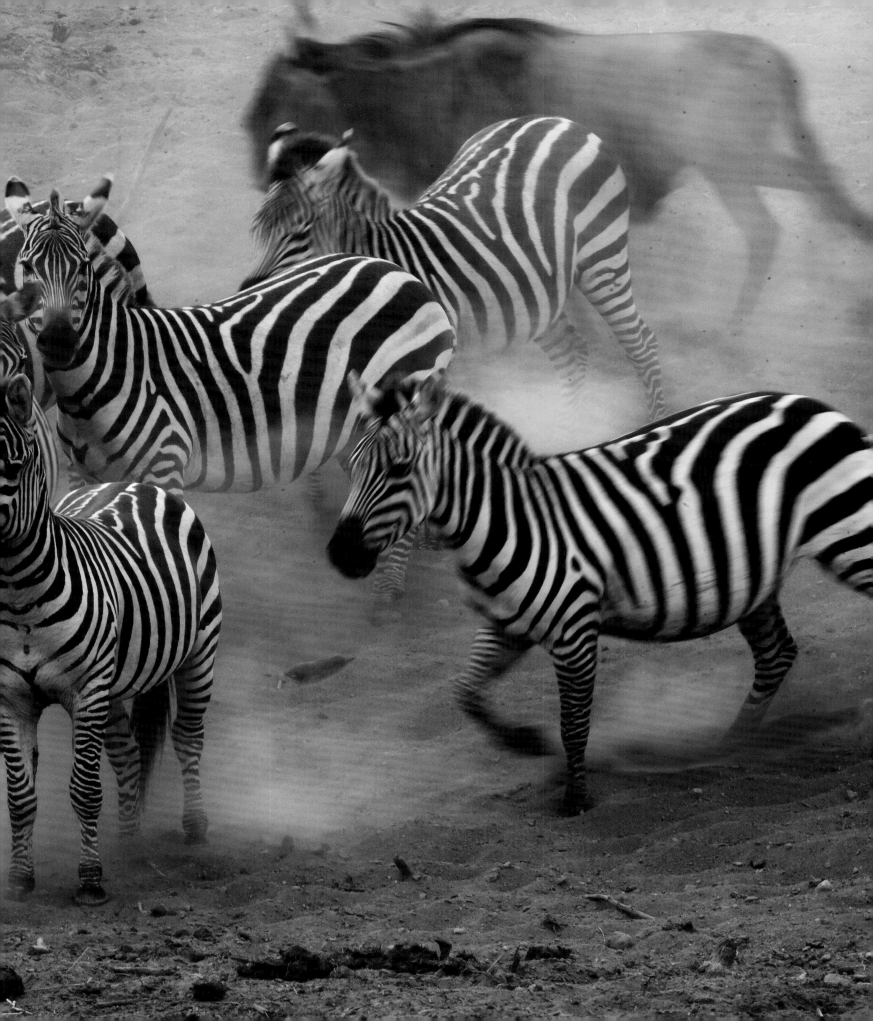

PREDATOR AND PREY

The natural world is complex, but put in its simplest form it is a daily struggle between life and death. There is an eternal battle between the hunter and the hunted and every second of every day this contest is being fought out from the smallest of organisms to the largest. The largest, such as elephants and whales, have few active predators in their natural world; their only real predator is mankind, who kills them for greed and in pursuit of mistaken beliefs.

Photographing the struggle for life can be a real challenge. Ultimately, I think a good set of pictures on this theme is comprised of three elements – a predator in the act of hunting, predator and prey together (showing the interaction between them) and the kill shot. I have seen photographers who glory in the kill shot and I believe this is a sad reflection of the human condition, how can you 'enjoy' something else's death. I have seen a lot of death whilst photographing the wild, and as an animal lover this can be very hard to stomach. However, in my opinion; one species' demise is another's gain. In reality nothing goes to waste and almost everything is a vital resource for something else. My job is to record nature at its most raw for others to appreciate, but sometimes it is very difficult for me to overcome the fact that I am a human being with caring emotions.

Being present for the moment of the kill is an exceptional piece of luck and trying to capture this critical moment may mean that you will miss a lot of other good photographic opportunities. An even more compelling version of a hunting shot is the prey's-eye-view of the predator; you may remember an earlier lion shot of mine that used this to good effect, as I was the intended prey. Here is a much more menacing shot of a lion, taken just a few weeks before starting this book. The menace and power is there for anyone to see, and just take a look at the muscles in the back and the way that the lioness is tensed ready to spring. The difference between this image and that earlier one is that this one has been thought out rather than just being taken; it has an element of composition on the leading diagonal and also includes the habitat. It is not in Red5 light, but I think that the murderous look on the face of the lioness more than makes up for that; in fact this was one of only two occasions when I have been nervous enough of a lion's intentions to move away rather rapidly. There is absolutely no doubt in my mind that she meant this. You know, everything happens for a reason and in this case it was not the mouth-watering sight of me that caused this reaction, it was the fact that she had two newborn cubs hidden from view, something we didn't know at the time. Mothers are always protective of their young and you can't blame her for wanting to kill me, some days I'd kill me too.

You might wonder what this lion is doing in a tree, as lions are predators of the plains. During the middle of the day it can get incredibly hot on the plains, uncomfortably so, and so certain prides of lions have learned that by climbing trees they can hang about in a cooling breeze. Leopards use the same trick and I have photographed them countless times sleeping away the afternoon heat, only stirring when the temperature cools as the sun goes down.

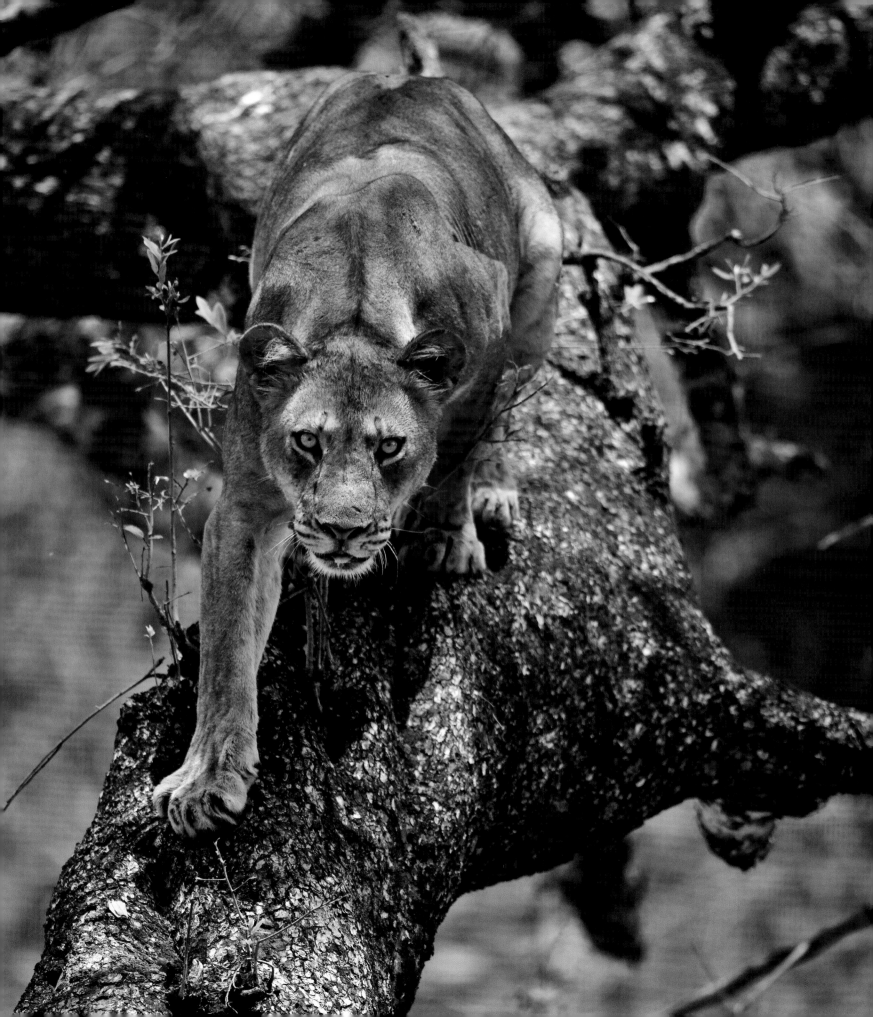

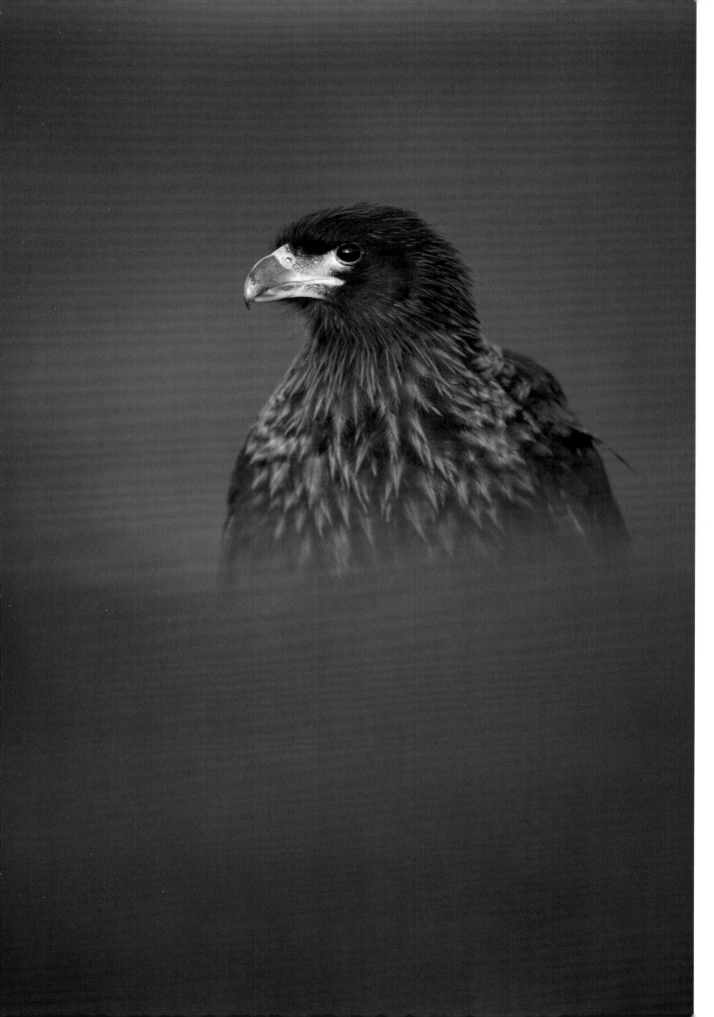

Opposite: **It is a gruesome image** *but tells and important story. Please don't turn the page but instead sit and ponder it for a while.*

This is a good candidate *for the 'Just Plain Beautiful' portfolio. The caracara has all the classic ingredients for a great portrait: a diffuse background and foreground, a razor-sharp subject and a very simple composition. Since caracaras are curious and highly intelligent birds they will stalk anything and it is easy to get this kind of image. I played dead in the fireweed and one came to investigate within minutes. The crux of wildlife photography is about knowing animal behaviour and, believe it or not, no amount of technical wizardry would have got me this shot otherwise.*

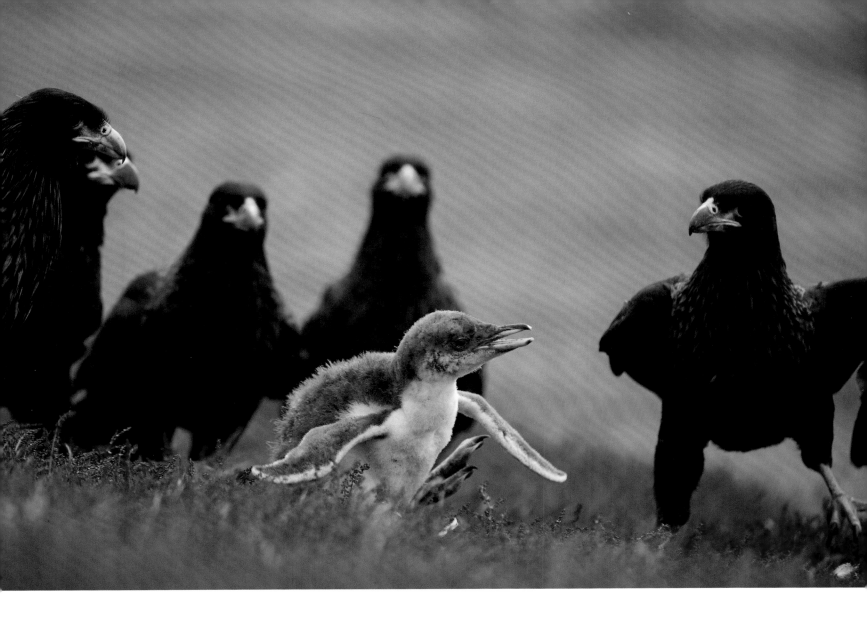

Food for thought

In the left-hand image this striated caracara looks elegant in the fireweed, but take a look at the one above and see how the mood has changed. This serves as a graphic illustration of how a predator can be a real Jekyll and Hyde for the wildlife photographer; viewed as beautiful one minute and a killer the next.

The morning I took this shot I remember walking past the gentoo penguin colony and thinking that one of the youngsters was a little bit too close to the edge and looking rather vulnerable. When I returned a few hours later I saw the chick wandering away from the colony. Sadly for the chick, mine was not the only pair of eyes watching it. Within moments striated caracaras surrounded it and from that point on there was only going to be one outcome. In the days after this image did so well in the BBC Wildlife Photographer of the Year competition,

many people asked me why I didn't do something to stop it, like taking the chick back to the colony for example? My view is simple, the caracaras also have young to feed and who am I to decide who lives and who dies? The caracara had as much right to live as the penguin chick and it was up to fate to decide who would survive to see another day. It is my firm belief that we interfere too much in the natural world; it has managed for millions of generations without our input and nature always has a way of balancing itself out. My ethics have never allowed me to interfere and never will, but it doesn't mean that I don't care. For an hour after the chick was killed I sobbed my heart out and was inconsolable and a strange dark mood descended on me for a few days afterwards. As photographers, it is our emotions that govern how we record what we see, but I wish that I hadn't seen that.

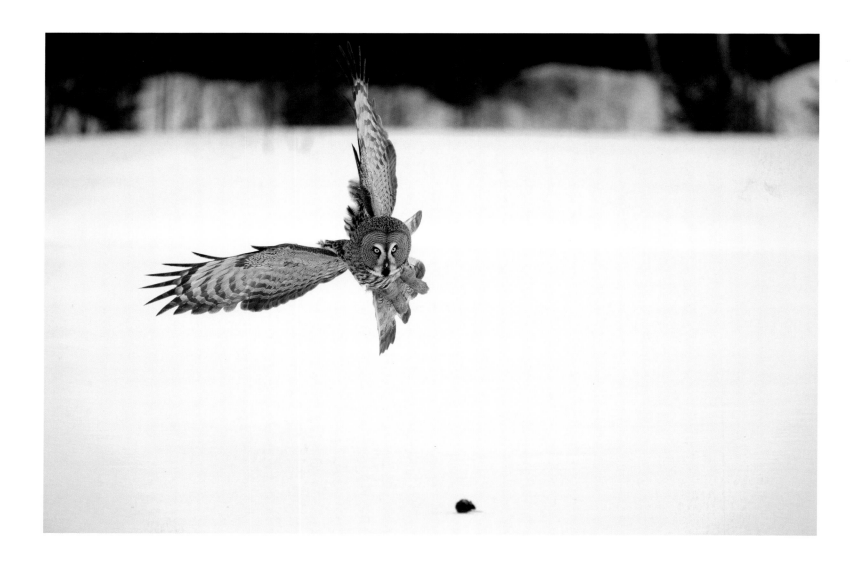

The silent hunter

Great grey owls are very special birds for European photographers as they always manage to look great in photographs, no matter what the light or situation. All owls look good but very few actually let you into their world like the great grey and share their struggle for life with you. One of the main reasons you can do this is because, like the short-eared owl, they are diurnal and hunt in daylight.

This owl waited on the forest edge for several hours without moving, scanning the field for a telltale sign of its next meal. Just as I thought my hands would fall off with the cold, the owl suddenly twisted its head and stared halfway across the field. Their hearing and

eyesight are amazing and I did not waste any time looking for the object of its attention, it had a much better view than I did and I knew it had seen something interesting. Off the perch it came, swooping down in a long steady glide to the field.

The right-hand image shows that you don't need to be a Trigger Happy Trevor to get the best shots. Cameras that sound like machine guns don't belong in the world of wildlife and whilst it might seem like these cameras will always get the shot for you, there is no substitute for timing. In this shot the owl's talons are millimetres from the mouse and the mouse itself is still oblivious; the sequence was taken with a

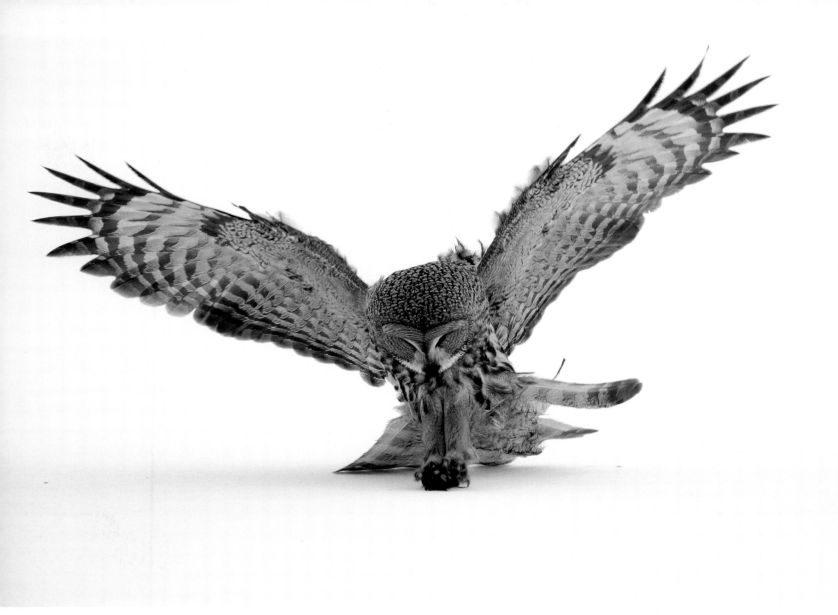

1DS MKII which shoots at two frames per second. The strike picture was therefore a one-shot deal. The other vital lesson to learn here is that it is easy to get distracted and miss the action. Staying mentally focused on what you are doing, ignoring everything and everyone else around you and staying in your own little world is important for a good wildlife photographer. I was in my own zone when taking these images. I was only interested in the world through the viewfinder for those few seconds of my life.

During the swoop *I had the owl squarely in the centre of my viewfinder, servo/tracking autofocus set, centre point locked onto the head, exposure set for a fast shutter speed. A meter reading was taken from the snow as I knew that the exposure would go haywire when the bird was on the move from the dark background it was sitting in. As a rule of thumb, I over-expose by 2/3 of a stop when it is cloudy and as much as two stops when the sun is out. Then I take this reading, select manual mode, dial it in and forget about it unless the conditions change. Preparation is everything.*

Below: **A lean, mean, killing machine;** *what a truly magnificent predator and one that has stood the test of time. I have rarely had the chance to get this close to a Nile crocodile but this guy was sleeping as we approached and seemed unusually chilled with our presence. I tried lots of different compositional ideas and in the end settled for this slightly off-centre one, with a large depth of field to get everything sharp. For me, that green eye is something from another time, when dinosaurs ruled the Earth.*

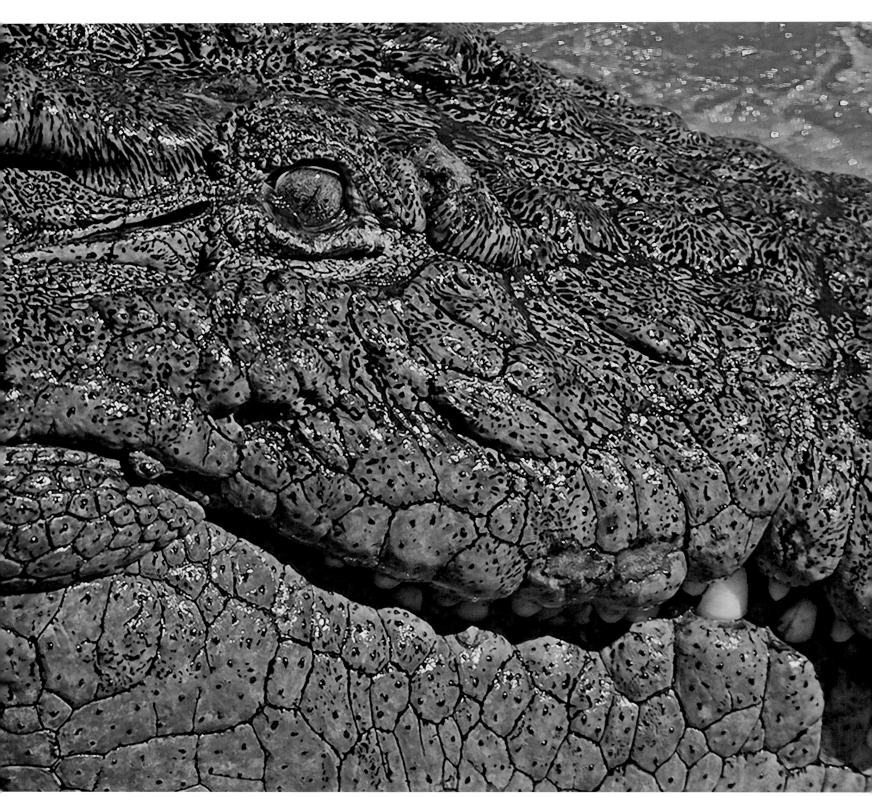

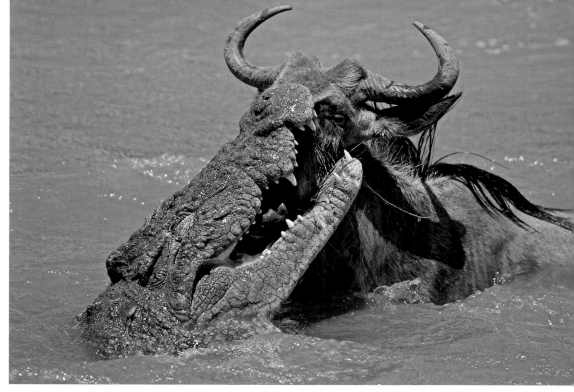

Migration crossing

An experience that will haunt me forever is the first time I saw a wildebeest taken by a Nile crocodile. Each year the annual wildebeest migration reaches the raging waters of the Mara River, graveyard for generations of wildebeest and the home of the immense Nile crocodile. Silently the crocodiles lurk as the wildebeest cross, ignoring the masses and targeting those travelling as family groups who are the most vulnerable. The scene, as a crocodile closed in on one group, seemed to run in slow motion and the wildebeest, being mid-channel, could do little about it. I could see the terror on their faces as the crocodile slipped underneath the water and they surged forwards in a last, fruitless attempt at escape, but to no avail. Erupting from the water, the crocodile took hold of the wildebeest, grabbing it by the snout in a vice-like grip. Slowly they both disappeared below the water's surface; the wildebeest calling until its final seconds of life. Through the lens I could see its eyes wide open in terror but it was the noise that it made, and the sudden way that it ceased, that will live in my thoughts forever. It was an incredible sight and one that epitomises the cycle of life in all its gory detail.

Top: **This is a weird image** as time appears to be frozen still. It is the eye of the wildebeest, though, that gives the game away, it is clearly terrified, and more than any image in this chapter highlights the relationship and struggle between predator and prey. It was horrible light, right in the middle of the day, but in situations like this it doesn't matter as it is getting the shot in the first place that counts.

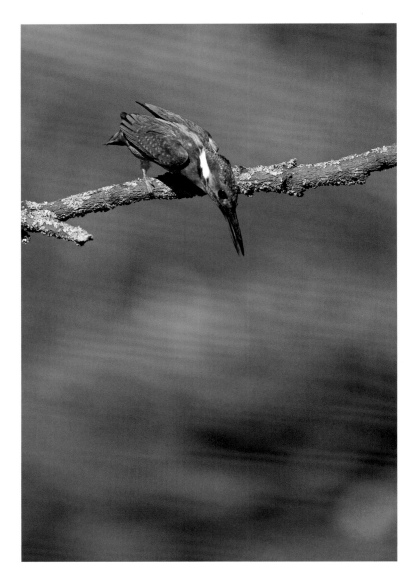
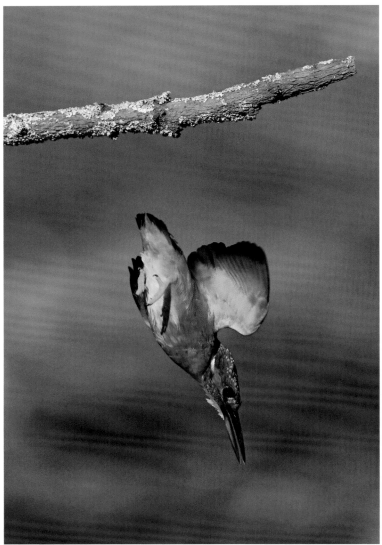

Just gone fishing!

A kingfisher's dive is like lightning. *When they make their mind up to go they are off that perch in a flash. I quickly found that my main problem with photographing them was that, through the viewfinder, I was physically too slow pressing the shutter when they dived. I attached a remote release cord and pressed my face up against the hide window, concentrating totally on the kingfisher and watching its every move. If it flinched I took a shot, which meant a lot of wasted shots, but eventually I learned to spot the minute, telltale signs milliseconds before the dive. Proof, if it were needed, that practise makes perfect and understanding animal behaviour is the key to great wildlife photography… that and luck!*

Watching kingfishers hunting is great fun; once they spot something in the water below, they dance backwards and forwards along the branch trying to get in the best position. When they go, they go, hitting the water like a blue rocket and usually emerging with a fish struggling in their beaks. I used to watch from my hide as they erupted from the water and wondered how on earth I could capture that without the need for specialist equipment. It was a challenge and one that I readily took on. Challenging yourself is important to developing your photography and can be the catalyst in the process of improving your skills. I believe that one of the trademarks of a good photographer is the ability to solve problems and to improvise. I sat in the hide and thought…and thought….and thought. After a few weeks of experimentation I finally worked out how to do it and my favourite image from the sequence is the one opposite. Overall, I took over 1200 shots of the kingfisher diving and only 32 had a recognisable part of a kingfisher in them; a handful had the whole thing; this was by far the best.

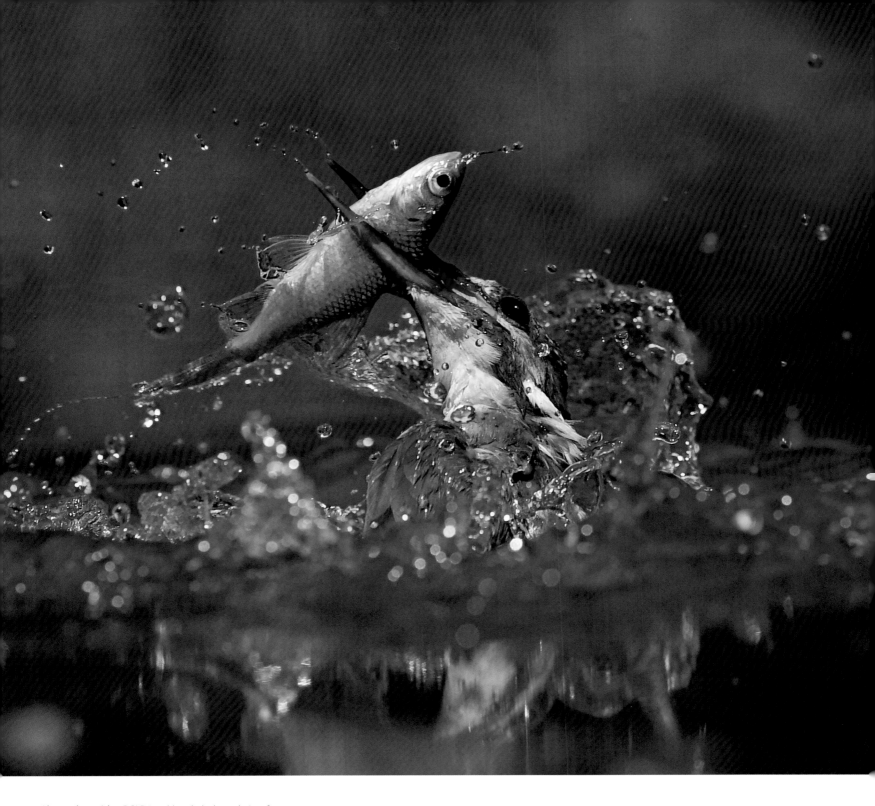

I knew that with a DSLR I could push the boundaries of exposure by under-exposing by two stops to get an extra two stops of shutter speed; combine this with ISO 400, and on a very bright sunny day, I could get 1/8000th second. Admittedly, the RAWs had blocked shadows and needed a lot of post-processing to make them printable, but I was more interested in proving that it could be done with normal equipment than anything involving technical parameters. Photography is an art form and not just a series of numbers.

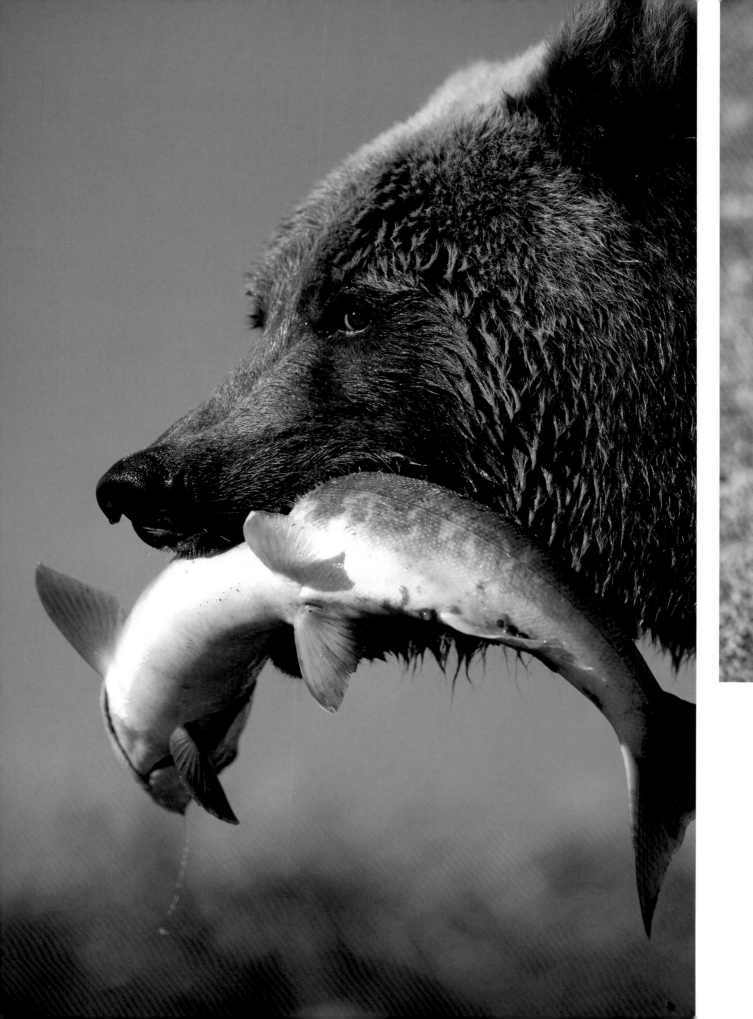

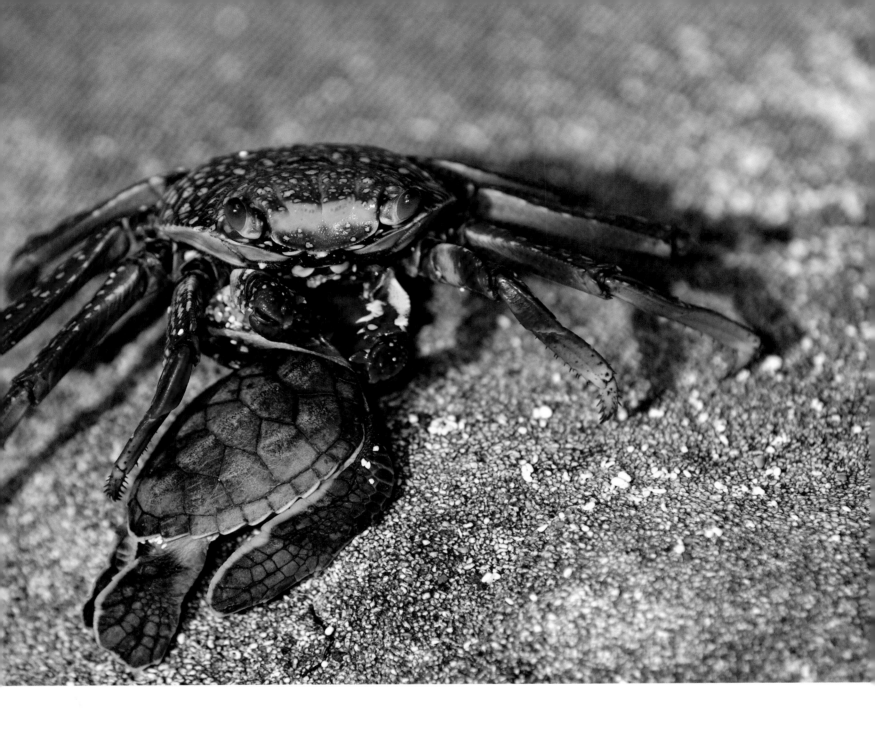

A difference in scale

Showing a predator with its prey is an essential part of the natural life story. It uniquely defines the relationship between the creatures and can also cause some surprise; who would expect a crab to eat baby turtles?

This is a bear called Nemo, *a really laidback female who could give fishing lessons to the best in the world. Her technique was to watch intently from the side of the river then suddenly dive in and invariably come up with a silver salmon struggling in her jaws. Once when I was watching, she emerged from the water and was immediately challenged by a larger bear. She walked behind us, using us as a shield as she knew that the shyer male bear (who was obviously not a dominant chap) would not come near us. It was a beautiful picture to take as she came within feet of me. I love the watchful expression on her face – I just wish that the fish was facing the other way!*

It was quite a shock *to turn up to a turtle-hatching beach one morning to find the Sally-Lightfoot crabs scuttling around with dead turtle hatchlings in their jaws. I had seen them filter-feeding on the shoreline but had never imagined that they would prey on anything larger than that. To survive in the wild you have to be an opportunist and take whatever you can get.*

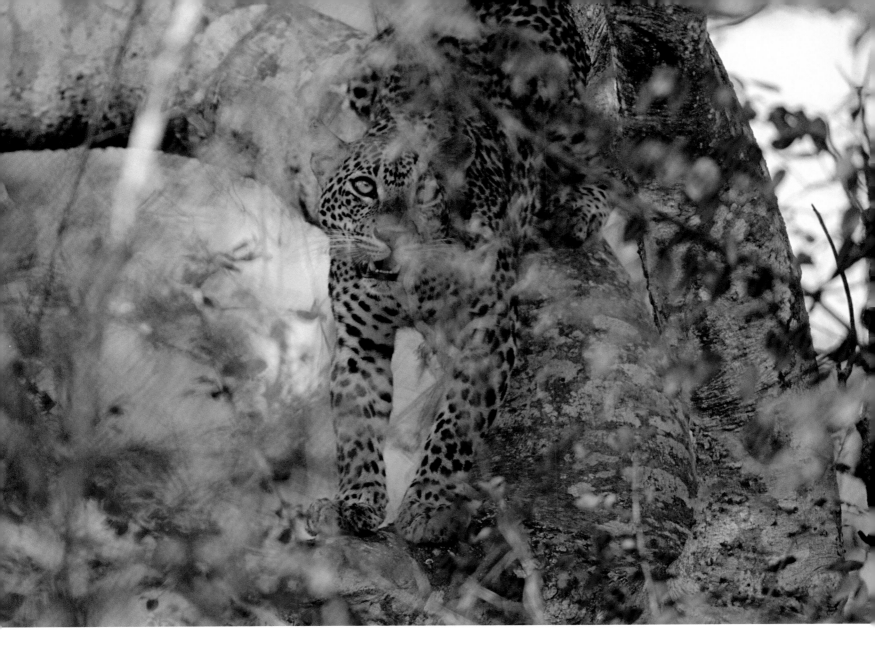

Camouflage

Natural camouflage allows a predator to sneak up on unwary prey or a potential meal to remain undetected right under the nose of a hungry predator. Photographing an animal that is camouflaged goes against everything that we naturally do as wildlife photographers – usually we are trying to show the animal, not hide it. Emphasising camouflage techniques requires a subtle approach and success does not always come easily since you have to find an animal that does not want to be found!

This is a leaf-tailed gecko from Madagascar; amazing isn't it? When it sits still against the tree it is almost impossible to detect. It has a great anti-predator trick of dropping its tail if physically moved. Moreover the detached tail keeps twitching to distract the predator whilst the gecko makes a hasty exit. Incredible. The only way to show the subtlety of the gecko's camouflage is to shoot in dull, overcast light without any flash. The story of this shot is to show how a predator would, or perhaps would not, see it.

I really love taking shots like this, as they often require a double-take. The leopard's spots render it nearly invisible as it stalks down the tree and the challenge for me was to find a tiny window in the foliage where I could see the eye clearly. The only way to do this was to turn off the autofocus and focus the lens manually.

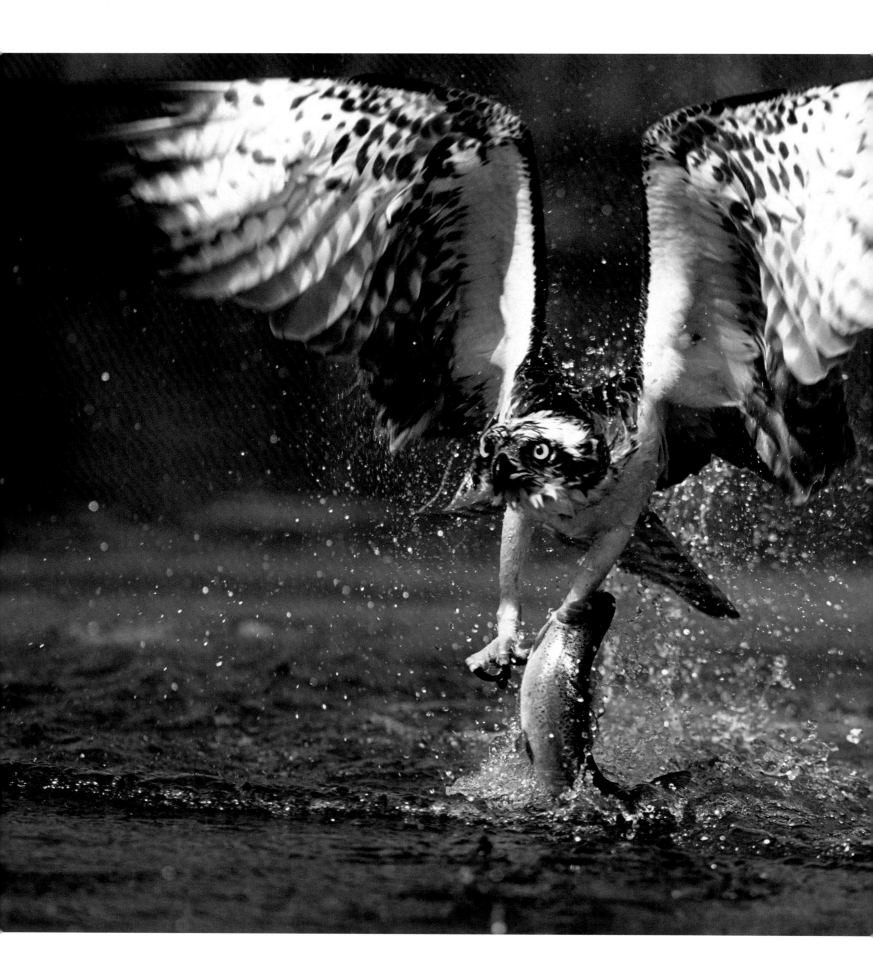

Heading up the driveway *of a big country house on the way to a meeting with the landowner, I was amazed to come across a sparrowhawk plucking a pigeon that it had just killed. As soon as it saw the car it flew up into the nearest tree and I seized the opportunity. I pulled the car in next to the pigeon so that it would mask me from the watching sparrowhawk, took a tent peg from the collection of junk behind my seat and rammed it straight through the pigeon's chest. Why did I do it? Well, all will become clear. I backed the car slowly away, parking at the maximum distance for my 500mm lens with a 1.4 x tele-converter, set up a beanbag in the open window and put up netting all around me to mask my shape. Then, I sat and waited…and waited…and waited. Eventually, the sparrowhawk came down and started plucking the pigeon again. The next thing that it did was to grab the pigeon and try to take off with it – but Aha! That is why I had staked it down because I knew it would do this. A few moments passed and then I started taking shots; this one was taken when the plucking stage was almost complete, hence all the feathers. About an hour later there was nothing left of the pigeon but my tent peg was still there. Everyone was happy – except that, as usual, I was horrendously late for a meeting.*

I wanted to show you this image *which I still think is one of the best that I have taken, even though it is a scene that may be quite familiar to you, an osprey pulling a fish from a lake. It was a good friend, Scottish professional Neil McIntyre, who inspired me to do this through his wonderful images. I love the way that the osprey hunts; it really goes for it. There's none of this grabbing stuff from the surface as many birds might do, oh no, the osprey powers into the water like a falling brick, creating an enormous splash. For a few seconds it looks completely dazed but then turns into the wind and erupts into the air, hopefully with a struggling trout or salmon in its talons.*

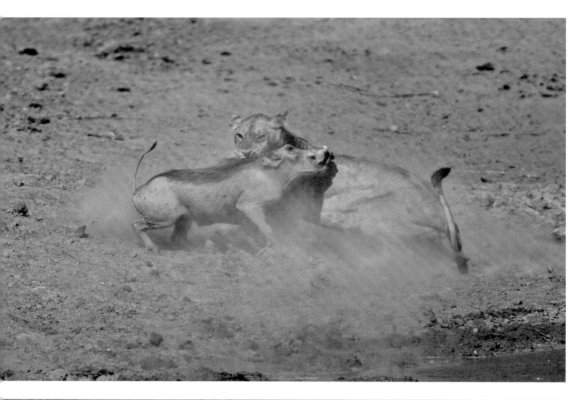

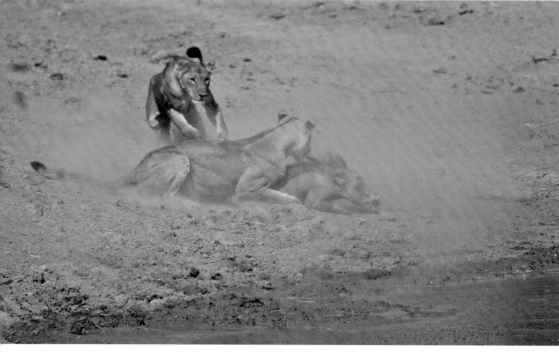

There is nothing quite like watching a lion kill *from start to finish, it is a rare sight and a privilege to witness. In this case, following the initial ambush made by a lone lioness, the rest of the pride arrived. A tug of war ensued over the warthog who, incidentally, was still very much alive.*

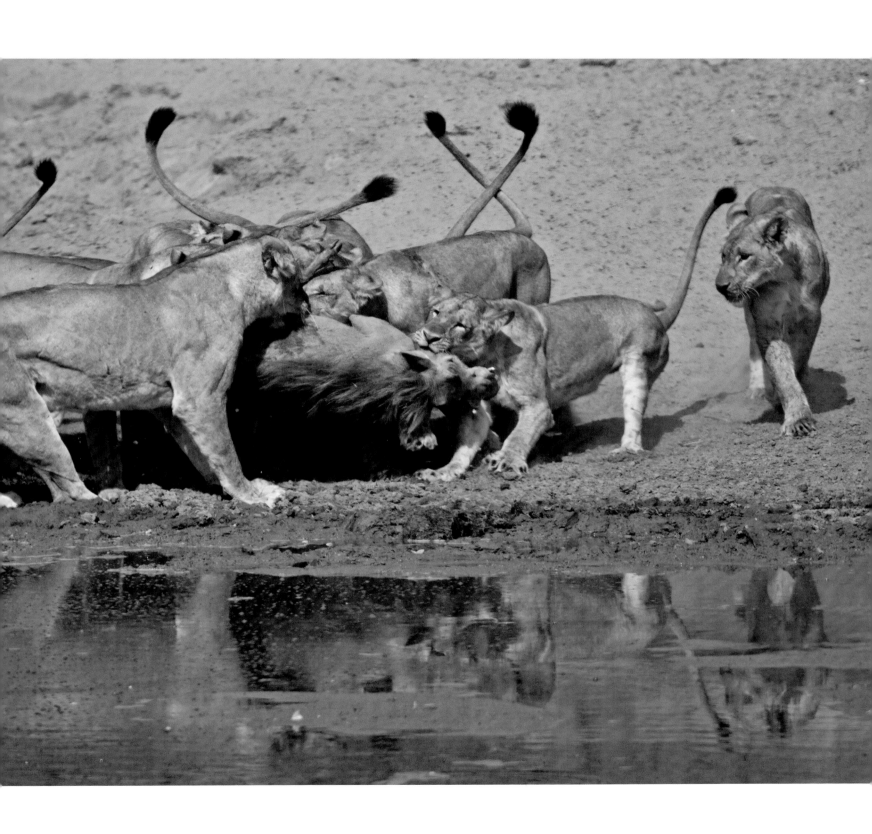

GOING PLACES

Skill in handling light is obviously important to all photography regardless of whether or not it features wildlife. One other aspect of photographing wildlife with a stills camera, however, is the fact that animals are living things and therefore move; whether the movement is fast or slow, capturing it requires another set of finely tuned skills and a another kind of expertise.

Throughout this book I have referred to other branches of photography and the techniques and inspirations which they share with my own speciality. The skills of sports and action photographers provide the inspiration for this particular collection of images. Action is also my main sphere of expertise and I relish the challenge of nailing a great image showing the power of nature. Action shots are great fun to take and as a story-telling medium they can depict power, aggression, and strength or, at the other end of the spectrum, grace and beauty.

Wild animals rarely move in a straight line and their unpredictability keeps you on your toes photographically. The subjects are often chasing something that does not want to be caught, or fleeing with many sudden changes of direction. Action wildlife photographers need to possess a wide skill set; they need to be confident in shooting hand-held, need to be able to react instinctively and quickly to a situation and need to use, and make adjustments to, their camera and autofocus instinctively. The last point is very important as the action photographer has literally split seconds to get the shot, and needs to concentrate totally on what is happening through the viewfinder. The briefest glance away could mean missing everything.

Any professional, from a sportsman to a mountain rescue specialist, will tell you perfection only comes from practise and this is something that we photographers forget at our peril. You should be so in tune with your camera when you use it that it should feel like an extension of your body. Once you have mastered this, then getting that killer action shot will be a whole lot easier.

Predicting animal behaviour is an essential skill for any wildlife photographer and it is not even one that is photography-related. It can make the all difference and give you a crucial edge when faced with a situation where every second counts. I had no idea that this grizzly would run straight towards me, but she was fishing and liable take off after a salmon in any direction at any time. Therefore I set the autofocus to tracking mode before she entered the water and never took my eye from the viewfinder whilst she was fishing. There was another good reason for me being prepared beforehand; the sight of a huge female grizzly pounding through the river right at me would have been a little distracting, to say the least, but I suppose it could have been worse: I could have been the salmon.

Composition

Man has been fascinated by flight since the very beginning and I doubt there are many of us who do not look at a flying bird with envy. Being able to see the world from above, with the freedom to go where you want, when you want, would be a lifestyle that many of us would choose. OK, it has its downsides, like when some sharp-beaked merchant with long talons is intent on having you for dinner, but for the most part being able to fly for even a few minutes would simply be an unforgettable experience.

This is a magnificent white-tailed sea eagle, taken with the help of my great friend and fellow eagle-lover Ole Martin. It is deliberately framed on the right-hand side of the picture in order that it should seem to be looking into the dead space to the left. I know that this may go against the grain, but I think that it is essential to give the image some balance and make it more pleasing on the eye. In fairness, I should add that getting a fast-flying bird composed to one side of the frame is incredibly difficult and that, in the case of some speed merchants like the falcon family, actually getting it in the frame at all is a major achievement. If you do have the chance to try to add a bit of composition then do make the extra effort, as it will definitely pay off. Try using an off-centre focusing point (a gamble, as they are not as accurate as the central one), but no one ever said flight photography is easy.

Tracking autofocus was used *for this shot and my arms were virtually falling off hand-holding my 500mm lens for the whole of the eagle's approach. Since the light was good, I bumped the ISO up to 400 so that I could increase the aperture to f11; this would allow me to get the wings sharply in focus from edge to edge and I figured it would give me a better chance of getting a sharp head, too. The downside to doing this was that at f11 the depth of field would bring the low clouds into play too, perhaps more than I would have ideally liked, but without them the pictures would have been very dull.*

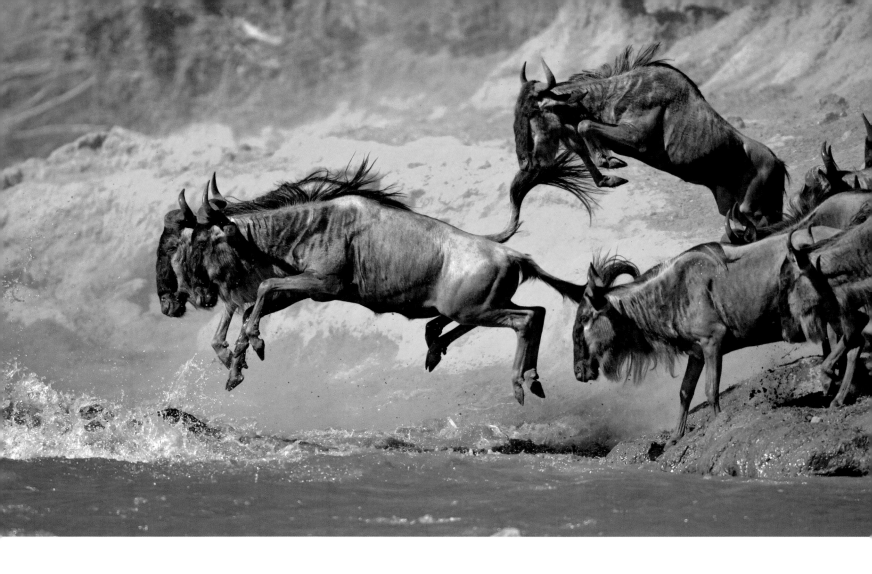

Choosing autofocus points

Action shots do not have to be aggressive and overpowering, all they have to do is to truthfully reflect the way in which your subject moves. The Verreaux sifaka is very much the ballerina of the animal kingdom, dancing gracefully from tree to tree with an amazing poise that is extremely difficult to illustrate well. This is one of the favourite action pictures in my collection as it captures the sifaka's graceful and elegant movement perfectly. This was the result of spending a week with a troop of them and learning to predict when and where they would move. Since I used a vertical format here I would never consider using a single autofocus point at the top of the frame as these are traditionally very inaccurate, so I selected all of the points and hoped that the autofocus would lock onto the face, as it provided the greatest contrast, being black.

The annual wildebeest migration in the Serengeti-Mara ecosystem comes to a spectacular peak when the herds reach the raging Mara River. Throwing caution to the wind, the wildebeest race into the rapids and swim for their lives, some are so desperate to get to the other side that they do incredible leaps to get a head start. Focusing on them is very difficult and I have given up using servo/tracking autofocus as I have more backgrounds in-focus than wildebeest. With this particular crossing I used one-shot autofocus and selected a focusing point which covered the wildebeest on the right before they jumped; fortunately they were all jumping parallel to where I was parked, otherwise this approach would not have worked.

Meet one of the two fastest land animals on Earth. *Everyone knows about the cheetah's amazing ability to run but the Thomson's gazelle is always overlooked. You see, the Thommie has to be fast, because it is the favourite prey of the cheetah and has to run like the proverbial clappers at the first sight of a cheetah appearing out of the grass. Most photographers on safari are unfortunately only interested in getting an image of the cheetah and this is a real shame as the Thommies are equally beautiful and every bit as challenging to photograph. There is a lot of 'trophy photography' these days, and although I love to photograph big cats and other large mammals, I am drawn to the antelope and gazelle families from my love of stalking deer in Britain. They have a grace and finesse that no cat can possibly emulate.*

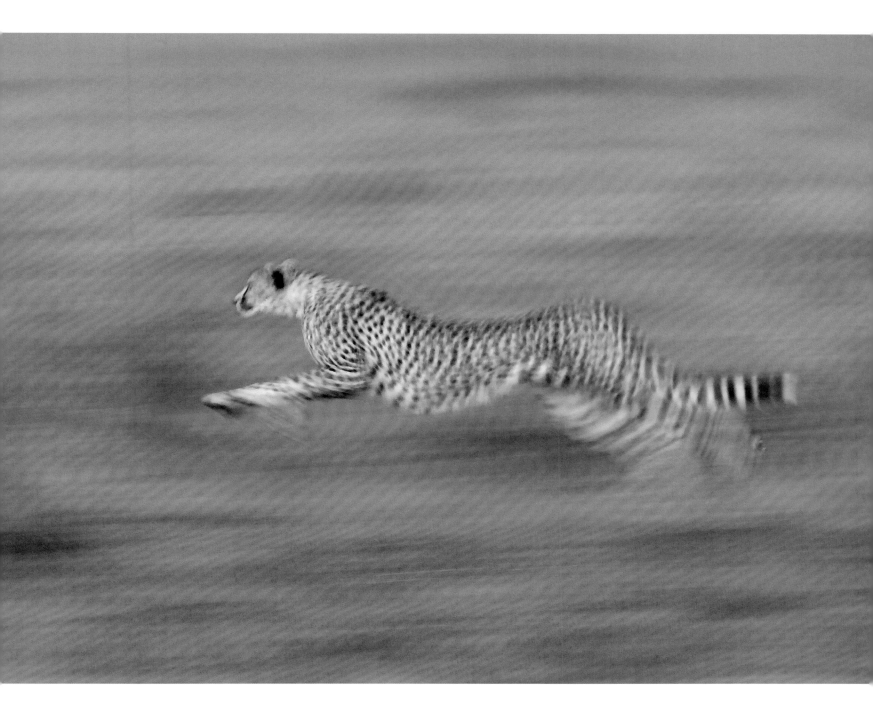

The story to both of these shots *is a life-and-death chase which is told all the more effectively by the combination of a slow shutter speed and panning the camera during the motion. I shoot a lot of motion this way, especially speed merchants like the cheetah, as I think that it gives a true impression of the speed and adds an artistic feel to the shot. Not an easy technique to master, but one that I have been encouraged to adopt more and more by looking at the work of my French colleagues.*

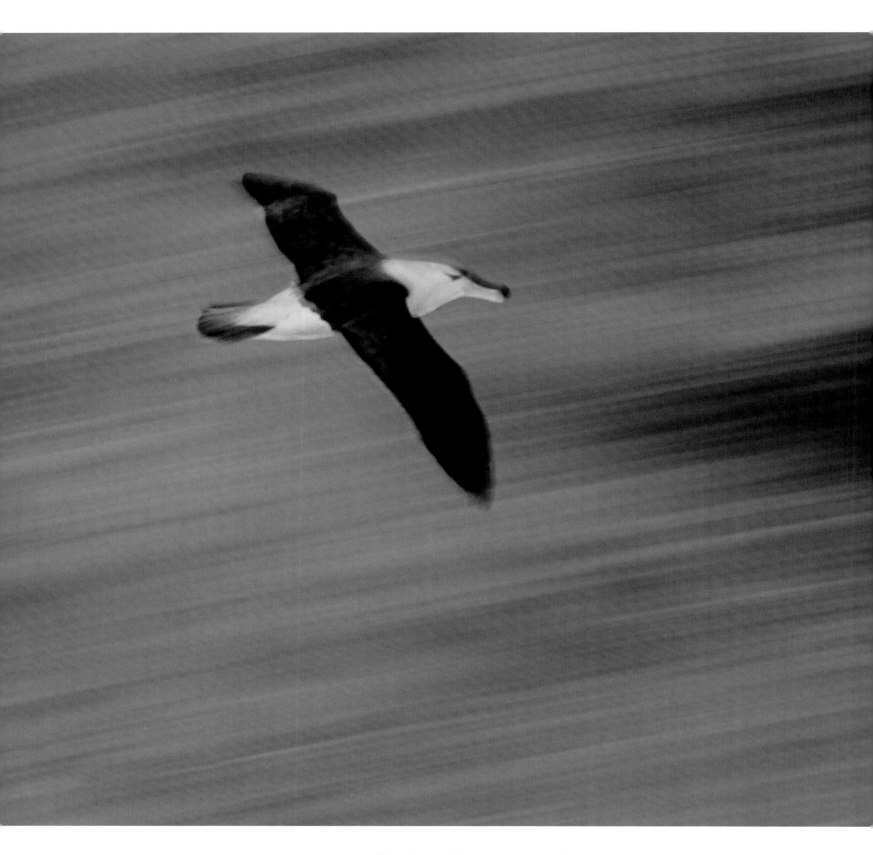

Motion streaks like this are difficult to judge correctly; if you have the shutter speed too high then you will not get any streaks, too low and it will look a mess. The subject needs to still be recognisable for this to work and for this exposure I used about 1/15th second; there is no hard and fast rule for this as it comes with experience, after a while you will instinctively know what exposure is about right. Photography is never more than just an educated guess based on experience; everyone, and that includes me, gets it wrong sometimes. Learn from your mistakes and try again is my only motto and it's the same for every other professional that I know.

Second sync flash

In seafaring folklore, albatross have a reputation for bringing bad luck because they are believed to be the souls of dead sailors. From my point of view they are simply stunning. The albatross is in severe trouble and the more people that care about them the better chance we have of saving them for generations to come. So I had no hesitation in including another image of these incredible ocean wanderers.

This particular albatross species is the black-browed and this shot was taken on the Falkland Islands. It was late in the evening, the light was grim and it had been a long and frustrating day: the wind had made it dangerous to go anywhere near the cliffs and had tried its best to rip my shelter apart, too. Eventually, the wind died down and I decided to take a beer and a sandwich to the cliff tops and watch the albatross sail by below me. I was alone on this island located at the very extremity of the Falklands, and relishing the isolation and careless abandon that this kind of lifestyle gives to me. In a wilderness like this my thoughts are my own, I do what I want at my own pace and have no pressures or contact with the outside world. Heaven. I sat with my feet dangling over the edge of a cliff, a 500ft straight drop to the abyss below and cracked open the beer, life is rarely much better than that.

After a few minutes, a procession of albatross flew below me against the background of the sea and an arty thought popped into my head. The light was too low and poor to freeze the motion of the albatross. So I put on the flash, together with an extender to boost its range, set the shutter speed to 1/15th of a second and the flash to second curtain synchronisation. The shutter speed was deliberately slow to create the streaky effect and sense of movement. The flash would light the albatross and define it against the background and the second sync would ensure that the motion trail would be behind the albatross. I tried it a few times, moving my shoulders too, when the shutter was open, to accentuate the streaking effect, and finally got a decent enough shot. Panning shots can work wonderfully; the key is to keep your camera moving to keep pace with the subject whilst the shutter is open; wiggle those hips and you'll get more than admiring glances.

Just through determination and self-belief in a novel idea I had created something from nothing and I think that this is a lesson that we can all learn as photographers. In fact, this is the hidden skill of the true photographer, turning a half-chance into reality. After all, what does it cost if you get it wrong? Digital photography is effectively free once you have invested in the gear, so why not take a few risks and try something new; if it fails then work out what you did wrong, delete the thing and try again until you get it right. There are no short cuts to success, just sheer hard work.

Motion as art

We had walked a few miles and it had taken us a couple of hours before we found the gorillas. The sky was overcast and the gorillas were in the depths of the forest and showed no inclination to move out into anywhere brighter. This is the story of my life; I find the animal in bad light. Actually, it is probably the story of every photographer's life as bad light can ruin anything; the problem is that as a professional you generally have to make the most of any given situation. Imagine a wedding photographer telling the bride that they cannot shoot today because it is raining! So the solution is to think outside of the box and try to be a little creative.

I knew that there was not enough light to stop the motion of the gorillas walking, so instead decided to use the low light and the slow shutter speed to create the shot that you see here. I love it because it is different and because of the expression on the little chap's face. Since the story here is the youngster being carried by the mother it is not essential to get all of the mother in the shot, we only need an impression of her. Like I have said constantly throughout this book, it only takes something small to make a picture into something special.

This kind of artistic shutter-speed shot is a bit hit-and-miss and the only way to get a feel for what shutter speed you need is to practise. Much depends on just how fast the subject is moving and it is a fine line between getting it right and creating something unrecognisable. To get this blur, I used a shutter speed around the ½ second mark as I knew that the gorillas weren't moving fast enough to create the streaks with anything faster. I took about fifteen images in the sequence and only two work, this one being the clearest. But that is fine by me as it is the final shot that counts and the missed ones are only memories for the few seconds it takes to press the Delete key.

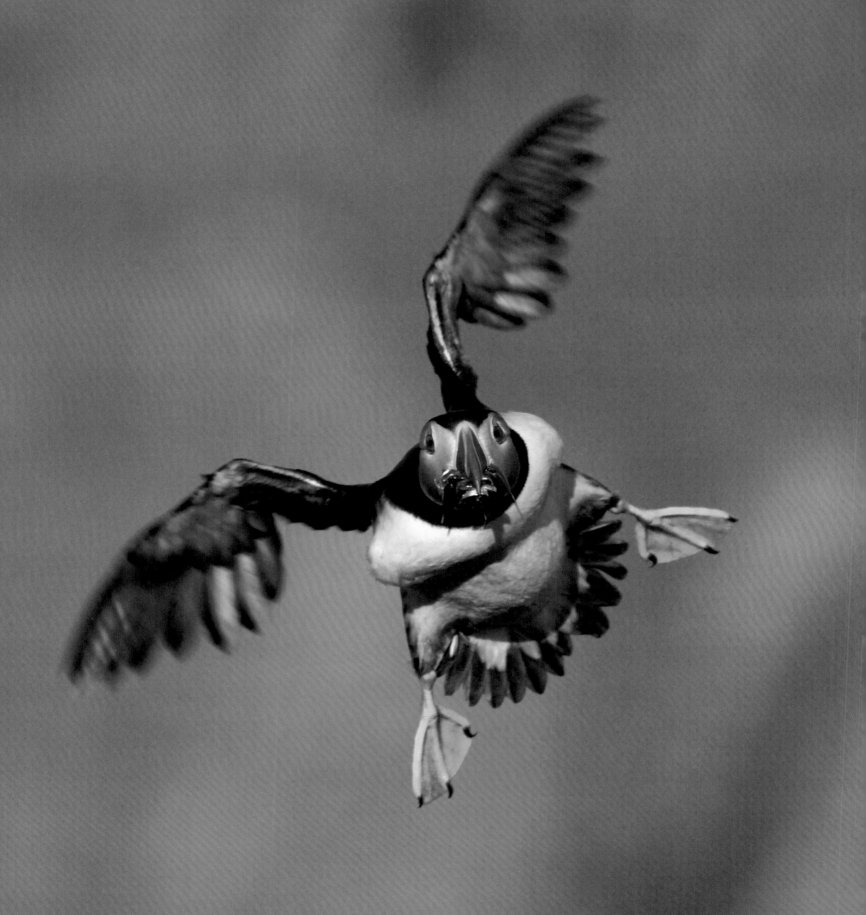

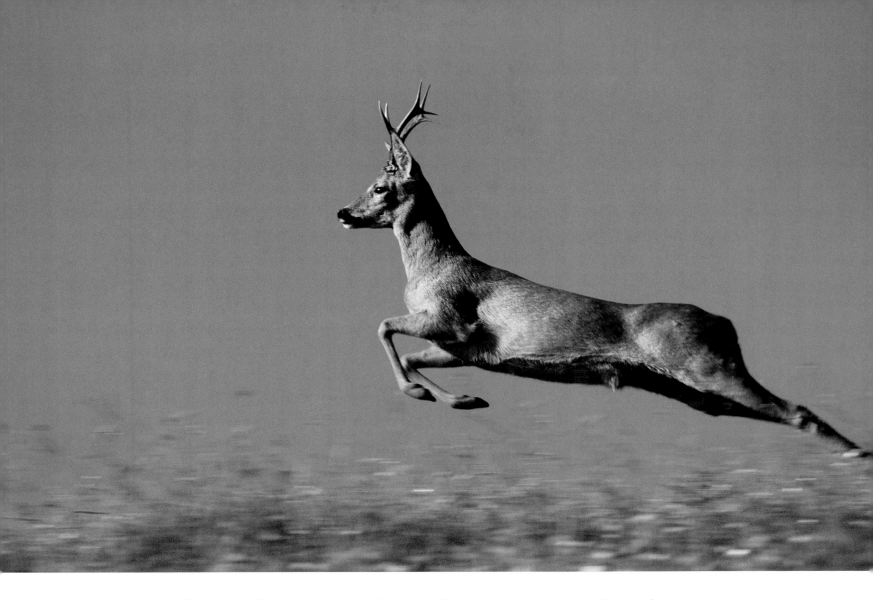

Puffins are 'ultra' difficult to photograph in flight, especially head-on like this one. They fly incredibly fast and seem to be very small in the frame right up until the last moment. On this occasion I had tried for several days on Fair Isle in the Shetlands Islands to get this shot, but each day I had been thwarted by the lack of wind to slow down the puffins' approach. Fortunately, the wind finally appeared with a vengeance and I knew, given the wind direction, that they would have to stall slightly just before landing. Sitting on the edge of the cliff I could track their approach for over a minute, keeping them in the centre of the viewfinder until they flung their wings out and braked madly to avoid crashing into the cliff. This shot was one of the lucky ones when it all worked to plan, but there weren't many of them. Even at a really high shutter speed the wings are still showing some motion, clearly indicating the rate of knots at which the puffin is steaming in. I love this.

This image of a roe buck has appeared in several of my books already, simply because I love it so much. Shot hand-held during a five-second, chance encounter, it shows that sometimes you just have to shoot on instinct and hope for the best.

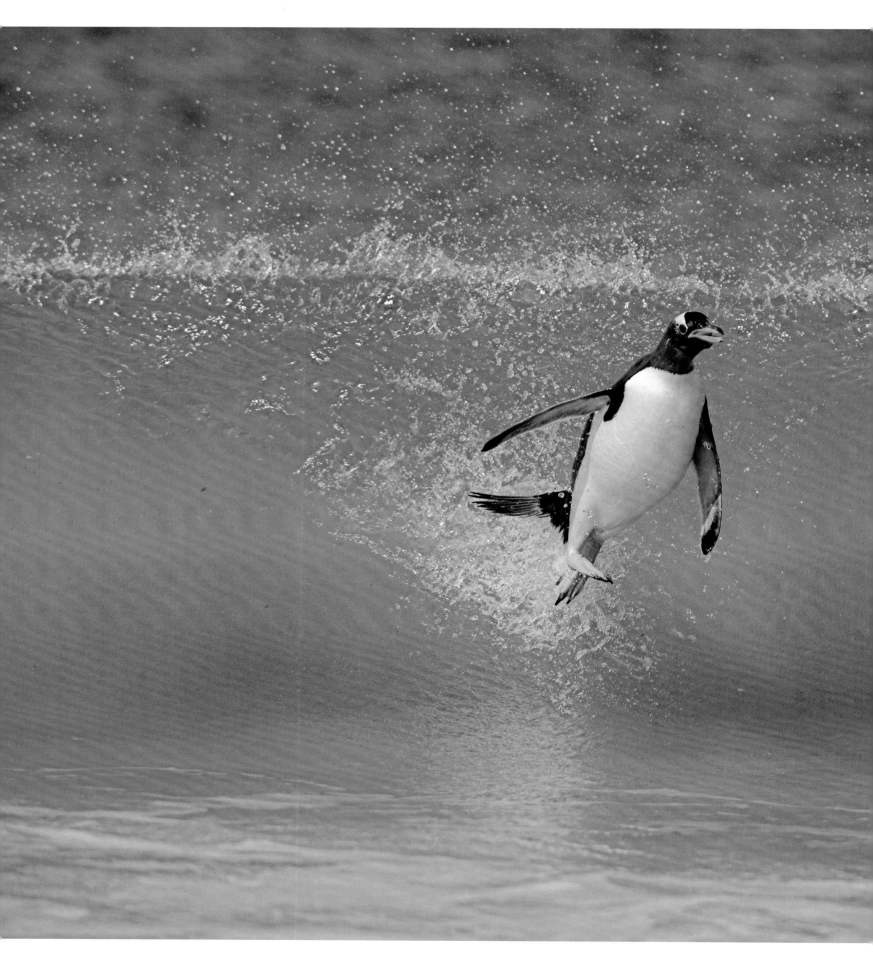

Predictive autofocus

Tracking or servo autofocus is a boon for the action photographer as it removes a lot of guesswork from capturing vivid action images. The knack to using it is to keep the subject as near to the centre of the viewfinder as possible, to follow the motion smoothly and to wait until the subject is in where you want it before blasting away. I wait until I see the shot that I want in the viewfinder before pressing the shutter, as I know that this shot and the few that come after it will be far better than any of those that I would have shot before. It might sound cool, having a camera like a machine gun, but it's really cool to actually get the picture you want in just a couple of selective shots – one being the ultimate achievement.

This surf dude was a difficult shot to take, mainly because I was laughing most of the time. It was truly incredible. My shot started when they were a couple of minutes out from the beach and still swimming underwater; they are fast beneath the waves and do this for safety as it helps them avoid lurking sea lions which may eat them. It was important that I tracked them as early as possible, as their evasive manoeuvres tended to throw the autofocus off, resulting in a high proportion of missed shots. Keeping a steady hand and a smile on my face, eventually one would burst through the top of a wave and surf right into my viewfinder. Awesome dude, take the waves man!

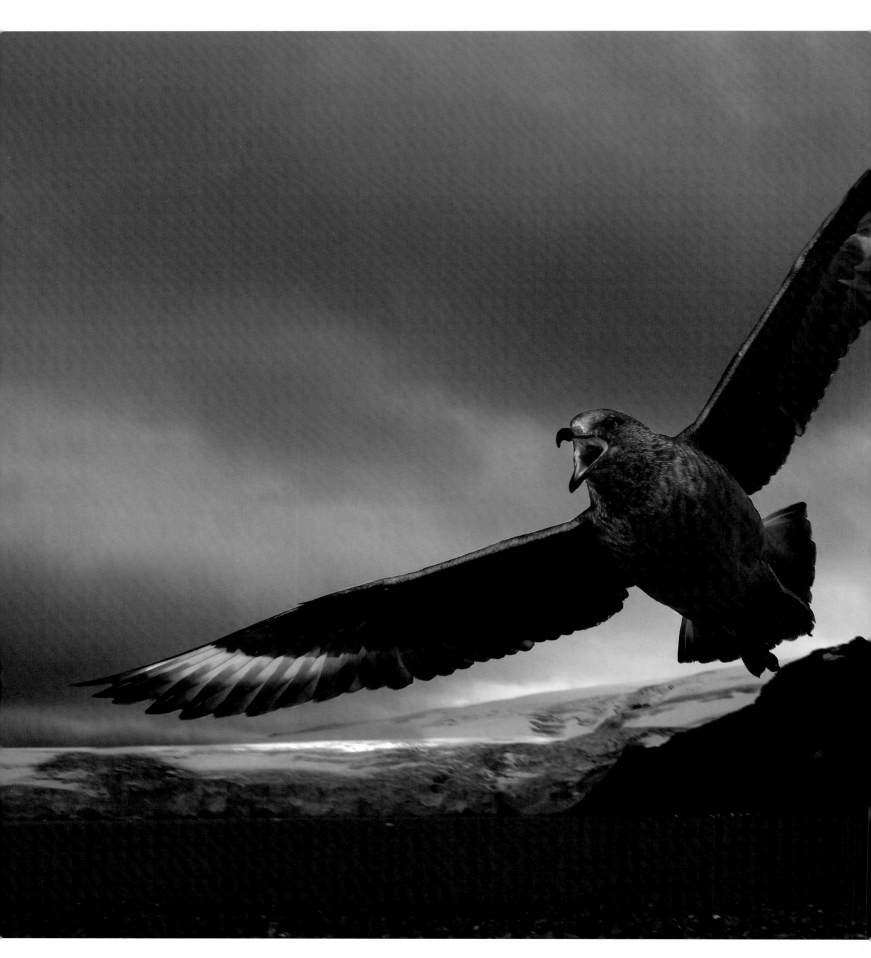

Balancing the light

I have been dive bombed by Antarctic skuas more times than I care to count and am always amazed at their aerobatics and their determination to see me off. The skuas behave like this because there is a nest somewhere in the vicinity and they are just doing what comes naturally. Aggression in nature always has an explanation, but this is little consolation when you are being dive bombed persistently by a sadistic parent. On this occasion I had been assailed by several pairs of birds on the way from the boat to the penguin colony I was heading for, so on the way back I decided to try to get some shots. The light was dreadful but Antarctica is always the land of opportunity and had provided me with a really stormy sky; this gave me the one final ingredient I needed for the idea I had. The skua itself would provide the main interest in the image but the problem would be exposing it enough to make the details of the bird stand out without losing the mood of the background. The solution was to resort to flash, and I say 'resort' because I always hate using it with wildlife of any kind as I consider that to do so shows a lack of respect.

So, I always try to use flash with caution and on this occasion attached a diffuser cup to cut down the harsh light of the flash and produce a much softer effect on the bird; the added bonus of a diffuser was that the reduction in power would mean their was less chance of flash affecting the bird's eyesight, which would have probably make it even angrier! With flashgun attached, I set the autofocus to servo/tracking and started the walk of death. Quickly, I was attacked again and all plans of standing there and composing the shot promptly disappeared…I used the camera to fend the bird off and fired it at the same time. With murderous intent, it circled and came in for repeated attacks, each time I took shots whilst fending it off and I must admit that my pace quickened considerably until I broke into a run to get the hell out of there! The final shot that you see here has been straightened slightly and shows another benefit of shooting at a slightly wider angle than you would normally. It's one shot that I won't repeat in a hurry!

This is the kind of image that is built in stages. *My first job was to work out the background exposure and for this I deliberately shot –2/3 stop under-exposed to get the moody effect. Then I powered on the flash, set the exposure compensation to zero and added a diffuser cup. Normally I would set the flash at –2 to prevent any effect on the background exposure but this would not happen here, as it was not close enough to be affected. The diffuser cup was used to soften the light as the skua would be close, damn close, and could easily be over-flashed.*

INSPIRATIONS

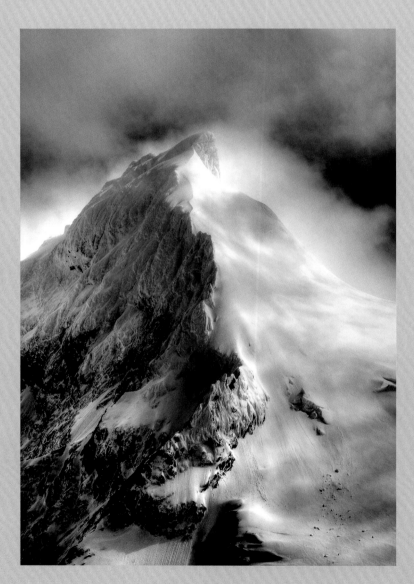

Throughout *Concepts of Nature* I have tried to show how photographers from many other genres have inspired my work. It is my sincere belief that, as photographers, we have to be open and honest enough to admit that we can all improve our work, and then have the courage to learn from others and admit that we have done so. So here are a few of the photographers that have inspired me and continue to do so to this day.

Ansel Adams and **Joe Cornish** – yes that's right, two landscape photographers. You see, landscape photographers use light in a very pure way to tell their stories. These two photographers are different, of course, but the underlying skill is that the light is the most important element in their work. Ansel's photographs remain timeless, reflections of wild America that display a unique understanding of the relationship between light and shadow. Joe's pictures are a real craft with an amazing attention to detail, perfect composition and a use of soft light that I find constantly inspirational. My Antarctic and South Georgia landscapes were taken after looking at a fair collection of the work of both these great men and it is to them that I give credit for my perhaps passable attempts to show the wonder of this last great wilderness.

Frank Hurley – Shackleton's official photographer on the ill-fated Antarctic expedition on the good ship *Endurance*, Hurley took some of the most memorable Antarctic images of all time. My favourite is the night-time shot of *Endurance*, trapped by ice and being slowly crushed to pieces. Despite the ship's impending doom Hurley rigged up lights to illuminate her for the ultimate one-shot deal. Awesome.

The peak of Mount Warburton dominates the northern end of King Haakon Bay on South Georgia. I took this shot because I loved the way that the light fell on the snow, and also the contrast between the snow and the rock face to the left.

I deliberately shot this impressive Antarctic iceberg with a polariser, to accentuate the contrast between the iceberg and the sky, as I knew the image was destined for monochrome. The three floating bergy bits in the foreground help lead the eye into the main iceberg, giving foreground interest and something alive in the otherwise black water.

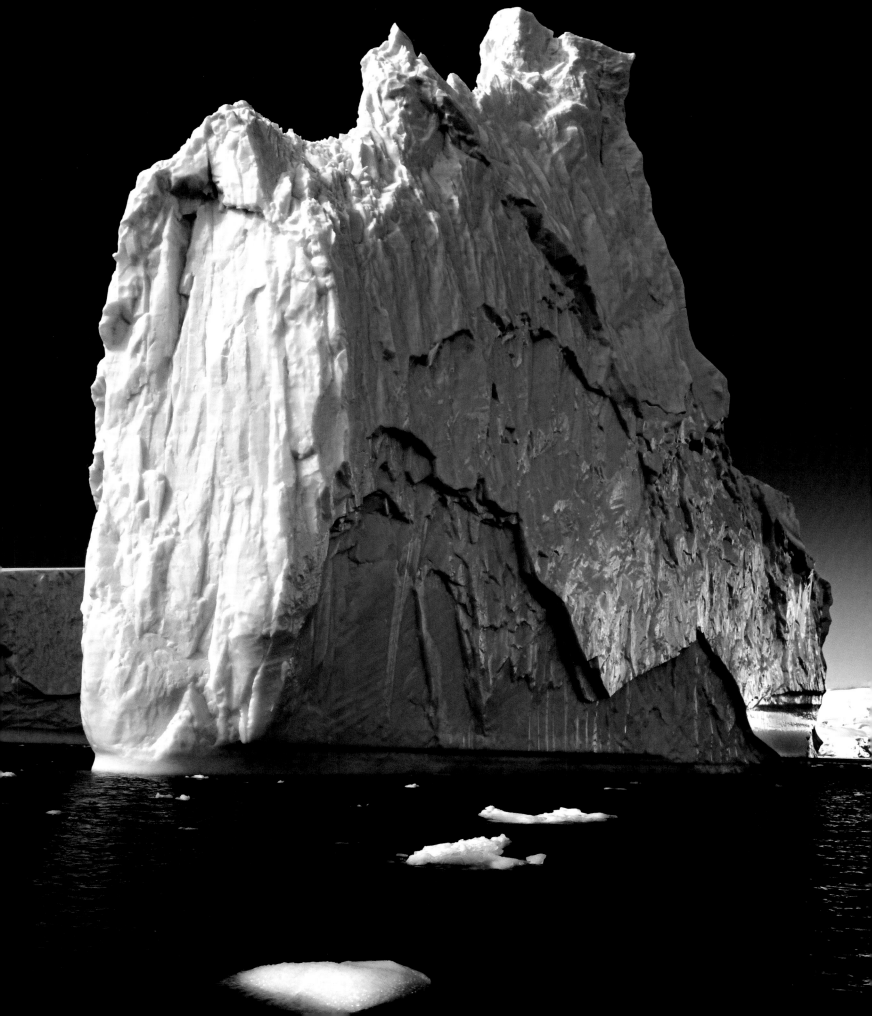

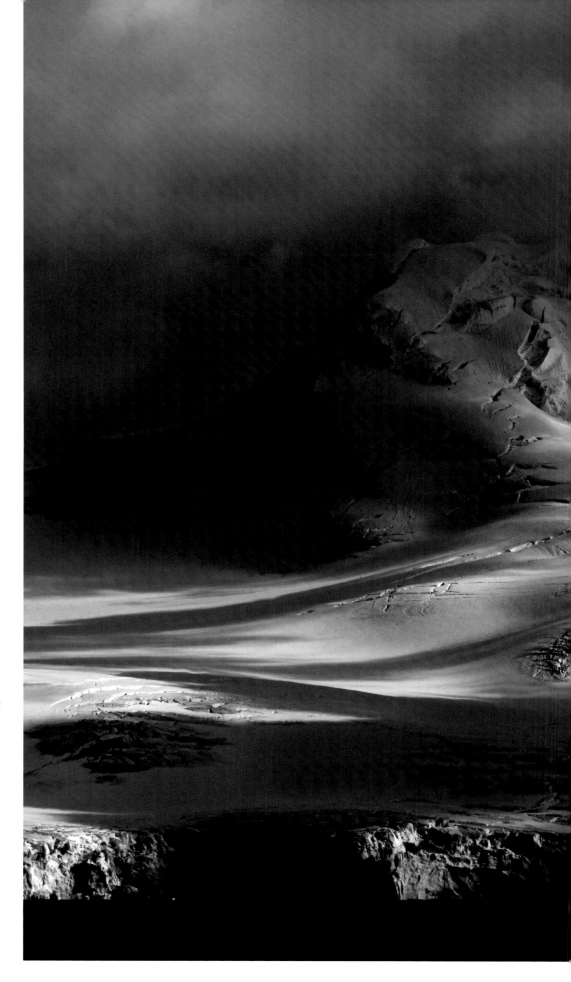

One thing I have learnt from looking at the photographs of Joe Cornish and Ansel Adams is not to shoot when the light is not right and to wait for that special moment. On this particular day the light was intense and I loved the way that the cloud swirled around the mountain peak creating areas of contrast. This is one of my favourite Antarctic landscapes.

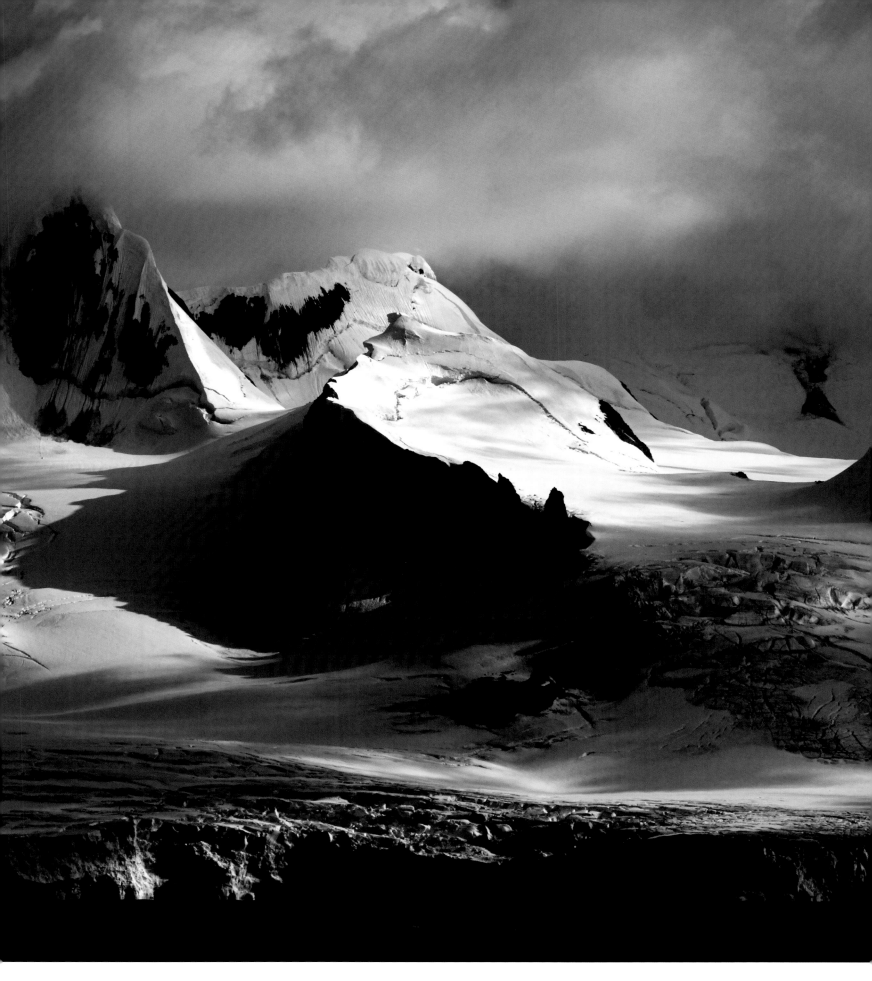

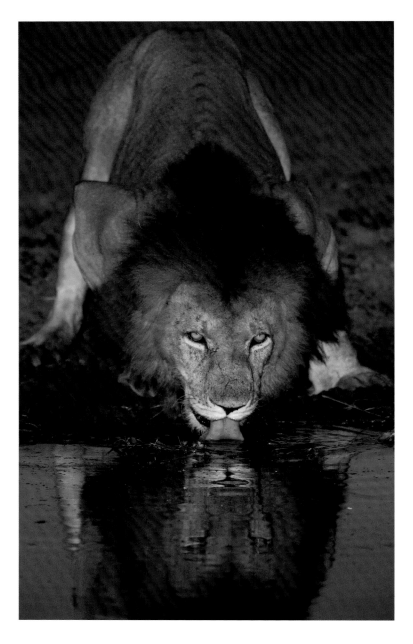

Cherry Kearton – one of the first wildlife photographers, I still have his book *Photographing Wildlife across the World* on my bookshelf today. He was a real pioneer, a traveller who loved wildlife photography and produced incredible images considering that he was working in the early 1900s. At this time hunting was the accepted norm in all of the locations that he visited and photographic equipment was designed largely for social photography and certainly not for wildlife. The fact that always inspires me about Cherry is his passion for wild animals and his understanding of the natural world, something that is getting increasingly lost in this technological gadget crazed world. He loved lions especially, describing them as 'brutes', and my lion images are all dedicated to his work on these much endangered big cats.

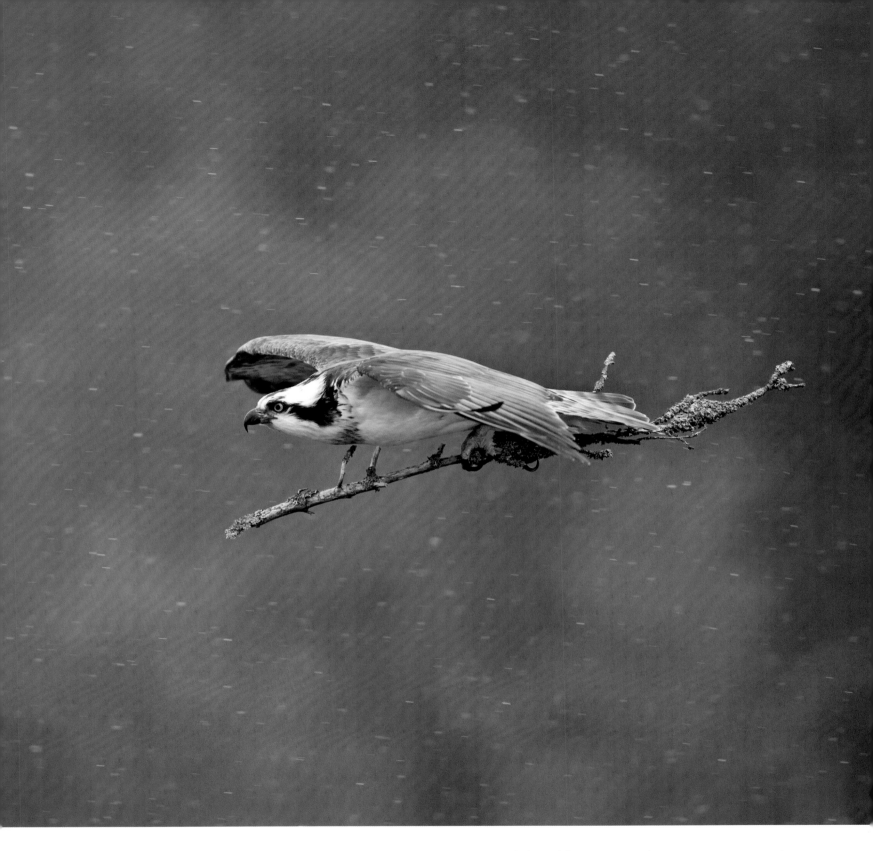

The Finns and the French – my photography began to undergo some pretty radical changes when I was exposed to the work of professional colleagues from Finland and France. Notable amongst these are Eero Kemila and Vincent Munier, both of whom are true wildlife photographers in the purest sense of the words and have been, and continue to be, an inspiration as well as friends. They taught me to look at light in different ways and to give space to my work rather than trying to fill the frame all the time. The results you can see throughout this book and images like this male osprey carrying a stick to the nest in a snowstorm are a testament to the feeling of space that I now try to portray in my work

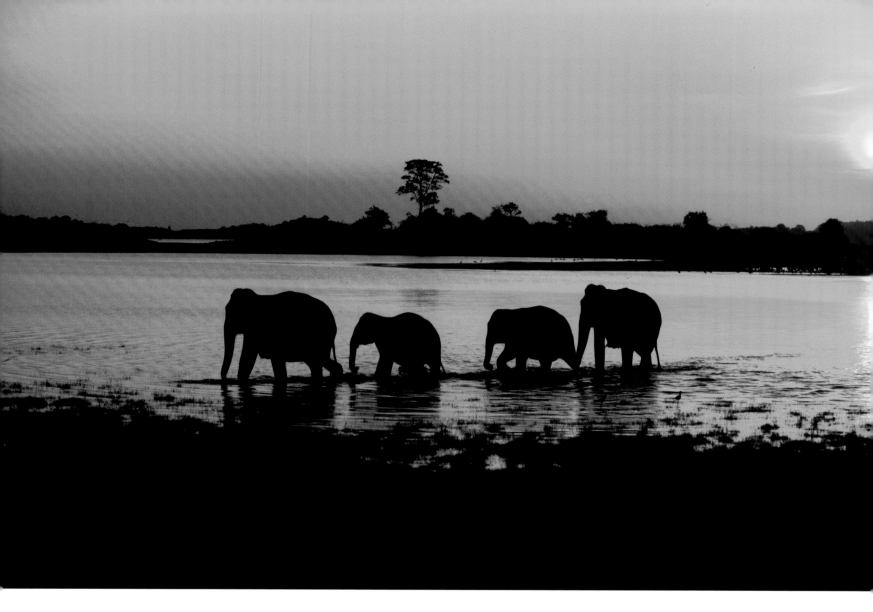

Galen Rowell – I didn't get the late Galen Rowell's work when I first saw it, for me it was too wide-angle and I just didn't get the message it was trying to convey. By the time I did understand it, and boy did I get it, Galen had been killed in an air crash and I have always regretted never meeting this great man. Of all the modern photographers, it is Galen whose ethics and vision have the most to teach us all and his work has been the inspiration for my latest projects in South Georgia on 'Living Landscapes'. The temptation to zoom right into these elephants was great, but the shot that you see here has a good balance between the habitat and the Asian elephants.

The Scots – my exotic images overshadow much of the work I have done in the UK, but I do have a great passion for our native wildlife. As an amateur photographer I admired the work of a great many UK-based photographers, but it was that of Laurie Campbell and Neil McIntyre which inspired me the most. Their images are simply beautiful windows into nature and a reminder that wild Scotland is more than a match for any other wilderness on the planet. Their images of red squirrels have always been the best and this is my twist on this much-loved and much-sought-after British mammal.

ABOUT THE PHOTOGRAPHS

Concepts of Nature is almost at an end. The following pages detail some of the technical equipment that I used to take the images reproduced in this book. In a nutshell, this can be summarised as Canon camera equipment, Paramo clothing to keep me dry and Jobo downloaders to keep it all safe. However, it always seems a crime to me to bring wildlife images down to this technical level, as the gear is not the only common factor that links all of these images. The other common link is the emotion, my emotion at the time I pressed the shutter button and I hope that it is reflected in each image. Sometimes I was happy, sometimes sad; sometimes I was just damn angry with life and I think that all photographers must put their emotions and passion into their work. That makes it unique and a truly personal representation of the world and how you see it.

Here's my final story of the book. The handsome chap shown here is a capercaillie, a bird that I felt lucky to see, let alone photograph. This one was a rogue male, without any females, and I knew that during late April this kind of male was very dangerous and likely to attack. But as I fought through the deep snow to get into the forest I did not feel particularly nervous. A few minutes after meeting the capercaillie my opinion had changed somewhat; it had a determined look in its eye that I didn't like but I still did not take the threat of an attack very seriously. As it approached, rather too confidently for a bird that barely comes up to my knees, I decided to back off a little to give it some space. I took one step back and found myself up to my waist in snow; the capercaillie immediately saw its chance and launched its assault. While struggling to free myself from the snow, I tried to fend it off with camera and lens. With contemptuous ease it ducked under my pathetic attempts at self-preservation and whacked me solidly round the head with its wing. It hurt a lot as their wings are tough. Coming in for a second round it hit me squarely on the finger and I heard the crack straight away. Twice again my fingers took the full brunt, as it came back for more, each time ducking around my tripod with a belligerence that I just couldn't believe. Eventually I forced myself out of the snow and stumbled away, with the capercaillie posing victorious behind me. And you know what, I was smiling all the time. I was smiling when I was taking pictures and I was smiling and laughing when I was getting attacked (although not as much as my friend Eero, I hasten to add, who could barely take the shots of me so helplessly was he cracking up).

As a rogue male, *this capercaillie had no fear of me and came a lot closer than I would have preferred. This image was taken on a 70-200mm lens, at the shorter end of the focal range, and the predictable end result is shown over the page…*

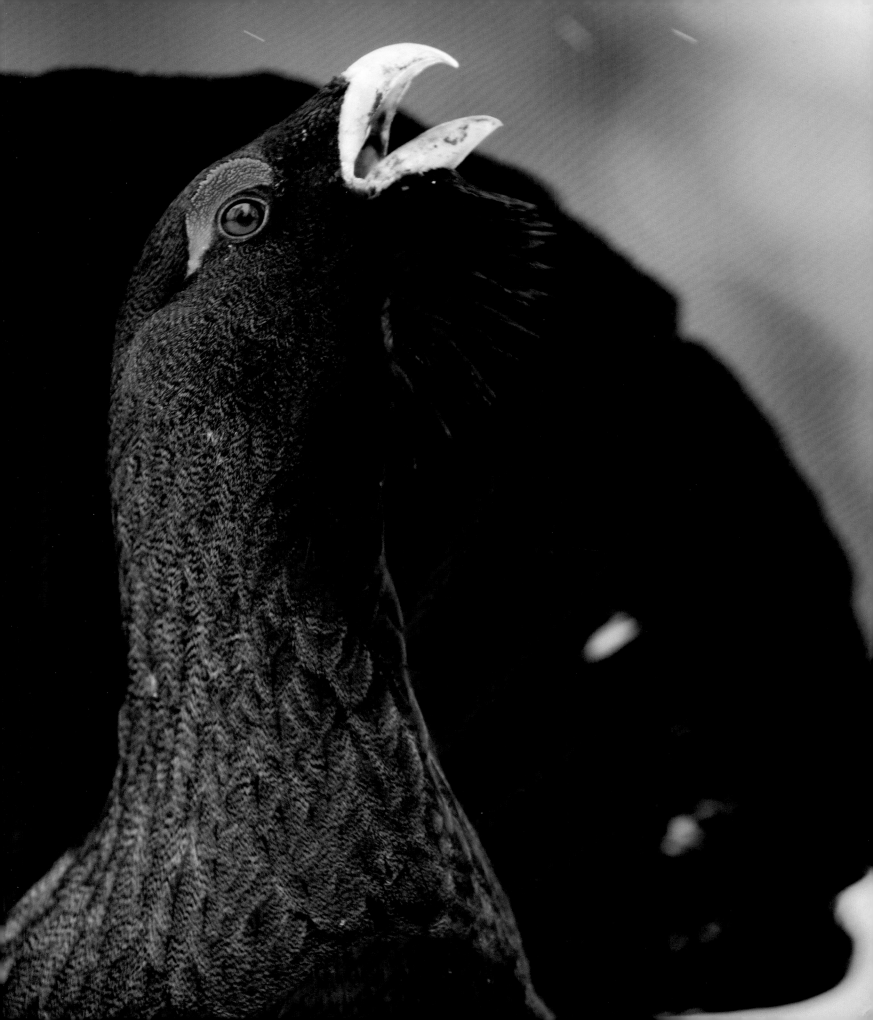

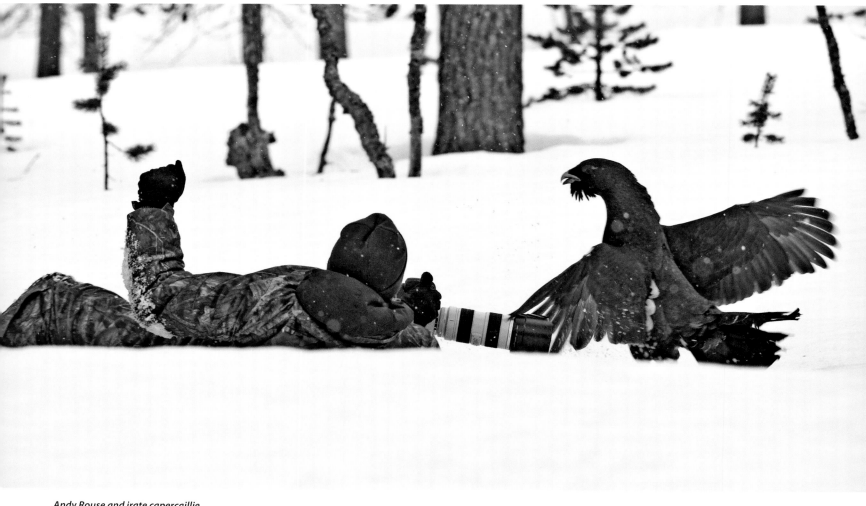

Andy Rouse and irate capercaillie

Photo by Eero Kemila

Throughout this book there have been many similar stories and, trust me, I have thousands more that will remain unpublished. But the moral of each is that photography must be fun. Sadly, I think that in recent years it has become all-too serious, with all the emphasis being put on what gear you use or how you can fix things in Photoshop. For me, the fun part of wildlife photography is spending time alone with nature and pitting my wits against her. Everything else, as far as I am concerned, is an annoying yet necessary sideshow; it is the actual taking of the picture that counts and being at one with nature.

People ask me about my ambitions and I have one very simple one, to make a difference to the wildlife that I photograph. As a photographer I can best do this by taking shots that others, better qualified than I, can use for good purposes. As a teller of visual stories I can help by revealing the lives of wild creatures to people who might never be lucky enough to witness them at first hand. My conservation fund, in partnership with Paramo, raises and donates money to small conservation projects worldwide. Just to show I bear no grudge, this year a capercaillie research project received the main donation as this amazing bird has every right to survive.

It is my hope that *Concepts of Nature* will inspire you to try new things with your photography and to get out there and appreciate the wonderful world around us. All I ask is that you treat everything with the utmost respect, that you do your bit (no matter how small) to reduce the effects of climate change and that you enjoy your photography. Finally, remember this, the only person who you have to please with your pictures is you, it does not matter what others think as long as you are happy with what you take. Don't follow other people's rules and don't let anyone else tell you what to do, develop your own style and learn to express the light that you see in that style, don't conform and enjoy your photography. Photography is not a technical science or a series of numbers; it is the ultimate art form for self-expression. Photography is fun… let's keep it that way.

TECHNICAL INFORMATION

Cover image: **Great grey owl**
Finland
Canon EOS 1Ds MK2, Canon 500mm f4L IS lens, Gitzo 1548 tripod, 1/250, f4, ISO 200.

Page 1: **Tabular iceberg**
Antarctica
Canon EOS 1Ds MK2, Canon 24-70 f2.8L lens, handheld from a helicopter, 1/350, f8, ISO 200.

Page 3: **Green turtle hatchling**
Ascension Island
Canon EOS 1Ds MK2, Canon 24-70 f2.8L lens, handheld from above, 1/180, f4, ISO 200.

Page 4: **Silverback**
Rwanda
Canon EOS 1D MK2, Canon 300mm f4L IS lens, handheld, 1/30, f4, ISO 400.

VISION – EXPRESSION – INSPIRATION

Page 7: **Cheetah**
Masai Mara, Kenya
Canon EOS 1Ds Mk1, Canon 500mm F4L IS lens, beanbag from vehicle, 1/125, f5.6, ISO 100.

Page 9: **African elephant**
Botswana
Canon EOS 1V, Canon 17-35mm lens, miniature tripod, Canon LC-3 trigger, 1/125, f11, Fuji Velvia 50 rated at 100.

Page 10: **African lion**
Botswana
Canon EOS 1V HS, Canon 70-200mm f2.8L lens, handheld, 1/60, f5.6, Fuji Velvia 50.

Page 11: **African lion**
Masai Mara, Kenya
Canon EOS 1Ds MK2, Canon 300mm f2.8L IS lens, beanbag from vehicle, 1/90, f4, ISO 200.

Page 12: **Polar bear footprints**
Svalbard, Arctic
Canon EOS 1V HS, Canon 17-35mm lens, Gitzo 1548 tripod with Kirk ball head, 1/15, f16, Fuji Velvia 50.

Page 13: **Polar bear**
Svalbard, Arctic
Canon EOS 1V HS, Canon 600mm F4L lens, Gitzo 1548 tripod with Wimberley head, 1/125, f4, Fuji Velvia 50.

Page 14: **Polar bears**
Svalbard, Arctic
Canon EOS 1V HS, Canon 70-200mm f2.8L lens, Gitzo 1548 tripod with Wimberley head, 1/60, f2.8, Fuji Provia 100 pushed to 200.

Page 16: **Humpback whale**
Caribbean
Nikonos V, 14mm lens, 1/125, f8, Fuji Provia 100 pushed to 200.

Page 18: **Hippopotamus**
South Africa
Canon EOS 1D MK1, Canon 500mm f4L IS lens, Gitzo 1548 tripod with Wimberley head, 1/60, f4, ISO 200.

Page 20: **African white-backed vultures**
South Luangwa, Zambia
Canon EOS 1Ds MK2, Canon 70-200mm f2.8L IS lens, beanbag from vehicle, 1/90, f2.8, ISO 200.

Page 21: **African Lion**
Masai Mara, Kenya
Canon EOS 1Ds MK2, Canon 300mm f2.8L IS lens, beanbag from vehicle, 1/250, f4, ISO 200.

Page 22: **King penguins**
Falkland Islands
Canon EOS 1Ds MK2, Canon 24-70mm f2.8L lens, handheld, 1/90, f5.6, ISO 200.

Page 23: **King penguins**
Falkland Islands
Canon EOS 1Ds MK2, Canon 70-200mm, f2.8L IS lens, handheld, Canon speedlite 580 flash with diffuser set to minus 2, 1/60, f5.6, ISO 200.

JOURNEY SOUTH

Page 25: **Macaroni penguins**
South Georgia
Canon EOS 1Ds MK2, Canon 70-200mm f2.8L IS lens, handheld, 1/125, f11, ISO 100.

Page 26: **Lenticular clouds**
South Georgia
Canon EOS 1Ds MK2, Canon 70-200mm f2.8L IS lens, handheld from ship, 1/90, f8, ISO 200.

Page 27: **Peters Glacier**
South Georgia
Canon EOS 1Ds MK2, Canon 24-70mm f2.8L lens, handheld from helicopter, 1/320, f8, ISO 200

Page 28: **King penguin and chick**
South Georgia
Canon EOS 1Ds MK2, Canon 70-200mm f2.8L IS lens, handheld, 1/500, f5.6, ISO 100.

Page 29: **King penguins**
South Georgia
Canon EOS 1Ds MK2, Canon 300mm f2.8L IS lens, handheld, 1/90, f11, ISO 200.

RED5

JUST PLAIN BEAUTIFUL

ATMOSFEAR

Page 95: European brown hare
UK
Canon EOS 1V HS, Canon 600mm f4L lens, beanbag from vehicle, 1/250 f4, Fuji Velvia.

Page 96: Roe deer
UK
Canon EOS 1V HS, Canon 300mm f4L lens, handheld, 1/60, f4, Fuji Sensia 100.

Page 97: European red fox
UK
Canon EOS 1V HS, Canon 300mm f4L lens, Gitzo 1548 tripod with Wimberley head, 1/90, f4, Fuji Velvia.

Page 99: Herring gull
Norway
Canon EOS 1Ds MK2, Canon 300mm f2.8L IS lens, handlheld, 1/500, f4, ISO 200.

Page 100: Black swan
UK
Canon EOS 1V HS, Canon 300mm f4L lens, Gitzo 1548 tripod with Wimberley head, Canon Speedlite flash with extender, 1/250, f6.3, Fuji Velvia.

Page 101: Little blue heron
Everglades, USA
Canon EOS 1V HS, Canon 600mm f4L lens, Gitzo 1548 tripod with Wimberley head, 1/60, f4, Fuji Velvia 50 pushed to 100.

Page 102: African elephant
Botswana
Canon EOS 1V HS, Canon 600mm f4L lens, Gitzo 1548 tripod with Wimberley head,1/125, f4, Fuji Velvia.

Page 103: African leopard
South Africa
Pentax 645 NII, Pentax 400mm f5.6 lens with 1.5x teleconverter, beanbag on vehicle,1/60, f4, Fuji Provia 400.

Page 104: Golden eagle
Europe
Canon EOS 1Ds MK2, Canon 500mm f4L IS lens, Gitzo 1548 tripod with Wimberley head, 1/250, f4, ISO 200.

Page 105: Red squirrel
UK
Canon EOS 1Ds MK2, Canon 300mm f2.8L IS lens, Gitzo 1548 tripod with Wimberley head, 1/125, f4, ISO 400.

Page 106: Burchell's zebra
Kenya
Canon EOS 1Ds MK1, Canon 500mm f4L IS lens, beanbag on vehicle, 1/60, f4, ISO 200.

PREDATOR & PREY

Page 109: African lion
Zambia
Canon EOS 1Ds MK2, Canon 300mm f2.8L IS lens, handheld, 1/250, f4, ISO 200.

Page 110: Striated Caracara
Falkland Islands
Canon EOS 1Ds MK2, Canon 500mm f4L IS lens, handheld, 1/350, f4, ISO 100.

Page 111: Striated caracara with penguin chick
Falkland Islands
Canon EOS 1Ds MK2, Canon 500mm f4L IS lens, Gitzo 1548 tripod with Wimberley head, 1/125, f4, ISO 200.

Page 112: Great grey owl
Finland
Canon EOS 1Ds MKI, Canon 500mm f4L IS lens, handheld, 1/500, f4, ISO 200.

Page 113: Great grey owl
Finland
Canon EOS 1Ds MK1, Canon 500mm f4L IS lens, handheld, 1/500, f4, ISO 200.

Page 114: Nile crocodile
Kenya
Canon EOS 1Ds MK2, Canon 500mm f4L IS lens, beanbag from vehicle, 1/500, f5.6, ISO 100.

Page 115: Nile crocodile
Kenya
Canon EOS 1Ds MK2, Canon 500mm f4L IS lens, beanbag from vehicle, 1/500, f5.6, ISO 100.

Page 116: Common kingfisher
UK
Canon EOS 1Ds MK2, Canon 300mm f2.8L IS lens, Gitzo 1548 tripod with Wimberley head, 1/2000, f5.6, ISO 400.

Page 117: Common kingfisher
UK
Canon EOS 1Ds MK2, Canon 70-200mm f2.8L IS lens with Quantum remote trigger, Gitzo 1548 tripod with Wimberley head, 1/8000, f4, ISO 400.

Page 118: Grizzly bear
Alaska
Canon EOS 1Ds MK2, Canon 70-200mm f2.8L IS lens, handheld, 1/125, f5.6, ISO 100.

Page 119: Sally Lightfoot crab
Ascension Island
Canon EOS 1Ds MK2, Canon 70-200mm f2.8L IS lens, handheld, 1/125, f4, ISO 100.

Page 120: Leaf-tailed gecko
Madagascar
Pentax 645NII, Pentax 300mm F4 lens, Gitzo 1548 tripod with Wimberley head, 1/60, f8, Fuji Velvia.

Page 121: Asian leopard
Sri Lanka
Canon EOS 1Ds MK2, Canon 500mm f4L IS lens, handheld, 1/125, f4, ISO 200.

Page 122: Osprey
Finland
Canon EOS 1V HS, Canon 300mm f2.8L IS lens, handheld, 1/500, f5.6, Fuji Provia 100.

Acknowledgements

I would like to thank the following people who were, in some way, involved in
Concepts of Nature…you will all know the reasons why

Commodore Nick Lambert, the crew of HMS *Endurance* (especially Carl, Pete, Johnno, Gary,
all at the Petty Officers Mess, Stimpy and all the Lynx pilots), Rear-Admiral Ian Moncrieff
and family, Nat Winsor, Jane Rumble, Andrew Jackson, PVV, Ole Martin Dahle, Eero Kemila,
Derek & Jules Shenton, Gavin & Marjorie Blair, Greg & Wendy Trollip, Arne Kristoffersen,
Safdar and all at Canon Service Centre, Gordon Robertson, Donald & Sheena, Alf, John
Njenga, Isaack Ntari, Gabby, Chris Green, Frank & Joan, Chris Sperring, Duncan Glenn, Clint
& Simyra, Bear guides extraordinaire Bradski, John and Kevin, Keith Kirk, Ifham Raji, the late
Dr Ravi Samarasinha, Rob and all at Paramo and finally Colin McCarthy.

A special thanks to Eddie Ephraums, commissioning editor, book designer and mentor for
Concepts of Nature – don't let the squirrels get you down, Ed. Finally, as always, to Tracey
for putting up with me for all these years.